Engaged with the arts

Engaged with the arts
Writings from the frontline

John Tusa

Engaged with the arts
Writings from the frontline

John Tusa

I.B. TAURIS

LONDON · NEW YORK

Published in 2007 by I.B.Tauris & Co Ltd
6 Salem Road, London W2 4BU
175 Fifth Avenue, New York NY 10010
www.ibtauris.com

In the United States of America and in Canada distributed by
Palgrave Macmillan, a division of St Martin's Press
175 Fifth Avenue, New York NY 10010

ISBN 978 1 84511 424 4

A full CIP record for this book is available from the British Library
A full CIP record for this book is available from the Library of Congress

Library of Congress catalog card: available

Typeset in Quadraat by Steve Tribe, Andover
Printed and bound in Great Britain by TJ International Ltd, Padstow, Cornwall

Contents

Introduction

When my first collection of essays about the arts, Art Matters, was published in 1999, I had completed four years in the job of Managing Director of the Barbican Centre in London. By the time this new collection is published, I will have completed eleven and a half years at the Barbican, with some six months to go before retirement. Thinking about these essays, I am struck by how much has changed in the past eight years in the arts world as a whole.

The arts have passed from funding at starvation levels to funding at comparative levels of decency. This allowed arts organisations in every field to demonstrate that investment goes directly into the arts themselves and not into the wage slips of those who work in them – unlike many other examples in the public sector. The range, imaginative quality and ambition of all arts programming has expanded hugely. Such ambition and delivery reaches far outside London and the South East of England. In my experience, London is the most exciting city for the arts anywhere in the world.

If that were all that was involved in the arts scene, this would be a short book. Behind the actuality of thriving arts experiences, the business of running the arts is as taxing and complicated as

1

it ever has been. Success has brought its own challenges. Most of them are addressed in this book. They include the much-discussed question of the nature of leadership in the arts; the correct way to balance arm's length funding – not a phrase often used – with the increasingly intrusive and questionable regime of objective setting; how institutions are changed and change themselves; and the obsessive matter of how those with private money should be treated if they are inclined to give at all.

These and many others are the stuff of constant – sometimes bitter – debate within the world of arts and their funders. That is why the book is sub titled 'Writings from the frontline'. Neither success nor funding in the arts is ever won without a struggle; the battle metaphor is no idle one.

I make no claim to have won many of these battles; I do believe I have at least stood and fought them.

Some – not all – of these essays appeared first as journalism or as speeches. All have been rewritten, sometimes significantly. Taken together, I hope they represent the key issues that anyone in the arts world has to address and grapple with. Certainly, no one involved in the arts will be able to ignore the issues I write about. I may have missed some subjects out; but those I include are the meat of the business.

A word of caution. I write very little about the activity of arts programming as such. This is because I do not programme myself and am not qualified to do it. My responsibility is to create the best possible conditions under which arts programming can flourish. If I have contributed to that process at the Barbican, it may be because I have tackled the issues I write about in this book.

The Barbican would not have succeeded as it has done without the exceptional skills of the arts programming team. Led by the Arts Director, Graham Sheffield, for the last eleven years, Robert Van Leer (Music), Louise Jeffreys (Theatre), Robert

Rider (Cinema) and, most recently, Kate Bush (Visual Arts) have masterminded the arts programme to the point that *The Times* wrote in September 2006 that it was the 'world's top ranking arts centre ... for adventurous programming and sustained quality'. No accolade could have been higher or more deserved.

Throughout these years, I have enjoyed – and I mean enjoyed – frequent, informal and totally open discussions with my directors – Graham Sheffield, of course; Diane Lennan, Human Resources Director in name but strategic thinker by nature; Mark Taylor, the most relentless pursuer of commercial exploitation conceivable; Sandeep Dwesar, the most imaginative, flexible and ingenious Finance Director; and Michael Hoch, a dogged deliverer of projects through thick and thin. Their insights, actions and thoughts inform much of the content of this book.

For the first seven years of my time, I was blessed with a PA, Joanna Fyvie, who ran me, much of my life and some of the Barbican with total lack of complaint and huge efficiency. Since then, Leah Nicholls, my Executive Assistant, has done all of the above and more, has created space in the diary for the time needed to think and write and has contributed to an atmosphere where we can each say the unthinkable out loud to one another. Ali Taylor was patient and indefatigable in combing my files to identify research material for these essays.

Eleven years ago, the City of London Corporation appointed me on a wing and a prayer to take the Barbican out of crisis. Having set that as a goal, the City's leaders then expected me and my management team to do just that – make the Barbican successful and bring credit to the City itself. Working within tight and tightening financial parameters – the idea that the City gives us limitless funding is, sadly, fantasy – the City has operated a light regulatory regime, believing that responsibility delivers better results.

I and my colleagues are grateful for that trust, believe it has been a wise policy and also believe that we have shown that light touch regulation works. I am personally grateful for the fact that the City gave me the responsibility to speak up for the Barbican in public and have not complained when I have spoken out.

Finally I salute, acknowledge and thank my wife, Ann, for her stamina, patience, resilience and devotion in making my job a part of her life. The past eleven years would not have been the same without her, not a quarter of the fun, and I would not have been able to do it as I have. Most of the utterances in the following pages have been tried out in (semi-controlled) explosions over the dinner table. To the extent that they have been refined, even house-trained, I owe it to her.

The frontline

1

And do the arts still matter?

And do the arts still matter?

Six years ago, I published a volume of essays about my first five years experience in the arts world, called *Art Matters*. Heady with the excitement of an environment, at once personal and professional, that was utterly new to me, I plunged into campaigns, both political and theoretical, which defended the arts. The need for such involvement, such engagement in the arts, has not diminished. But so much in the arts has changed during the last six years that a good starting point must be a fresh look at the assumptions that prevailed then.

Six years ago, the theoretical questions circling the arts were much as they are today. I described them as amounting to a 'great existential doubt, far worse than any political anxiety, as to whether a particular government cares for the arts: does anyone care? Can we expect them to care if the national education system and the mass media do not play their respective parts in transmitting the great inherited cultural traditions?'

Six years ago, too, I tried to express that existential doubt in more detail:

> *The arts stand naked and without defence in a world where what cannot be measured is not valued; where what cannot be predicted*

will not be risked; where what cannot be controlled will not be permitted; where whatever cannot deliver a forecast outcome is not undertaken; where what does not belong to all will be allowed to none.

How much has really changed? Are those doubts still valid? Does the need for public justification of the arts remain as urgent?

Given such doubts six years ago – and they can be voiced in identical terms today – it seemed only right to go beyond complaining about the problems of a perfect theoretical justification and attempt a positive statement of why art mattered and why it was worth fighting for:

The arts matter because they are universal; because they are non-material; because they deal with daily experience in a transforming way; because they question the way we look at the world; because they offer different explanations of that world; because they link us to our past and open the door to the future; because they work beyond and outside routine categories; because they take us out of ourselves; because they make order out of disorder and stir up the stagnant; because they offer a shared experience rather than an isolated one; because they encourage the imagination, and attempt the pointless; because they offer beauty and confront us with the fact of ugliness; because they suggest explanations but no solutions; because they present a vision of integration rather than disintegration; because they force us to think about the difference between the good and the bad, the false and the true. The arts matter because they embrace, express and define the soul of a civilisation. A nation without arts would be a nation that had stopped talking to itself, stopped dreaming, and had lost interest in the past and lacked curiosity about the future.

Six years on, I still stand by that definition. Some were inspired by it; others had their reservations. No such definition was ever going to be compelling to all, still less to be in any sense conclusive. Soon after writing it, I felt the need to try again, to attempt a more refined case for arguing that the arts deserve special concern in society because they are a special activity. By changing the parameters, by introducing a fresh set of paradoxes, I hoped to move the debate to a different part of the battlefield. It was slightly different in tone – though no less urgent – and went like this:

> Art is about searching and sometimes finding; it defines pain and sorrow and sometimes softens them; it is about exploring confusion and defining disorder; it is about sharing the private and listening to silence; it is lasting but not immediate; it is valuable but priceless; it is based in the past but reaches for the future; it is free to anybody but may not be used by everybody; it is universal though it may be attacked as exclusive; it is diverse and not homogenised; it resists categories and makes connections across them.

After the publication of *Art Matters*, these justifications for the arts were often raised at book fairs and public lectures. After one of these occasions, a local authority politician said, 'I'm sure that's all very well but none of it applies to me and what I do.' There was no arguing with that. His comment was a salutary reminder of the gap between a somewhat specialist language of the arts and the more practical considerations of the outside world in which the arts exist. If a justification for the arts is to have resonance, it needs to do so in the real world of politics, votes and funding. I thought I needed to try harder. So, six years later, with the local politician's mild rebuke still in my ears, here is a further version

of 'Why Art Matters', one couched in terms that I hope the local politician could relate to:

> The arts matter because they are local and relevant to the needs and wishes of local people. They help citizens to express their needs and to clothe them in memorable forms. They offer a way of expressing ideas and wishes that ordinary politics do not allow. The arts are immediate, intense and owned by the people who create them. The arts regenerate the rundown and rehabilitate the neglected. Arts buildings lift the spirits, create symbols that people identify with, and give identity to places that may not have one. The arts teach the young how to create, inspire the imagination and believe in their own potential. Where the arts start, jobs follow, jobs which are individualistic, independent, and forward looking. Anywhere that neglects the arts, short changes its people.

Now all of that is, actually, true. The arts have acted as a pole of economic and social regeneration in many places. Though it is worth reminding ourselves, as the architect David Chipperfield has pointed out, that the arts may be a necessary condition of post-industrial regeneration; they are seldom if ever a sufficient condition. They cannot deliver economic and social regeneration by themselves. The so-called 'Bilbao effect' was not achieved primarily because Frank Gehry's extravagantly iconic Guggenheim Museum was built in a previously economically run-down northern Spanish port. That building followed a period of sustained local government investment in infrastructure including an entire new underground system. Gehry's Guggenheim became the symbol of Bilbao's regeneration and added its own contribution to the revival that was already under way.

The arts do stimulate the growth of a creative sector in the economy. They do play a part in the vigour of the ideas economy.

They do give children a chance to express themselves, to be confident in their emotional intelligence, in a way that much of the curriculum-heavy teaching in schools does not permit or stimulate. It is good that investment in the arts has these economic and social effects.

Yet true as all this may be, it still seems to miss the essential point. The value of the arts is not to be defined as if they were just another economic lever to be pulled, or a particular investment vehicle of choice. To behave as if they were, places them on a level of activity where measurement of results, predictability of outcome, and direction of activity are rated as conditions of success and therefore as grounds for investment in the first place. We are back in the bind of instrumentality: that something is worth paying for only if it provides a measurable result. It is the bind from which serious, creative discussion about the arts needs to be freed. For, on this argument, if art delivers nothing immediately measurable as an outcome, then any case for public support falls.

We all know that such narrowly defined numerical criteria cannot circumscribe arts activity, still less guarantee to deliver creativity in any art form known to us. The danger is that too much of the public and political dialogue remains based on such assumptions. The real question for politicians, audiences and artists remains: why does art matter, even if it cannot repay its public subsidy; if it represents an investment on which there is no direct quantifiable return; if it cannot guarantee support from audiences; if it cannot demonstrate immediate social relevance; if it cannot even say in which direction it should be moving to deliver true innovation?

Real art can – and probably does – fail every specific and measurable objective set by economists and politicians. That statement is inconvenient, awkward, true and, in the final

sense, irrelevant. Art that fails on all practical fronts remains art, sometimes great art. The criteria by which it is judged are different and must be appropriate to the activity. This is not to evade accountability; it is to insist that accountability must be right for the activity. This wretched conundrum is as much a matter for artists as politicians who need to find their own language for supporting the arts that goes beyond the crudely instrumental.

So is it possible to produce a still newer definition of why art matters, one which combines the fundamental importance of absolute values with an acknowledgement that instrumental considerations do, in the real world, form part of the case for funding the arts?

Here is a further attempt:

The arts can deliver ideas whose final value cannot be predicted or quantified; to curtail them on these grounds is to deny the possibility of an unpredictable benefit. The risk of funding the arts – however uncertain – offers the promise of benefits far greater than any immediate advantages derived from not funding them.

The arts link a society to its past, a people to its inherited store of ideas, images and words; yet the arts challenge those links in order to find ways of exploring new paths and ventures. The arts are evolutionary and revolutionary; they listen, recall and lead. They resist the homogeneous, strengthen the individual and the independent in the face of pressures from the mass, the bland, the undifferentiated.

In a postmodern world, in a world where individual creativity has never mattered more, where personal autonomy has never been so valuable, the arts environment provides the opportunity

for developing these characteristics. The investment in the arts is so small; the actual return so large, that it represents immeasurable value as research into ideas.

Is there a conclusive argument for justifying the arts as an activity that society should support? Unfortunately there isn't. Those who choose not to be persuaded will remain indifferent and cynical. Far more vital is that the arts world in all its forms presents the arguments for the arts on any and every occasion; that it contests the suggestion that only instrumental arguments are relevant in the debate about funding; that it insists that arguments about the intrinsic importance of values are a key justification for the arts.

Ultimately, the arts must continue doing what they alone can do – producing the exceptional, the unpredictable, the shocking, the curious, the witty, the spirited, the heart-easing, the mind-relieving. In short, the arts matter because so much of what falls into that over-used category is unique and recognised as such. What is the price of creating the unique in each generation? In truth and actuality, the price is small. Does anyone dare not to pay it?

Arts leadership: is it a mystery or plain common sense?

I was having a negotiation about the level of arts funding for the Barbican. Opposite me was the Chief Executive of the City of London – the Barbican's paymasters – otherwise known as the Town Clerk. He had explained patiently that financial times were tough; the government's rate support grant for the City had fallen; the City couldn't endlessly draw on its accumulated reserves to fund the annual revenue budget. Every other Corporation department had taken its share of cuts. As the second-largest item on the City's budget – after the City police – didn't I understand that the Barbican had to take its share of the pain?

I explained equally patiently that the Barbican had indeed played its part in finding economies; we had in fact taken a cut in annual funding for every one of the ten years that I had been Managing Director; despite this, we had maintained arts programming at a high level, both in quantity and quality; further cuts would damage both quantity and quality; and the organisation whose reputation would suffer most would be the City of London.

The Town Clerk looked at me with a baffled air. 'Your trouble,' he said amiably, 'is that you care too much!' Thinking about the accusation afterwards, I concluded that to be damned for 'caring

too much' was a huge compliment. More importantly, 'caring too much' was an essential ingredient of arts leadership; and 'The Person Who Cares Most' was a sound definition of the quality needed in an arts leader.

Leaders in the arts must care both wisely and well; cannot moderate or qualify their sense of the commitment that the organisation and the arts deserve. The nature of their caring cannot be modified, limited or qualified. It must be unconditional and without reservation. It includes fighting for resources, speaking up fearlessly for the organisation in public; even picking up a piece of paper in the public spaces. Each act demonstrates that the leader cares. Without such observable behaviour, no leader will be credible or can be effective.

It is only one of the qualities that an arts leader must demonstrate to be recognised as such by their colleagues. Being an effective arts leader is not a title to be personally assumed. It has to be earned and can only be bestowed by others, usually those who are being led!

And the starting point must be that the leader is not supremely qualified in all areas of activity. They are not 'bosses' in the crude caricature of a certain type of business leader. A good leader is like a film director or the conductor of an orchestra. The great Czech film director Milos Forman once said to me: 'My scriptwriter writes better scripts than me; my cameraman composes better images than me; my editor knows how to build a sequence better than me. Yet without me, the film wouldn't exist.'

Or, as Sir Colin Davis, President of the London Symphony Orchestra, put it: 'As a conductor you are not actually playing or singing yourself and other people are. You are there to help them perform. At the same time you have to energise the whole orchestra.' Both Forman and Davis demonstrate a properly modest view of what they do; yet we know that their contributions

create a whole that is far greater than the sum of the constituent parts. Indeed those parts would descend into warring factions without the presiding director of the work.

So should a leader be a generalist or a specialist, or an acknowledged authority in their field? The evidence is inconclusive and varies across the years. The post-war Royal Opera was created by Sir David Webster, whose previous job was managing a department store in Liverpool. In 1951, the newly built Royal Festival Hall was entrusted to Tom Bean, an arts administrator rather than an artistic visionary. More recent experience in London suggests that when the top position is given to an expert practitioner in the relevant art form, the overall results are far from satisfactory and have been on occasion quite disastrous.

Yet to draw the conclusion that a specialisation in the arts – or a particular art form – is a disqualification for arts leadership would be too drastic a conclusion to draw from a straw poll of recent cases. If it is manifest nonsense in relation to the whole category of museums and galleries, it is equally untrue to assert that 'only an arts person can lead an arts organisation.' For, perhaps paradoxically, the leadership issue does not revolve round the best skills set alone. Both specialists and generalists can be successful. The more important question is what kind of person, with what characteristics, is likely to make the best arts leader. First and foremost, it is a matter of character, instinct, outlook and values. These apply equally to arts generalists and specialists.

It goes without saying that an arts leader must understand that a gallery, opera house or concert hall is not just 'another' organisation whose structure is analysable in conventional business terms. Some of it can be understood in this way but the essential character does not lend itself to such analysis. What distinguishes any arts organisation – or any not-for-profit

organisation – from the conventional business model is that they are driven by deeply internalised values that put the realisation of the event – whether exhibition or performance – at the highest level of priority. Most of those working in and for such institutions believe they have a commitment to the event, the organisation that created it, the art form from which it grows, the history from which it springs and the future of which it will become a part. They believe too that they are custodians of these values and mere 'managers' and arts leaders do not own or realise those values more strongly than the staff do themselves.

This is a highly privileged atmosphere to work in. It involves a strongly internalised set of values that many organisations struggle to create. But any arts leader has to accept and interpret those values and work with them or risk falling at the first hurdle. This does not mean that incoming leaders cannot change anything. But if they tamper with or undermine the core values of the institution, then the consequences can be counterproductive unless they resonate with the individuals who make the organisation.

It is sometimes asserted that there is a 'problem' with arts leadership which requires special attention in the light of some well-publicised failures of financial control. Everyone is familiar with the 'Arts Losses Mount at Institution X' story, which always gets ready attention in the media. The implication invited is that incurring deficits is an intrinsic part of the arts management world. Yet even if this were accurate – which it is not – even the worst-run arts organisation never incurs losses – still less indulges in fraud – on the scale of the Enrons, the Parmalats or the BCCIs of this world.

There are arts institutions aplenty with flawed executives; such as the one who stripped out his company's senior management and was then amazed when it plunged into deficit. Or the

artistic leader who set his organisation on a radical new course, unsupported by a viable business plan, and then discovered the new course was a dead end, financially and artistically. Or the new institution whose budget was so padded with over-optimistic budget estimates that it was only a matter of (a very short) time before it fell into aching deficit. Or the newly appointed executive who conceived of his organisation's future in terms of a grandiosity that it could not – and finally, did not – sustain.

Yet chairmen of arts institutions who often come from the business world make mistakes too. I know of an arts organisation whose business chairman thought it unreasonable to expect his arts chief executive to prepare a business plan. Another from a similar background was wholly uninterested in his arts managers' proposals for reducing costs by contracting out core services.

Whatever the combination of arts understanding and common-sense business nous needs to be, there is no evidence that business disciplines by themselves hold a unique store of solutions to arts management problems, still less that they can demonstrate a unique record of putting them into good practice in the arts world.

So the arts leader's first task will be something different. Taking the store of management skills for granted, they will both understand the core values of the organisation and articulate them for the very people who may hold them instinctively but will do so often in a fairly inarticulate or inchoate manner – their staff. The arts leader as interpreter of, advocate for and spokesman for an organisation's beliefs about itself performs an essential function of leadership. To do this well does not depend on being either an arts professional or a pure manager. The particular skill involved is irrelevant. The activity of communication and representation, and the commitment to both, are fundamental conditions of success.

As I note elsewhere, and as I learned first at the BBC World Service, 'Leadership involves telling an organisation a story about itself, which the organisation recognises as true, and then telling the story to the outside world.' The leader is at once custodian of the narrative, myth maker, and myth interpreter.

To say this is to emphasise that the effective leader puts the values of the organisation and the people who hold them before his or her own feelings. The strong leader may need to have some of the qualities of the showman, the publicist, the propagandist, to do the job well. But if it is to be done truly well, then the egotism, the vanity, the self-absorption that often accompany the great showmen and publicists must be put to one side. A colleague once observed to me at the BBC World Service: 'A good manager must be unselfish.' He might have added that your colleagues are the first to spot if the leader is more interested in himself, his reputation and his future than he is in the future of the organisation he is supposed to be heading. Personal vanity or self-absorption is no rallying cry with which to get support.

These are fundamental characteristics, aspects of character, that a leader should have. If they are not strategically positioned in this way, they will make little headway. Yet the very word 'leader' makes clear the need for a sense of direction. A true sense of direction includes and encompasses an awareness of the past, of history, of the building blocks and errors that have got the place to where it is.

In the case of the Barbican, the organisation needed to acquire a pride in what it was, rather than what outsiders said it was; to confront and accept those experiences which had gone wrong; to possess confidence in the possibility that they might be put right; and to have the determination to put them right. Out of these ingredients, some of them outwardly unpromising, a new sense of purpose and direction could be forged. Such were the

deliberate and conscious ingredients that we included in the process of transforming the Barbican's view of itself.

The best validation of this approach to leadership came in 2006, when the *Evening Standard* commented that 'the Barbican has overcome its physical debilities of ugliness and incoherence by making a case for integrity and seriousness ... It sits on commanding heights of quality and enterprise.'

Once the core task of setting the direction and speaking up for it has been set in progress, much of the rest of the leadership agenda falls under the heading of tactics, wheezes and tricks of the trade, which make the act and example of leadership easier to turn into reality. This is not to disparage their importance or to underplay their difficulty. All in all, leadership is also a complex business involving a range of activities that cannot be neglected. It has been well put by the consultant Heather Newill, who identified the overlapping nature of the tasks facing an arts leader:

> The arts leader is expected to produce artistic excellence within limited resources, yet maintain financial stability; they must manage a commercial business enterprise, although creativity is rarely market-orientated; they are no longer funded just to direct an arts organisation, museum or gallery but must also fulfil a political agenda addressing regeneration, education, social inclusion and multiculturalism.

She concludes that the role of the leader is about 'managing contradiction'.

This where I part company with her. The idea of 'managing contradiction' rings too passively, too defensively, too cautiously. The arts leader must reconcile those apparent contradictions in

the role specification to the point that they are seen as connected activities rather than potential points of confrontation. As a first step, the arts leader must reconcile the varied activities within themselves. If they believe that there is a real conflict between arts and being businesslike, then their effectiveness will be undermined from the word go.

The very first year at the Barbican involved serious discussions that had to resolve the conflict between artistic demands for time in the concert hall – not surprising – and commercial demands for space to let – necessary to balance the budget. If the arts came first, they also made concessions to commercial requirements because the arts programming would decrease if the budget did not balance. This compromise may seem to be common sense, but it needed determined management time to get agreement and understanding that the interests and needs of both departments had to be met.

Any arts organisation must meet the multiple demands made of it because all are needed if it is to be a successful institution. The more hard-edged, material financial and commercial activities cannot be seen as unwelcome brakes on artistic activity. They should be accepted as conditions for fulfilling the arts function. So the practice of reconciling is so much more important than mere managing.

It is the principal business of achieving this reconciliation between apparently conflicting demands in a single institution that demands skills, tests and exposes character, and determines ultimate success or failure.

But character and aptitude are crucial too, though there are no rigid formats for either. Good leaders can be introverts or extroverts. But they need to manipulate three sets of paradoxical characteristics as they set about reconciling inevitable internal tensions. The manipulation oscillates around three sets of

binary poles: Patience/Impatience; Risk/Failure; Short Term/ Long Term.

Every leader needs to show patience in achieving long-term goals, but must also show a proper degree of impatience when short-term goals are not met. Timing may not be critical in the fulfilment of the big-picture goals. A month here or there in their achievement may matter far less than their successful completion in the broader time frame. But impatience when short-term objectives are not met, especially when their timing relates to specific needs or specific events, is entirely in place. Patience may be mistaken for complacency; impatience may be taken as mere irritability. But both need to be used – and sometimes deliberately calibrated for impact and effect – if the desired results are to be achieved. And everyone should remember that 'the boss is allowed to have feelings!'

Every leader needs a finely tuned awareness of the need to court risk and the ability to face up to – and own up to – failure. Risk avoidance or, worse still, risk aversion are no basis for development and progress. Caution cannot be written into the specifications for a leader. Prudence, yes; common sense, naturally; but caution as a discernible quality, never mind its first cousin, hesitation, should rule out anyone as a serious candidate for leadership. Any leader who refuses to face up to the fact that running an arts organisation is high-risk should not be considered for the job. For with high risk goes high ambition, an essential element in the leadership portfolio. No one was ever followed because they aimed low.

The third paradoxical aptitude relates to the others in a slightly different way. Time and circumstance frame every piece of planning or strategy. Most organisational change takes longer than assumed and often any progress at all is hard to see. At those times, the leader may have to accept that things are taking longer

than hoped. But they must have the ability to judge when every step taken in the right direction is just that – a small step perhaps but a step forward nevertheless. Many find it hard to identify progress when it comes in small quantities. The leader cannot be a Panglossian, where everything is for the best in the best of all possible worlds. But the leader should be an optimist.

The mosaic of qualities, skills, aptitudes and characteristics an arts leader needs also include some or all of the following:

A subtle balance between listening and articulating. A leader who directs without listening or listens but fears to lead is no leader. But he cannot be merely the sum total of the opinions of others.

An awareness that everybody who reports directly knows more about their specialism than the person to whom they report.

An interest in detail combined with the ability to blend the detail into a strategic picture.

The ability to know at the micro level but to think at the macro level.

Ultimately, leading an arts organisation is the most human of activities, calling on the most natural of human qualities: a sense of fun; a readiness to apologise and be vulnerable; an ability to say 'no'; the capacity to be ruthless but to be fair at the same time. Leadership is about the relationship with those being led. The rest is management speak.

Transforming an institution

Faced with the choice of taking over either a successful institution or one in the deepest trouble, the wise words have always been: 'Take on the one in deep shtuck. You can only make it better.' That wasn't why I became Managing Director of the Barbican Centre in November 1995, though it was certainly an organisation in deep trouble.

This was a very public event too, with the row over the summary departure of my immediate predecessor, Detta O'Cahain, spread in embarrassing detail over the pages of *The Times*.

The Barbican's owners and funders, the City of London Corporation, took dramatic action. They installed the Chamberlain – the Finance Director in conventional speak – to carry out a fundamental review of the Barbican. He considered closing it as an arts venue – but concluded that this would be too expensive and potentially devastating in terms of the Corporation's reputation. The Chamberlain reviewed the Barbican's core funding and significantly increased it. He remained puzzled by it as an institution, bemoaning the prevailing atmosphere into which he had been plunged – 'There's so much emotion over there!'

I knew none of this in detail when I took over. I was vain enough, or confident enough, to believe that whatever troubles

existed were remediable. I had seen and worked under good and bad editors in BBC radio and television, good and bad managing directors, men and women, with and without vision, the predictable and the wayward. Consciously or unconsciously, I had spent twenty-five years in broadcasting as a journalist passing a critical eye over a wide range of very variable management techniques long before the business of management had been professionalised, mystified, jargonised and fetishised.

Less consciously still, I was putting what I observed in the BBC together with what I had taken in as a child and adolescent from my father's practice as the managing director of a shoe manufacturing company, the British Bata Shoe Company, with its factories at East Tilbury on the Essex marshes.

A few simple but big things stood out from how he did his job, though I did not appreciate at the time that I was observing senior management at work. In a factory of some 3,000 employees, mostly manual operatives, he knew a third of them by name and many more by face. He walked the factory floor every week, showing an uncanny ability to pick up the badly stitched pair of shoes that were just about to be packed and despatched for sale.

Quality control was monitored at weekly lunch meetings when under-performing managers had to explain themselves, surely a recipe for indigestion and ultimately ulcers. Dedication to results was such that the annual family Christmas Eve dinner – beloved of Czechs – was always interrupted by a phone call carrying the financial and sales results for the Bata shops during the pre-Christmas fortnight. (The combination of sales performance and Santa Claus – not to mention the birth of Christ – struck me as an oddly pagan mix.)

This was the unexamined detritus of how to manage that lay as a deep mulch in my mind, to be dug up and used in ways I would never have guessed.

When, as a journalist and broadcaster with no management experience at any level, I made my pitch to be considered Managing Director of the BBC External Services (later renamed as BBC World Service), my only argument against the riposte that I had no management experience whatsoever was that I had seen BBC management at work and, more importantly, that my knowledge of the External Services' values and ethos – not to mention journalism and the political environment within which it worked – was very strong. I had, after all, worked there for most of my BBC life.

In management speak – which I neither knew nor could use – I was well qualified to handle the 'affective' part of the organisation; I knew how it and the people who worked there felt and what they believed. The BBC Governors had to trust – and I had to believe – that I could learn about the 'effective' part of the organisation – how it was run – as I went along; that I could learn on the job.

In fact, this part of my hunch – and the BBC Governors' act of trust in appointing me as Managing Director in September 1986 – was proved massively correct; running the BBC World Service was very largely about understanding its feelings, its value system, its ethos, all of which delivered the high level of dedication, professionalism, idealism and ultimately effectiveness in the basic task of broadcasting.

There were many lessons to be learned about acquiring the skills that delivered the levels of 'effectiveness' that the Whitehall management revolution demanded. In the late 1980s, professionalism in the job and effectiveness in doing it were too often seen as antithetical and contradictory. The high-level management task was to show staff that what appeared to be the fresh onerous demands of management effectiveness actually enabled the organisation to realise its values, to strengthen its ethos rather than to weaken it.

This proved to be a very full agenda of six years of transformation. The BBC World Service – the world's most influential radio station, broadcasting in thirty-seven foreign languages and English – was a unique organisation, unrivalled by its competitors such as Voice of America, the German Deutsche Welle, still less by the propaganda stations such as Radio Moscow. But it had been so battered by government cuts and inquiries that it needed help to remember just how good it was. Internal self-belief had to be strengthened by external acknowledgement and recognition. The transformation required was a transformation of self-confidence. I defined the job at the time as 'telling the organisation a story about itself that it recognised; and telling that same story to the world and winning recognition for it'.

This was easier said than done. Not that there was any real resistance to a new approach to internal communication; to a more robust response to outside comment or criticism; to a more open, inclusive management style at all levels; to the clear, public articulation of the instinctive values of the World Service; to a greater degree of recollection of the World Service's past history as well as a renewed amount of ambition for its future.

The main reluctance to act came from old habits and inertia. No one had asked the organisation to act in this way nor had anyone suggested that the organisation might benefit throughout if it did. Good broadcasting was good broadcasting; it took place in the studio not in the office. It could not be improved by being passed through an additional filter of so-called good management. Institutional sluggishness can be as hard to overcome as actual open resistance. Each of the activities set out above needed a policy, a practical approach to putting them into practice. Each required determination and energy to start them, continue them and refine them. Transformation came relatively slowly but come it did.

By 1992, when I left the BBC World Service, it had developed a high degree of self-confidence and institutional assurance, was open to challenges and was capable of learning, adapting and changing. It had become a thinking, self-scrutinising organisation.

These were the management skills and experience that I brought with me when I became Managing Director of the Barbican Centre. Even before I arrived, in November 1995, I knew that transformation on all fronts was the challenge of the time. I could not have anticipated the size of the problem.

The organisation that I found was frightened, resentful, suspicious and sullen. They were told little about what was happening and felt under-consulted, under-informed, undervalued and constantly under threat. Staff worked for an organisation whose artistic offering was variable at best. When it was excellent, credit accrued to somebody else: the resident companies – the Royal Shakespeare Company and the London Symphony Orchestra. They operated in a building that was controversial and unloved, and which management had recently tricked up in a grotesque refurbishment which involved no staff consultation and invited – and duly received – ridicule from the public.

The main conduit of information about what was going on was the King's Head pub at the corner of Silk Street, where tales of misery and woe were exchanged. A gentleman from The Stage, the theatrical trade paper, stationed himself there regularly and, in return for providing a sympathetic ear and the occasional beverage, got good copy for his pains. Everyone knew what was going on at the Barbican – staff read it first in the press.

Early on, we held an all-staff meeting, a previously unknown event. Afterwards, the grudging response from staff was that while it was good to have had one, they doubted there would ever

be another. It was not difficult to prove the wary and suspicious wrong in this respect. Colleagues could only be won round if they were respected, trusted with information, and deeply involved in the tasks that needed to be done if success was to be achieved.

Over the years, we created the elements that we have today as regular features of internal communication. Each year includes an all-staff Annual General Meeting at which the Business Plan and the Annual Report are the centrepieces – staff need to know the strategic position within which they work. At the quarterly staff meetings, all the current initiatives, innovations and developments are presented by those principally responsible for them. Every month, a set of items about important changes or initiatives – called 'core briefs' – are discussed within every division by directors on a rotating basis. A monthly staff newsletter is available on the internal net and includes personal items and photographs, as well as hard news. In the last decade, there have been no external leaks to the media and the King's Head has reverted to being just a watering hole. Information, freely offered as a right belonging to colleagues, is at the heart of any institution, certainly one that is on a steady trajectory of change.

Changing an institution – particularly a deeply troubled one – takes time and effort. In November 1995, when I became Managing Director, the senior Direction team was not a team, but a collection of warring individuals. Worse still, they were of very varied levels of ability. Change could not take place on such fallible foundations. Getting change at the top involved departures. They took place early and quickly; they were some of the best decisions I made. The next-best set of decisions involved recruiting their successors; the great majority of the directors recruited early on remain at the Barbican, providing a solid, highly competent base for managing on a wider front.

Persuading the next level in the organisation – the heads of department, the HoDs – to become actively involved in running the organisation was even more difficult. Too many of them were scarred or tainted with an over-bureaucratised past. Too many of them saw their job as being to meet the job description and no more. Too many of them seemed unaware of their colleagues' needs, or unaware that collaboration was a key part of their job. It was chimney-stack working at its worst. Faced with the offer of a freer, more open, more creative, more involved form of collective partnership in working, faced with the challenge of taking responsibility when it was offered, some simply baulked; for these, it was a threat rather than a door to freedom. However the opportunity was offered, it was turned down.

By coincidence, and a measure of design, those that saw things in the old, narrow way drifted away. There was no 'night of the long knives'. But we would not retreat from our belief that a changing institution had to share and accept responsibility more widely, more deeply and more enthusiastically. We could now recruit a new series of HoDs who sought responsibility, offered ideas, embraced partnership and were not bound by the sterilities of bureaucratic rules and regulations. It all took time; changing an institution is not for the impatient. But it needs consistency and firmness of purpose.

It was only after we had been at the Barbican for some four years that my colleague, the Artistic Director Graham Sheffield, observed, 'Is it just me or do things feel as if they are getting a bit easier?' He was right; but it had taken four years to repair the pre-existing damage. The really constructive work could begin.

Throughout this time, Graham and his arts HoDs had been reconstructing the arts programme. Arts renewal and organ-isational reconstruction were marching in step. Each element of the arts programme needed revitalising and renovating. Faced

with the departure of the Royal Shakespeare Company as the year-round provider of theatre, we had to transform ourselves from mere managers of the theatre to programmers of what was presented in the theatre. We were the 'owners' of the theatre programme in a way we never had been previously. Through our new theatrical brand, Barbican International Theatre Event – bite – we became the artistic entrepreneur for London's international theatre offering.

In music, the artistic challenge was to take a similar ownership of the concerts presented in the Hall. Here, second-rate hall hires from outside promoters were eliminated and a high level of promotions by the Barbican itself was developed which matched the brilliant existing offering of our resident orchestra, the London Symphony.

While parallel changes were being driven in the other art forms, they all reflected a fundamental wish to evolve from the basic 'classical' repertoire to an approach that extended those foundations through a commitment to openness and internationalism, with important splashes of adventure and innovation.

If these changes in the very substance of the art forms were not enough, one more transformation was needed. We were determined to mend the neurotic schism in too many arts organisations between the primacy of the arts as arts and the disciplines of good budgetary control. We absolutely rejected the notion that using resources efficiently was antithetical to arts programming; that budgetary control was beyond the ken of a good arts programmer; and insisted that we ourselves had the greatest interest in financial control and administrative efficiency because it meant that there was more to spend on the arts.

The arts HoDs we recruited were, in general, not only superb at their jobs, but also ruthless in their budgetary discipline.

They represented a new generation in the business. In being as they were, they set a good example for the rest of the building. I always stated openly that while we were not a 'business' – that was obvious – we were and wanted to be 'business-like'. In part, my attitude was influenced by the presence of the Barbican's own commercial division, which had to squeeze every penny it could from the exploitation of our assets – from conference suites, to catering, AGMs, and exhibitions.

In good measure too, we needed to demonstrate the strength of our financial responsibility so that our principal stakeholders – the City of London Corporation – could be convinced that the considerable sums they invested in the Barbican – some £19 million in 2005 – were being well used.

Beyond that, the task of reconstructing an organisation that the City had once considered abandoning was helped immeasurably by the light managerial rein the City of London Corporation exercised. I and my management team were never burdened with an oppressive, intrusive and often irrelevant regime of objectives and performance indicators. Wisely, the City of London took the view that they had hired the best possible team to give them an arts centre which was recognised as being excellent – and therefore consistent with the City's own ideals – and in the process brought reputational gain to the City. We had to be artistically excellent as a contribution to the City of London's own political justification for continuing to exist. The deal was that we would use limited resources from the City efficiently and professionally but that we would not be over-regulated in the process. It was a smart bargain and the light rein under which we worked meant that the public gain to the City from its Barbican investment was as good as it could get.

Partly as a result of the management regime under which we worked, but mainly as a result of our own inclinations, we

never oppressed our colleagues or ourselves with management gobbledegook or institutional psychobabble. We knew what it sounded like; we knew when something lay below the blather. We worked on a solid basis of practical aims, realistic objectives geared to making the building better, the way we worked more effective and the art we presented better and richer. In short, we knew exactly where we were going but expressed it in plain English and through understandable objectives. Apart from anything else, this approach saved a huge amount of time.

More importantly, being robust about the false tyranny of objectives did not prevent us from meeting what were generally seen as key social indicators. The Barbican's diversity statistics are better than any of our competitors by several percentage points. Our audiences have become younger, more open-minded, more challengeable. Audiences have changed as programming has changed, but not because indicators and objectives to achieve this end were set. Best of all, while audiences value the range and quality of the arts programme, we are not seen – or felt – to be an elitist institution. This makes the acquisition of high net worth sponsors who seek exclusiveness somewhat difficult, but it gives the Barbican something far more precious; a personality of total artistic integrity that its audiences recognise as something they value.

Because the organisation had become responsive, creative, opportunist, flexible and smart, we overcame difficulties that outsiders predicted we could not. The Barbican is a totally different arts institution ten years on because it has become an organisation capable of facing and delivering change. We absorbed the RSC's departure and created a wholly new theatre programme; we reshaped the music programme; we absorbed the art galleries and integrated them into the Centre's arts planning; we rebalanced the cinema programming between the

commercial ingredient and its art-house aspect; we evolved fresh ways of integrating arts planning across all the art forms.

And we did so while closing and renovating – on a carefully phased basis – every part of the Barbican's physical environment over a period of seven years and at a total cost of some £35 million. It could not have been done without the closest cooperation between all managers in every discipline. A decade of renewal in the organisation meant that the circumstances in which the arts could be delivered had been transformed.

Today, we are discovering that the fruits of a decade's work are still ripening. There is a still greater readiness and ability to accept responsibility at all levels. We are discovering reservoirs of talent in comparatively junior ranks. Devolution of responsibility and initiative is going still further. The Barbican has become a smart, quick, un-pompous, open-minded, fresh, flexible organisation, because that is what the people who make it are. It is their achievement; they represent huge potential. The organisation has made it possible by being open with those who work in and for it.

4

Living without objectives

In a world ruled by prescriptions, it is a shocking question to face. Does living without objectives make life pointless? Can any manager or any organisation know where they are heading without objectives to steer by? On the other hand, if an organisation claims to have a clear sense of direction, should that sense of purpose not be easily expressible through a defined set of objectives?

The debate about the use of objectives as a management tool – especially in the arts – becomes more complicated. If an institution is ready – in a very open and public way – to live by stated objectives, is it prepared to be judged and even to die by them? And what does failure mean? Does failure to meet an objective represent real failure, or could it suggest that the objective itself was wrong in the first place, misguided, irrelevant, or plain misleading? The questions facing those who insist on the value of objectives continue. Does failure to meet them constitute a useful guide to correcting a future course? Is meeting all stated objectives – or success, in this language – a true indicator of effectiveness or could it actually be a screen for failure to be truly imaginative, flexible and adventurous? What is the opportunity cost of ignoring fresh objectives beyond those originally adopted?

Perhaps the only way to address these knotty issues is to be bold and to dare to be 'objective about objectives'. Being objective involves a readiness to think the unfashionable and suggest that the world – especially the arts world – would be better off without them. Of course, as you might expect, anybody who suggests that it is possible to live without objectives is rather proud of having done so – vain even. Whether the vanity is well founded or not remains to be seen.

But first, an important qualification is needed. The objectives whose spider's web embrace I avoid are micro in their approach, often numerically expressed, supposedly quantifiable, excessive in number, externally imposed, only partially relevant to the organisation on whom they are inflicted, and intended to be judged in a binary manner: if met, good! If not met, bad! They are almost always prescriptive, and, at their worst, carry the threat of punitive consequences as well.

Most serious arts organisations know and can state where they are going, what they represent, what they want to achieve and what they must do to realise their intentions. In modern bureaucratic cant, however, these are not objectives in the strict sense. These are, at best, mere goals. It is the contradiction between the two, the tension between them – between goals and objectives, between guidelines and indicators – that needs exploring and exposing. But the broad goals I sketched in above are the only ones worth having, worth doing and worth spending time on. This is not just a subjective assertion – there is much evidence from real life and experience to back it.

The first witness in support of this argument is Peter Drucker, the so-called father of 'Management by Objectives' (MBO). With a label such as that, he might be expected to be wholly in favour of today's 'objectives culture'. When Drucker wrote *The Effective Executive*, introducing the very idea of using specific objectives

to provide better management, it was a real novelty. Yet, over the years, Drucker's rather subtle, sensitive approach to using objectives as a tool for managing, became misunderstood, then misapplied and finally complicated, elaborated and excessively detailed. Objectives – and their lethal offspring, 'targets' – became an industry in their definitions, and offered potent instruments of control to those with the power to set them. Detailed objectives were, of course, said to be justified in terms of ensuring accountability, transparency and efficiency. In practice, they have almost always delivered perverse or counterproductive results, distracted from the real issues facing an organisation and produced less efficiency than expected or needed.

If all this was done in Peter Drucker's name, what did he really believe? He did not believe that organisations should be tied down with a myriad of Lilliputian guy ropes masquerading as instruments of effectiveness. Still less did he believe that organisations would run themselves better if they volunteered to do their own tying down! As Gulliver discovered, the guy ropes were there to restrict movement, to deny flexibility, to limit initiative not to enable it to happen.

In fact, Drucker's key approach to MBO was that it was a way to successful strategic planning and execution. If rightly implemented, objectives would emerge from the bottom up, from a team-oriented planning system. Drucker also carefully differentiated goals from objectives. Goals should be relatively few and long-term; objectives should be short-term and relatively – note, relatively – more numerous than goals.

But not all objectives are equal! Drucker believed that the most important twenty per cent of objectives delivered eighty per cent of the results; even objectives themselves needed to be prioritised. He warned that too many organisations set far too many objectives, too many of which were trivial and unimportant.

And everyone in today's arts world has suffered from the activities of the zealots of the 'objectives industry'.

And this fate is not particular to the arts world; it affects the entire public sector. A particularly ghastly fate has been overtaking Britain's Home Office, a body overrun with objectives and targets, and famously condemned by the incoming Home Secretary, John Reid, as 'not fit for purpose'. He might have paused to ask if the objectives culture had undermined the Home Office's very ability to work effectively. After all, the deputy chairman of the union representing the Immigration Service staff – a Home Office division – apportioned some of the blame for recent fiascos like this:

> There are multiple priorities, all of which are top priority and staff don't know what they should be doing. The more you fail to achieve a target, the more the targets are pushed. They concentrate on the target of the day and thereby fail to achieve all the other targets.

In another major Whitehall department, Dame Gill Morgan, chief executive of the National Health Service (NHS) Confederation gave this account of the operational experiences of NHS managers:

> Managers are judged by a narrower and narrower set of indicators. If they fail to reach them, they can be dismissed. People come and shout at you. Or you can be overwhelmed by help!

These are classic, current, public but not isolated cases of the distortions against which Drucker warned. In fact, the distance between what he wrote and how his theories are implemented

gets greater and greater. Targets – he insisted – must be agreed, not imposed. By implication, targets that are imposed lack consent and are unlikely to be met. Very few of the politicians or civil servants in Whitehall trying to get others to manage by objectives appear to understand this at all. All too often, imposed objectives emerge as diktats, which force the recipient – under pain of loss of funding – to do what the department says – 'or else!' Often arts organisations are warned by civil servants that unless they meet specified targets – for diversity, say, or attendance numbers – then they should expect to have their grant reduced. By this stage the 'objective' has transmogrified into a clause in a contract.

And Drucker had a very clear but simple message for how business and organisational leaders should use objectives: 'They put away their goals for six months and then come back and check. They find out whether they picked the truly important things to do.'

Think about it for a moment. Drucker assumes that leaders do not do their jobs by worrying whether they are realising their goals every day or every week. The leader has to address the job in all its everyday complexity, and should only check back on the desired goals every six months. At that point, some may be rejected as irrelevant because circumstances have changed or events have overtaken them. Used this way – as Drucker intended – the goals exist as reminders, as milestones, as way marks but not as daily shackles for determining management operations.

If any doubts remained about the damage that could be inflicted by an obsession with objectives – albeit done in the name of Peter Drucker – they would surely have been dispelled when President Bush's special adviser, Karl Rove, told a news magazine: 'I had read Peter Drucker but I had never seen Drucker until I saw Bush in action.'

And Drucker was not alone in thinking flexibly and pragmatically rather than dogmatically about the use of objectives. He had allies in Whitehall. What is so depressing about New Labour's obsessive misuse of objectives and targets is that the leaders of the Whitehall revolution in management under Margaret Thatcher understood Drucker's distinctions about how objectives should be used. Somewhere along the line, the lessons were lost or ignored.

That Whitehall revolution in management, whose application is currently and almost daily producing such unintended and undesirable consequences, dates back to Sir Derek Rayner, the Prime Minister's Efficiency Adviser from 1979 to 1983, and subsequently to Sir Robin Ibbs, head of the Downing Street Think Tank from 1983 to 1988.

In 1982, Derek Rayner's Financial Management Initiative was very aware that private-sector disciplines could not be applied wholesale to the public sector. 'Many government objectives are generalised and the test of their success is often acceptability rather than a quantified measure of output.' Because of this difference between the private and public sector, Rayner accepted that 'only partial indicators of performance can be devised'. Today, any government department that doesn't try to nail down its performance with fully realised indicators of performance would be excoriated and penalised.

And Rayner understood – as did Drucker – that organisations and institutions are run by human beings. They are not workplaces for automata. Drucker wanted ideas to bubble up from below to shape willingly accepted objectives. Rayner understood that management was about delivering a change of culture: 'It is brought about by acquiring new habits and being able to observe that those new habits are effective and enjoyable to perform.' When was the last time that any paladin

of the bureaucratic objectives culture enquired whether imposed objectives contributed to the enjoyability of work? When last did they consider that enjoyment might be a contribution to effectiveness?

Rayner's work, and many of his attitudes, was continued under the head of the Number Ten Think Tank, Sir Robin Ibbs. In his key paper, *Next Steps*, the Ibbs team looked at the impact that management change had had on civil servants working in Whitehall. It is a question which should be addressed directly at the heart of today's prescriptive objective-setting culture. Does it work in the office?

The civil servants interviewed by the Ibbs team said that the whole process of management change had – of course – been bureaucratised. It had not influenced how policies were developed; it had become a parallel, disconnected exercise that involved a lot of form filling. It led to being 'conscious about costs' but not being 'conscious about results'. It concentrated on 'inputs and their costs, not on outputs and value for money'. And, of course, the centre clung on to its powers, which – as Robin Ibbs observed – was 'totally at odds with the principles of good delegated management as set out in the Financial Management Initiative'. In sum, the benign, humanistic, subtle, incremental improvements in human and institutional behaviour aimed for by Drucker, Rayner and Ibbs had been turned into rigid structures of bureaucratic and ultimately political control. Which is exactly what has happened with today's 'objectives culture'. It replicates and continues all the worst distortions against which Drucker warned.

On this evidence, the only answer to the question of whether it is possible to live without objectives is not that it is possible to do so; it is essential for the health of any self-respecting organisation that it should do so. This is certainly confirmed by a decade of personal management experience at the Barbican.

Throughout this time, I and my management team have never been set detailed objectives and targets by our stakeholders, the City of London Corporation. Given that we receive some £19 million annual revenue funding and a further £4 million for capital renewal from the City, this might appear shocking, lax, inadvertent or, possibly, enlightened.

When challenged, I say that the Barbican works to four objectives in relation to our principal stakeholder. First, we do not incur a budgetary deficit. Second, we deliver the highest-quality arts to audiences. Third, as a result, we bring credit to the City of London for its support of the arts – the third-largest funder of the arts after the government and the BBC. And fourthly – I add flippantly – were I to insult the Lord Mayor, I would be sacked.

Such a light-touch regulation regime is both enlightened and effective. The goals are few; they are clear; they are simple; they are relevant. And it is obvious if they have been met or not. As such they square with another Derek Rayner principle: that any organisation should have a handful – note, a handful – of key performance indicators to go by. Effectiveness is not driven by the quantity of indicators employed.

The rest was up to the Barbican management team. Over ten years, the proportion of the revenue budget covered from own resources – i.e. box office and commercial – rose from thirty-six per cent to forty-five per cent. There was no external target for doing so.

Over ten years, the Barbican's audience has become younger, more ethnically diverse and more economically spread. In fact, our ethnic indicators are now the highest for audience diversity of any major London arts organisation. There have never been indicators for achieving ethnic diversity as such.

Over ten years, the Barbican's programming has become more international, more contemporary, more interdisciplinary,

and more interconnected. This came about not by identifying these goals as objectives, still less by setting numerical targets for them. Over ten years, we developed a Barbican brand which we express as 'International, Leading, Diverse and Excellent'. We are regularly judged to be a 'Cool Brand' by practitioners in marketing. But we did not set out to achieve this cult-ish status; it was a direct consequence of the multitude of decisions taken about what we wanted to be and the programming to be presented as a reflection of this self-awareness.

In other words we have behaved in a way totally consistent with classic Drucker prescriptions. We set goals that could only be judged over a long cycle – six months or more. We added to those goals as each was achieved. We did not burden ourselves with micro-objectives and indicators, and nor did our principal paymasters in the City of London. We took periodic failures to achieve our goals, at the time or in the manner that we wanted, in our stride. Failure to meet an objective did not represent failure to move in the direction of a goal. We could get on with the job of radically transforming an arts programme in four major art forms without distraction from incidental sub-indicators whose existence was not a material contributor to success.

To anyone who relies on scrutiny of indicators to run their business, the only serious response can be 'Don't you have a real job to do?'

Worryingly, high-level criticism of the distortions of the numerical objective culture has failed to dim its pervasive presence. Writing in 2001 in *The Observer* about a report which lamented the absence of sufficient statistics about the arts, Andrew Marr noted:

In the arts as everywhere, number crunching should be only part, and not even necessarily the dominant part,

of the conversation. We have to be alert to the damage that numbers can do to our wider thinking. I mean the narrowing of perception and discrimination caused by manic numerocracy. The arts are a prime field for the difficult, sometimes embarrassing display of wider judgement. But it is unlikely that reports complaining about the poor value for money measurement in the arts will give us more culture.

Six years later, little has changed, and Marr's warning remains relevant.

Two years ago, the Director of the National Theatre, Nicholas Hytner, came at the subject from a slightly different angle. Why, he demanded, were arts institutions being pestered with targets which implied that pure audience numbers were not the only benchmark; it had to be the right kind of audience:

Performing artists, once under attack for apparently not paying their way, are now in the dock for attracting the wrong kind of people. It doesn't seem to matter whether what we do is any good or not! Until recently, the National Theatre's audience was getting worse reviews than some of its shows. Then somebody noticed some kids in the house with studs through their noses and the reviews looked up. We want a diverse audience because we want a diverse repertoire.

And, he might have added, a diverse repertoire which stems from putting the arts first attracts a diverse audience. No indicators can achieve that result. Arts will always come before indicators.

Why do the bureaucrats, the officials, the scrutinisers, the dispensers, the over-zealous stakeholders, continue to do it? The

evidence is overwhelming that excessive numerical objectives cramp style, reduce effectiveness, diminish responsibility, limit imagination and ultimately deliver less value for quality and certainly less value for money. The list of ministers who have lost jobs and careers as a result of slavish devotion to their own targets grows by the month. Not only is the target culture counterproductive, it is also damaging to career prospects.

In the last two years, the evidence that objective obsession undermines good and effective administration has proliferated like bluebottles. The extraordinary thing is that, faced with the evidence that compulsive objective setting is counterproductive, the civil service and politicians have gone into denial. So why, in the face of mounting evidence from every sector of government, do they continue to insist on it?

The answer is that it is about power, control and fear of letting go. Of the three, control is the most important for bureaucrats. What could be a better way of controlling institutions from which you are supposed to stand at arm's length than by setting out scores, literally scores, of targets and indicators? What better way could there be of subverting managerial authority than imposing targets and indicators that are marginally relevant to the organisation's core activity? And what can be more effective as a method of enforcement than the open threat that Treasury funding will be reduced unless the indicators are adopted and met?

It is, in short, a sorry tale. The only happy endings occur when you do decide to strike out for yourself and live without objectives. Only then does your work truly have a point.

5

Living with politicians

It is a dilemma for everyone involved in the arts. How involved should the government be in the active promotion of creative activity? How much political intervention is inevitable to accompany public funding support? Can intervention be kept distinct from interference? Commitment, of course, would be desirable; involvement, definitely; real belief and understanding, preferably. Somewhere between these rather contrasting positions, a healthy base for the government's role should be found. In practice, as New Labour stumbles through its troubled third term, the signs are of the pendulum swinging towards interference rather than the more sophisticated enlightened commitment. If so, the outlook for the arts and government could be gloomy.

When Tessa Jowell, the reappointed Secretary of State for Culture, Media and Sport, was leading the celebrations for Tate Modern's Fifth Birthday in 2005, she declared she wanted to be regarded as a 'co-conspirator' in assisting the gallery to achieve its ambitious goals of developing itself still further.

That 'co-conspirator' had a ring to it – an odd phrase, surely. It was, after all, ex President Richard Nixon and his crew who were named as 'unindicted co-conspirators' in various plots

to undermine the United States constitution. Tessa Jowell's reference may have been inadvertent, but it sparked the thought that a truly 'committed' secretary of state would aim to go further, to be and be seen as an 'indicted co-conspirator' with the arts as a whole. Such a secretary of state would have the ambition of winning the epitaph that they supported the arts so passionately, that they were charged – like Othello – with loving 'not wisely, but too well'. That would assert the tone for more than a single parliamentary term.

Of course, the government has its agenda for the arts. Sometimes, it appears as explicit policy. At other times, it can only be fully imagined as a dream-like fantasy. What would happen – let us allow a moment of fantasy – if the principles enshrined in increasing 'customer choice' in the National Health Service were to be progressively rolled out for the arts? What is proving so successful for the nation's health can hardly be too good for its arts.

When systematically and progressively rolled out, choice could lead to a long overdue revolution in the ways that all arts organisations serve their customers. It should become axiomatic that waiting times for major exhibitions should be reduced. A 'triage' system would operate – as in casualty departments – to determine the exact state of need of the customers in the queue. Medical triage involves determining which of three categories a patient falls into: about to die; likely to hang on for a couple of hours; and suitable for several hours on a trolley in a hospital corridor.

Adapting this system to the needs of museums and galleries, specially trained 'arts-need officers' would decide which of three categories applied to those in the exhibition queue. Were they so desperate to see the exhibition that psychic or physical distress would result from unreasonable delay? They would be admitted

at once. Were they likely to experience only normal irritation or moderate levels of inflammation if they waited? These would be allotted the next-best time slot available. Were they only there because everyone had told them they should be? As in hospital casualty, that group could be delayed for some hours.

Such modern management techniques would help galleries to balance the excessive demand that exists for the clearly inadequate supply of first-class exhibitions, even in a city rich with them such as London. The suitability of the health service model goes further. Queue-jumping takes place in both health and the arts; it is achieved through private insurance in the health sector, through expensive membership schemes in the art world. The effect is the same; those who pay more go to the head of the queue. And, as with the NHS, the government might prescribe the policy of buying in more privately organised exhibitions to satisfy excess public demand. But, in this day and age, where customer choice comes first, neither in health nor in the arts should there be a justification for shortage of supply and waiting lists that represent unsatisfied demand.

Modern management techniques can go further. The visual arts world jibs at having to apply numerical indicators to measure its work. Quality indicators could be devised and would be acceptable. They could go like this. What is the point of owning and displaying the most beautiful objects if visitors only glance at them for a matter of seconds before passing on? Let government 'Quality Appreciation Indicators' – or QAIs – set targets for the time visitors should spend looking and appreciating what they see. These targets should rise steadily year on year from the present forty-five seconds spent looking at a particular painting to perhaps a minute and forty-five seconds. Galleries would be graded in league tables of 'Quality Time Spent in Viewing' – the QTSV indicator – and would be rewarded and funded accordingly.

Of course, this is fantasy, a *reductio ad absurdum* of government policies but one not too far removed from the kind of approach that actually lies behind today's targets and interference culture. Given the kind of indicators that are routinely set in many parts of the public sector, it would be rash to rule out the introduction of some genuinely loopy one for the arts.

Yet a genuine issue facing everyone in the arts is how to meet customer demand. What do visitors want? How is it identified? Once identified, if that is possible, how should it be met? These are such teasing questions that research – even if slightly tongue in cheek – should help find an answer to them, or at least suggest an approach.

Some six years ago, two artists set out to discover scientifically what was 'Canada's Favourite Picture'. Using the best available commercial market research, the Russian-born artists, Korman and Melamid, established that Canadians' favourite images were of hills planted with trees; that they preferred blue to any other colour; and they greatly preferred lakes to seascapes. Setting out the research evidence in detail, Korman and Melamid then painted a realistic landscape in shades of blue where a lake stood framed by tree-lined hills, and called it – with unchallengeable confidence based on measured consumer research – Canada's Favourite Picture.

Hanging beside this picture, and relying on the same research findings, was an abstract work also executed by Korman and Melamid, predominantly in reds and oranges. The same research had told them that this would be 'Canada's Least Favourite Picture'. It was a satirical comment on the dangers of using the narrow prism of market research to offer guidance about what art should be.

The only danger might be that someone in government could take it all seriously.

If the arts can expect little help from market research in determining what audiences really like, perhaps the electronic media could have a role in getting them closer to audiences in ways already pioneered on TV channels. A synergistic combination of lifestyle programming with a new approach to arts programming could lead to golden years for the arts on television, one that blended excellence with approachability and access. It is time to dream again.

Truly imaginative television commissioning editors could conceive a follow-up series to the award-winning *How Clean is Your House?* Once again, the intrepid team of Aggie McKenzie and Kim Woodburn would arrive on the doorstep, on this occasion to tackle an eminent artist in 'How Clean is Your Studio?' Including microbiological analyses of the accumulated droppings on the studio floor, it would almost certainly establish that the artist was lucky to be alive and should face closure of his studio on health and safety grounds. The exploitation opportunities for sales of marigold gloves, water lily tea towels and lavender water would be endless. How such a programme would demystify the artist's daily chores.

Intensive work would repay time spent in its development in a new revelation arts programme based on the huge success of *Footballers' Wives*. 'Artists' Wives' would uniquely reveal the realities of the arts world through insights into what artists' spouses get up to do when their partners are in the studio or at dinners.

The scope for such innovative arts programming is limitless, once started. History and culture could be made accessible in a wide-ranging new series called 'Celebrity History Makeover'. Possible examples could include *Changing Rooms'* Lawrence Llewellyn Bowen giving a contemporary take on what Versailles should look like; the *Ground Force* team restyling the Hanging

Gardens of Babylon; Max Clifford giving PR advice to Charles I on how spin might have kept his head on; and Rolf Harris being engaged to paint the Queen.

So New Labour's policy evolution towards the arts could indeed be marked by increasingly fantastical and onerous objectives, mediated by increasingly compromised television coverage. Perhaps a more reliable guide to the future comes from looking back at its record in its first two terms.

From 1997, the first term in office for 'New Labour' was marked by excessive enthusiasm for 'Cool Britannia', 'Creative Britain', Downing Street receptions for rock stars, little interest in the arts as such and continuation of the restrictive spending plans of the Conservatives. Money was kept short, tempers became short, words were exchanged, the 'luvvies were revolting' and a good deal of name calling followed, involving elitists, populists and philistines respectively. Yet the truth is that it was only the 'revolt of the luvvies', including the deliberately provocative 'Shadow Arts Council', led by Sir Peter Hall, that got the arts funding issue taken seriously in Downing Street. It led to a commitment by Tony Blair – at the celebrated 'Downing Street Arts Summit' – to 'write the arts into Labour's core script', a heady promise that faded as almost every other policy was given a pledge about its place in Labour's core beliefs.

In New Labour's second four-year term, the angry rhetoric died down as arts funding became more generous. With the increased funding, objectives were showered on all and sundry. Mainly, they were social or economic objectives – such as access or regeneration. Mainly, they omitted the only objective worth aiming at: the overriding responsibility to create great work in whatever art form. Wholly, they were looking for and were expressed in the latest management cant such as 'key deliverables', 'measurable outcomes', and much else in the same

vein. And, inevitably, arts programming was treated as 'product', as if it were subject to market-research criteria.

The second New Labour term ended filled with contradictions over its attitudes to the arts. On the one hand, the graph of increased government funding for the arts flattened out, starting a fresh round of blame and recrimination. On the other, the Secretary of State set out what many in the arts world assumed was a rather brave, personal manifesto stating that the arts mattered for their own sakes. Soon after, the official Department of Culture, Media and Sport (DCMS) line about the pamphlet was being discreetly spun: 'Instrumentalism is dead.' The arts were not to be judged by the scale of their contribution to economic regeneration, social order, or an increased GDP.

Sceptics about the strength of the DCMS by itself to subvert a key ingredient of government policy kept their doubts. They were proved right. There was never any indication from the Treasury that the 'end of instrumentalism' was a cry likely to move them any more than the cry 'La Révolution est Finie' checked the Terror. Instrumentalism, outcomes and deliverables is the only language of management the Treasury knows and believes in. Tessa Jowell's personal pamphlet remains just that in Whitehall – a personal statement, brave in its way, attractive enough, but never destined to become government policy.

While New Labour's third term carries within it the themes of the first eight years in office, it still retains an unformed look, as if a new synthesis is being sought. But its ingredients remain elusive. So what should the third term yield? We've come a long way from the posturing of 'Cool Britannia' to the dashed hopes of an 'end of instrumentalism'. Might attitudes be reconciled still further? Does the opportunity exist for the establishment of a new 'concordat' for the arts; one where the arts are valued for what they do, which is to enrich the mind and spirit of society;

one where the arts also deliver many social goods because that role has become an automatic part of our activity; a concordat where the arts are put first and the other benefits follow as a result of their excellence.

It ought not to be asking for too much. One of the conditions for a successful concordat would be a change of attitudes. Alistair Campbell once famously said of Tony Blair's public profile: 'We don't DO religion!' He might have added: 'We don't DO opera, classical music or art galleries either.' To this day, Tony Blair has shunned association with the arts. Some say that Britain has become enveloped in a culture of fear, driven in part by fears connected with acts if terrorism. Yet an equivalent and parallel fear exists, whose long-term consequences could be almost as damaging; an overt fear of culture, driven by lack of education and persistent attacks on the arts' alleged connections with elitism. Hasn't the time come for political leaders to stop being frightened of what focus groups may say on the subject?

The arts world needs to change its attitudes too. The arts should stop apologising for what they do. For a decade or more, the arts have delivered not only quality and excellence but access and regeneration as well. In other words they have achieved the essentials both in the arts and the government's socio-economic agenda. The arts should stop behaving as if they had not done so, as if they had failed to deliver on either count. No one should take the arts seriously if they don't believe in what they have done or are embarrassed to speak out about it. The arts world should reject further attempts to judge what we do by criticisms of the social make-up of our audience, the composition of our staff, or any other quota-based criterion.

While such considerations may be legitimate in terms of public policy, they contribute nothing towards the only thing that matters – the quality of the arts. We have to be far more

robust in rejecting skewed indicators, distorted objectives and fallible targets that contribute nothing to the central purpose of the arts. Whatever happened to the so-called 'arm's length policy' enshrined in the Arts Council of Great Britain, that once visionary body set up after the Second World War? Interference by the government is still interference, especially when dressed up as performance indicators.

And perhaps the government should apply to the arts the commitment so successfully deployed in the triumphant Olympic bid of 2005. The text of the London Olympic bid unashamedly pinned its colours to the mast of supporting the 'elite sports'. The bid succeeded because the elite nature of the sporting commitment was proudly acknowledged and praised. What about having a government commitment to the elite arts as well?

But the arts have a still wider role to play, one expressed by ideas far bolder than the restrictive practices of over-zealous bureaucracy masquerading as management theory. They have a role to play on and in the world stage for sure and the European one of which we are a part. Sadly, it is not yet a role that the government seems to understand or to value.

At a Europe-wide conference, hosted by the French government in 2005, addressed by President Chirac and called a 'Symposium on a Europe of Culture', the underlying assumption was that two millennia of European culture were a fundamental ingredient in Europe's identity, and a driving constituent of its future. Europe, it was argued, could not be understood and would not be valued without its arts. Such a clarion call for the role of culture in the whole vexed issue of identity, nationalism, and cultural assimilation came naturally to the French.

Sadly, the UK government showed no sign of wanting to be involved in this process of marrying arts and culture into the

processes of politics. This standoffishness can be explained only on the grounds that such windy stuff about the arts falls naturally from French lips but sits uncomfortably with the four-square pragmatism of the Anglo-Saxons. After all, culture is something the French get up to. If there ever were to be a British 'foreign policy for the arts', then shouldn't it start in and with Europe?

Surely the arts should have a view about such matters. Such international perspectives should form a legitimate part of the objectives, indicators and grand visions that truly justify investing in them. The arts could have a vital role to play at the interface of politics, identity and creativity. How closely should the United Kingdom identify with a Europe of twenty-five nations, of twenty-seven nations, one perhaps rising still further, whose slogan is 'unity through diversity'. The choice lies between belonging, on one side, to a continent which believes that the arts are exceptional and should be treated exceptionally; that they should not be blended, blanded and globally homogenised; that diversity of expression and creation is precious; that arts activity is not like any other globalised, commercially driven transaction.

The alternative is to hide behind a new American cultural hegemony, where the strength of the English language acts as a new kind of neo-imperialism in which we feel a vicarious and proprietary pride yet have no influence and no real interest. Are we to be passive and docile parties to the imposition of a 'Mac-Holly-Bucks' culture, because, like hamburger buns, it is sweet, bland, reassuring, profitable, easy to sell but ultimately terminally boring, and offers no sustenance physical or spiritual?

The Prime Minister gave as one of his reasons for backing President Bush in the invasion of Iraq that it was unthinkable for the USA to be left standing alone in such a historic action. Should not a similar question be asked in the arts, but be given the opposite answer? Perhaps the Americans need to be left

on their own in order to discover the hard way that the price of avoiding isolation is to think of others first.

Whichever party is in power in Whitehall, the arts should be more ambitious in their perspectives, more international, more ready to address the political aspects of the world in which they exist and operate; more ready to believe and assert that there is a real external dimension to what they do. The arts should aspire to a foreign policy but one driven by their knowledge, their perspectives and their experience rather than as a subset of the government's foreign policy. Such a range of objectives are worth defining and pursuing; these are the areas where the arts can make a huge contribution to society and politics. Pettifogging numerical micro-indicators are no way to try to grow the best imaginings of artists.

Europe believes in the arts as a deep part of the continent's identity and cohesion. Does the United Kingdom believe in the arts in a similar way, even as a contribution to our own unity in diversity? Do we truly believe in such an identity, one which is inclusive but does not involve the self-rejection of key elements of our historic identity? In asking these questions of itself, is Europe also asking the question of us? The arts have a role in defining the answers. That would be an objective worth setting, an objective worth living for.

6

The arts of giving

anyone involved in the arts is involved in giving – giving time, giving skill, perhaps in giving money itself. Quite often, one leads to another and many individuals end up giving in more ways than one. For those of us involved in managing the arts, a good deal of time is involved in asking for money. But, of course, we are involved in giving too – giving back to audiences, in the form of an experience not available elsewhere; giving to the community through outreach activities in education; giving back to the artistic community through providing opportunities for artistes to realise their creativity.

But it is the mutual involvement of – and interchange between – the act of giving and the act of soliciting that needs and deserves more examination by those who engage in one or other or both. Giving money to the arts and asking for money for the arts do not represent some binary system, implicitly or explicitly in a state of antagonism or mutual suspicion. They are mutually reinforcing, or should be, based on an understanding of combined self-interest. It should not be a game of cat and mouse, of hide and seek, of desperate arts manager wooing evasive and reluctant donors. It can be an activity where the shared love of an organisation brings together those who do with

those who support in a way that benefits everyone who attends the organisation in question.

Most of the examples I use, and most of the experience I draw on, come from the arts world. But I believe – or suspect – that the principles of soliciting and giving apply just as strongly to any kind of philanthropic giving in any charitable area.

My starting point is the belief that the British model of arts funding has many strengths. In broad terms, this mixed model assumes that a performing arts organisation which sells tickets at a box office should cover its annual revenue budget through an equal three-way split between box office and other earnings, public subsidy, and private and corporate support. Typically, the European system sees higher – sometimes dramatically higher – public subsidy as a source of revenue. This model involves a moderate dependence on box office income, minor private support, and some extraordinary examples of corporate backing, notably in Germany.

In Munich, for instance, when the Bavarian State Opera was planning a new production of *The Ring*, it needed to look no further than the head office of BMW who expected to fund such an item of state and international prestige. It is impossible to imagine a British car company acting in a comparable way.

In the USA, by contrast, direct state subsidy is minimal or non-existent, and arts organisations rely on the support of corporations, foundations and individuals of high net worth to assist the box office in covering expenditure annually. This can be spectacularly successful. In recent years, the Minnesotan Twin Cities of Minneapolis/St Paul have raised some US$200 million to renovate the Walker Art Gallery, expand the Art Institute and build an entirely new Guthrie Theatre. Such a combined private/corporate fundraising effort stretched the community to the limit but shows the US system at its best.

The advantages of the British system are that – at least in funding the annual budget – it is more differentiated; it acknowledges and spreads a wider responsibility for the funding and the existence of the arts; it places on the arts community a properly broad responsibility to seek support from many constituencies; it broadens the range of interest groups and stakeholders to whom they must answer. It also involves a general belief that the state, the public sector, has a fundamental role and responsibility in the public provision of the arts.

There are some notable exceptions of organisations which work well outside the one-third/one-third/one-third model in the UK. The first is the Wigmore Hall, internationally celebrated for its chamber music, instrumental and vocal concerts. By dint of sustained cultivation of mainly individual donors and supporters, by providing the highest quality of musical performance, and faced with static or declining public subsidy, the Wigmore Hall now covers almost ninety per cent of its revenue costs from its own efforts – i.e. box office and private support. This is an extraordinary achievement. Regrettably, the Wigmore Hall receives little public recognition for its achievement in combining artistic excellence with managerial professionalism.

At the other extreme of this funding model spectrum, we have the Barbican. The Barbican receives no government support whatsoever – that is to say, nothing from the Arts Council or the DCMS. The Barbican's principal funder is the City of London – or the Corporation of London as it used to call itself – which provides fifty-five per cent of our annual revenue income. The remaining forty-five per cent – a proportion that has risen dramatically in recent years – has come from the Barbican's own efforts at the box office, from earning commercial income, hosting conferences, providing banqueting and the whole panoply of add-on commercial activities.

What is missing in the Barbican model in a significant way is private support. This absence is explicable in historical and cultural terms. Many organisations and individuals assume that the Barbican is so completely and generously funded by the City of London that it needs no further support. Others regard the Barbican's deliberate non-elitism and the very diversity of its audiences as reasons for not supporting it personally. Some givers and some institutions crave exclusiveness in the arts. Whatever the reasons, the absence of such support leaves a funding gap at the Barbican crying out to be filled.

Perhaps this suggests that there are very few things in common between organisations and ways in which they solicit and raise private funding support. Or perhaps there are two almost universal experiences. First, every organisation I know finds it very difficult to raise private support. Second, almost all are very chary about admitting what their actual net support actually delivers in net financial terms – stripped of development costs.

So consider this very modern tableau involving the asker and the giver. Like it or not, they stand facing one another (let's not say, confronting one another). And there is a third element – the bystander, the observer, the arts press. Each has an acceptable purpose and can have an unacceptable face or faces. Take the unacceptable face of the arts asker – or receiver. In the celebrated, riveting and ultimately notorious BBC TV fly-on-the-wall documentary about the Royal Opera, called *The House*, the Royal Opera's Artistic Director, Nicholas Payne, was seen walking down a corridor on his way to a pre-performance reception for private supporters. Looking straight at the camera he said, 'Oh well, let's go and talk to the fucking ra-ras!' It must have set back Covent Garden's fundraising somewhat. It certainly invited the thought that if you despise the givers, then you should not take their money.

But there are givers who are less than attractive. In my judgement, they include those who only support events or organisations because they are seen to be exclusive and elitist. As a marketing tool, this is perfectly understandable, though there are companies such as Travelex which have won major public recognition through their subsidised £10 ticket scheme which directly helps those who have less money rather than subsidising those who have enough.

Or there are undoubtedly givers who believe that support entitles them to special involvement in artistic decisions. The most notorious such instances were both involved with the Met in New York. Mrs Sybil Harrington would fund any new opera production provided Franco Zeffirelli designed and produced it and Placido Domingo sang in it. 'Good choice', as they say in over-pushy restaurants. But governance issues apart – and they are important – nothing is more calculated to lead to creative atrophy than one set of artists and performers – be they never so good – doing the same works over and over again.

And there is an unacceptable face to the third group, the press and media. By and large, their attitude to the role of private financial support for the arts is at best neutral, often ignorant or indifferent, at worst hostile and prejudiced. Rationally, they understand that private support for the arts is a condition of its taking place. A single glance at the front pages of almost any opera programme shows that significant new productions are only delivered because of support from a syndicate of individuals.

Given that the business of charitable giving for the arts attracts so much attention and causes so much puzzlement, research deserves more attention than it gets. There is, of course, folklore. Often it comes up with surprising answers. Who is more likely to give? The person who has already given. Won't they develop donor fatigue? Not if they are asked nicely. Aren't

supporters reluctant to give? Only if they are never asked. Isn't it embarrassing to ask? Why deprive a potential supporter of the pleasure of saying 'yes'. Who is best qualified to ask? The person who has already given.

Folklore also asserts with total confidence that 'the poor give more to charity than the rich.' Research contradicts this view. Those on low incomes – less than £35,000 per annum – give more than two per cent of their income tax effectively. Those on middle incomes – £65,000 per annum – do give slightly less (1.6 per cent). Yet once incomes rise over the £100,000 level, charitable giving increases to three per cent. Most revealingly, those on low incomes, usually coming from several different sources – that is to say, the retired – give the highest proportion of their income to charity, a remarkable four per cent. Research does not show what the giving record of the really rich is – those with incomes over £250,000.

An important distinction needs to be made here, which accounts for some of the difference between the way the British and the Americans behave in their giving. The British give from income rather than from wealth. The Americans give from accumulated wealth and the tax breaks and the tax advisory system are geared to making giving from wealth both easier and acceptable.

Yet, despite all the differences in the way individuals behave when we give charitably, we do give. Do we give as well, as wisely, as effectively as we can? Do we get the pleasure that we should from giving? Are we really serious about it?

It's time to look at a shining example of good practice. I'll call it 'A Good Man in America', for that is what he was. His name was Ken Dayton, for years CEO and Chairman of the Dayton Hudson Corporation of Minneapolis. They owned the major department store in the Twin Cities and then started the

Target Group of supermarket malls. Dayton was chair of the Board of American Public Radio – which is where I first met him – a Trustee of the Getty Trust and a lifelong supporter of the Minnesota Orchestra.

In their first fifty years of active giving, Ken and Judy Dayton contributed US$100 million to charities. It was in every sense a joint operation between two people whose outlook on having wealth and giving it was absolutely united. Ken Dayton died, sadly, some two years ago. But, true to their joint dedication to philanthropy, Judy Dayton has continued doing what she was so good at – asking others for support for major arts projects. She could ask for support because she and Ken had given support in the first place. And since Ken's death, Judy Dayton has been a pillar of the massive fundraising drive that funded the rebuilt Walker Art Gallery in Minneapolis.

Now what is important – and what Ken and Judy Dayton believed to be important – was not so much the quantum given as the thought that lay behind the giving. For Ken gave a lot of thought as to how to give best: best for the recipients, best for your family, and – absolutely crucially – best for you. Fortunately, he put these thoughts on paper and they seem to me models of concise, wise and sometimes bracing advice about how to be a great giver.

In the late 1980s, after a mere joint forty years of giving, Ken Dayton set out Ten Principles for 'The Art of Giving'. These are the ones that I believe have the greatest resonance and are the most original contributions to a philosophy of giving. First: 'A good giver aims to be a good giver.' This involves being serious and thoughtful about it. Next Dayton principle: 'A good giver enjoys giving. He or she is happy to part with the money because you know it is going to help. For some, giving is a painful and necessary act. For the good giver, it is a joy.'

It gets more radical. Ken Dayton insisted that the very least a giver could do – should do – was to agree to listen to what he called the 'solicitor', the person 'doing the ask'. He should respond as quickly as possible, he insisted. 'How about tomorrow at 10.30?' Of those who don't entertain soliciting, Ken observed: 'I know an extremely wealthy individual who won't ever see a solicitor. He is a miserable person!' I think you're getting the feel of the man.

The good giver shouldn't be arrogant. 'After all, all we're being asked for is money. The solicitor is doing far more for the good of the community'. Don't delay for months before answering. If the answer is no, then say no quickly. Give as much, not as little as you can. Give immediately or as soon as possible. And finally – back to Mrs Harrington and Alberto Vilar – 'A good giver is not demanding.'

Dayton spelled this out: 'A good giver gives freely rather than with all sorts of conditions. A good giver has faith in the institution that receives the gift.' I think Ken, a stickler for governance by the way, would have objected on governance grounds if a supporter had tried to trespass on what were primarily management or Board prerogatives, including artistic policy. If a supporter wanted to do more than contribute a gift, then Dayton's solution was 'personal involvement and volunteered time'.

Now Ken and Judy Dayton lived openly by those principles and the entire Twin Cities arts, business and philanthropic communities would have noticed if they didn't. There was no danger of failure in this respect.

A decade later, at the first $100 million mark, Ken Dayton wrote another seminal piece, called 'The Stages of Giving', showing how any individual with something to give could move from giving the minimum, to giving as much as possible, to giving the most the taxman allows, to going 'Beyond the Max' as he so

pithily put it. Underlying it all, Ken and Judy believed that if you have money to spare, you should give it; you should plan your giving; you should enjoy giving, and, ultimately, they believed you would benefit hugely and personally from doing so. Ken was not a churchy person but the New Testament phrase 'The Lord loves a cheerful giver' might have been made for him.

There were, I think, three key stages in the evolution of the Daytons' philosophy. The first came when they realised that there was a gap – a benign one – between what they wanted to give, what they were in a position to give and what they could get tax breaks for. It must have been a wonderful moment when Ken and Judy realised that if they allowed themselves to be constrained by tax breaks, this limited the amount they could give. It was the taxman who was determining how good they could be as givers. This was stupid and intolerable.

So they just ignored the issue of tax breaks even when it meant losing chunks of tax deductibility – which, over the years, they did. But, wrote Ken, 'what a wonderful feeling it was to be able to give as much as we wanted and could afford.'

The next revelation came hotfoot on the heels of the previous one. They had been allowing the Maximum Allowable rule to determine what they gave. Once they had decided to ignore that rule, what should govern the true level of their giving? Over-simplifying what was clearly a serious business, the Daytons asked themselves how much they needed to live on; how much they needed to create more wealth; then set a limit on their wealth and finally – wait for it – suggested that you 'give away everything you earn beyond that figure'. Ken Dayton's observation: 'We have been able to share our wealth and see it at work while some have been concerned primarily with increasing their wealth.'

And Ken Dayton's conclusion is certainly worth sharing: 'Planned giving (thoughtful giving) can and should be a lifetime

endeavour and should command the same kind of dedication and energy that accumulating wealth does. Only then does one live life to the full.'

What is remarkable is that these are not a collection of pious platitudes coined by someone spouting from a hortatory pulpit. They are practical principles, based on actual experience, achieved practice and a profound sense of the psychology of the giver and the asker. Few can give as generously as the Daytons of Minneapolis. All can learn something from the attitudes behind the spirit that informed their giving. Then giving becomes not a reluctant duty, an onerous burden, but a pleasure, an opportunity and, finally, an art.

A tale of two millions

There are two areas of human activity where interference is presumptuous. Don't tell anyone how they should conduct their sex life; worse still, don't even think of telling them how to spend their money. This is the tale of two men who each blew a million pounds in very different circumstances, though both were connected with the arts. The public response to these two stories demonstrates how thoroughly mixed up our attitudes are. At a time when all the warnings from Whitehall speak of the inevitable reduction of public subsidy for the arts and the growing need to engage private funders in their support, the two stories are at once cautionary, alarming, and timely. But will the arts world listen, or change its behaviour and attitudes as a result?

The two people involved could hardly be more different. Bill Drummond is a rock musician and legend, one half of the 1980s pop group the KLF. When he appeared at the Barbican in October 2002 as part of Ian Sinclair's show about the M25, an atmospheric response to the notorious motorway through literature, poetry, opinion and music, Drummond's arrival on stage was greeted with a mixture of knowing awe and unqualified enthusiasm.

The other player in this story is Martin Smith. He is a banker by trade, and was Chairman of English National Opera for five

years. Until recently – and possibly even to this day – sections of the arts world and many in the arts media would pelt him with rotten eggs if he appeared on a public platform. As it is, he endured press coverage over two years that was unremittingly hostile, constantly impugned his motives, questioned his skills and represented the equivalent of having buckets of ordure poured over him.

What do Drummond and Smith have in common? Each got rid of – or gave – a million pounds of their own money in very different ways that were (just) connected with the arts. The money was hard-earned, honestly acquired, and undoubtedly theirs to dispose of without obligation to anyone except their nearest and dearest. So why have they been treated so differently by the public and the arts media?

In Bill Drummond's case, he and a colleague flew secretly to the Scottish island of Jura in August 1994, taking a million pounds in £50 banknotes with them. They then burned the money in a derelict beach house. The act of arbitrary destruction was enacted in secrecy but was also videoed and subsequently shown throughout the country. While some called Drummond a 'useless art moron', the million-pound bonfire was more generally greeted as an existential satire on materialism, the video being greeted by one writer as having the 'same feel as a symphony'. Very few dared to suggest that maybe the million pounds might have been better spent on something, well, more obviously useful or creative. In general, the view was that it was Drummond's money, it was a bit of fun, wasn't it, and undoubtedly both an iconic act as well as an ironic one. Some welcomed it as the former, others as the latter; either way it could not fail as an each way bet on calculated nihilism. Judging by the response to his appearance at the Barbican, Drummond caught the mood of the time accurately.

By contrast, the banker Martin Smith gave over a million pounds of his own money to fund the restoration of the London Coliseum, home of English National Opera and in dire need of renovation. As Chairman of the Board, he did what all arts chairmen are required to do these days when an organisation starts fundraising – he led from the front and from his own purse. He didn't make much of a song and dance about it, any more than the other Board members who together coughed up a fifth of the total restoration cost of £43 million. No one in the arts media, to my knowledge, ever said 'thank you' to Martin Smith for helping to create a spanking new home for English National Opera or for taking a conspicuous personal lead in the process.

Why the double standards? Why did Drummond get cult status for burning a million and Smith villain status for giving a million? At one level, the answer is simple. Drummond is a rock hero who appealed to our instinct for anarchy. Martin Smith and many of his friends are bankers or stockbrokers, consultants and so on. At all events, they deal in money, they have plenty of it themselves, they work in the City, and to some sections of the arts world and the arts media, the very idea of a 'banker' and their kin being involved in the arts is anathema. From this standpoint, no one in the City is remotely qualified to advise – by definition – on the running of any arts institution, especially, it seems, an opera company.

Here the story does get more complicated and the cases diverge. Specifically, Martin Smith's crime as Chairman was to sack English National Opera's General Director, Nicholas Payne, in 2003. His grounds for doing so – fully backed by the Board and the Arts Council – were that the financial results for ENO were running into what appeared like an irreversible deficit. With no evident plan for turning the deficit round, Smith felt he had to ask Payne to leave.

At this stage, the music press made a fantastic volte-face. Until the moment of his dismissal, Nicholas Payne's artistic regime at the Coliseum had been under critical attack in general. The criticism reached a climax after an ill-judged and artistically crass production of Verdi's *Il Trovatore*, which Payne insisted on directing himself. He would save the costs of buying in an outside director as a two-fingered gesture of protest against the Board's insistence on the need to balance the budget.

Yet once the Chairman, the banker, Martin Smith, had dared to oust an 'arts leader', the music press to a man and woman turned from assaulting Nicholas Payne to defending him and discovering in him qualities that they had never noticed in their previous coverage. Martin Smith could do no right, because he was a banker!

In the general vilification thrown at Smith for allegedly setting out to destroy ENO by dismissing Nicholas Payne, one of the additional charges most frequently levelled was that he and his City friends wanted a repertoire diet of 'bankers' opera' – wall to wall *La Bohème*, *La Traviata* and *Carmen*. Not only were they intruding into the business of the opera company, secretly they wanted to control its repertoire, to undermine its artistic integrity, in the interests of personal vanity and to the advantage of 'corporate hospitality'.

Yet at the height of such attacks, the cover of the ENO programme for the UK premiere of Poul Rudders' *The Handmaid's Tale* acknowledged that the production was made possible by the personal financial support of six people; they included one management consultant, a banker, a stockbroker, an actuary and their wives. In reality, so-called 'bankers' opera' was delivering modern opera that the company could not otherwise risk producing. The same experience applied to the then imminent new cycle of Wagner's *Ring*. Neither *The Handmaid's Tale* nor *The*

Ring could have been mounted at all without such strong private (often bankers') support. Yet no music writer or critic bothered to acknowledge or comment on this fact, even to admit that their own prejudices were strewn with contradictions. What would have been the media outcry if the story been 'ENO Fails to Find City Support for Modern Opera?' How the bankers would have been reviled for their indifference and philistinism.

The fact is that sections of the arts media and the music community are seriously confused about such private funding. It's not just that the very idea of saying 'thank you' seems to stick in their gullets; they also appear to have a perverse need to rubbish benefactors just when they are most needed. While prevailing attitudes towards Martin Smith were seriously muddied by the Payne affair, the total refusal to acknowledge his leading role in renewing the Coliseum should have made his media critics shift uneasily. Even if he had got the Payne affair wholly wrong, that should not have invalidated his role as a major giver to a crucial arts project.

Most of the private donors I'm writing about don't want public recognition at all; they just like spending their money in this way. It is a gloriously selfless act from which the rest of us, as audiences, benefit. Any chance of a word of thanks from the media and some in the arts world? Fat chance! After all, they're only bankers.

Lurking not so far behind these attitudes, which would claim that they put the art first and commerce second, is a deep and shoddy vein of sheer snobbery. Some critics think that anyone who makes money can know nothing about art. Come to that, most of us do know less about art than the critics. On this basis, arts givers would be few and far between. If – according to the critics – the givers do claim to care, this is dismissed as an expression of their vanity, an ego trip or a wish to exercise

power. These submerged private prejudices are never admitted, never acknowledged, never explored or justified in public. But they exist and confuse the whole debate about the private and public funding of the arts.

Of course, some donors do want naming rights, especially in connection with big capital gifts. It is hard to see this as an impossible or unreasonable part of the deal. Yet, recently Michael Attenborough, Director of the Almeida Theatre in London's Islington, announced that funding for the rebuilt theatre was complete and had been achieved 'without selling our name'. He was right to be proud about raising the money, but wrong to seem to sneer at the Royal Court who changed their name to the Jerwood Theatre at the Royal Court because of the wishes of a key funder.

The Royal Court is not diminished by using their funders' name, any more than the 'Jerwood Hall at the UBS LSO St Luke's Education Centre' – quite a mouthful admittedly – diminishes by one jot Sir Clive Gillinson's visionary idealism in building LSO St Luke's as a unique orchestral education space. I'm not aware that Tate Modern is artistically compromised by its historic association with a sugar baron, or the Carnegie Hall by its connections with a steel magnate.

For we still operate double standards in Britain when judging how people should spend their money. No one has ever enquired how millionaire lottery winners spend their winnings, still less Who Wants to be a Millionaire? contestants. Do they ever put money into the arts? It is up to them to decide what they do with their windfalls. And no doubt the lucky recipients say 'thank you' when the windfalls drop into their laps.

In the end, Britain's arts world has to make up its mind. If it takes money from the rich – even bankers and their friends – they can get into the habit of saying thank you rather than

sneering. The truth is that any arts institution needs to make at least a third of its income from private and corporate support. Without it, arts programming, particularly at the innovative end, will simply be decimated. The arts need private money, private backers, private sponsors.

And if they do not collectively learn to say thank you and to grant respect to those who do put their money into the arts, the next time a Martin Smith feels the urge to part with a million pounds of his money to support the opera, he might just decide he would be more highly regarded if he went into the centre of Trafalgar Square and set fire to it.

How to recognise an audience

next to asking ourselves what music, theatre, film and visual art we should programme, I and my Barbican colleagues spend most of our time talking about audiences. Our opposite numbers in the nation's arts venues and museums must be just as obsessive. Just who are our audiences? It is a simple-sounding question that then splinters into a myriad of others, raising issues of economics, social behaviour, impulse, instinct and many other aspects of human psychology. Keeping track of audiences needs constant attention. How are they changing? How can we woo them and keep them loyal? The art comes first, of course, and with it the artists. Without them, there would be no art. But without the audiences, it would be a sad, solitary sort of activity; without audiences, there would be no one to share the art, absorb it, react to it, criticise it, recognise it, reject it, warm to it, pay for it and, ultimately, make it come alive.

For art involves communication, expression, sharing and engagement. It is a two-way process. The arts need the audiences to make the activity of creation as engaged as it needs to be. The artists want the response from the audience to help them judge their work. Anyone who says that they run an arts centre for the artists is missing the point of the artistic experience.

Could the arts exist without the audience – sometimes described as the customer or the client – in one degree or another? Of course, poets write poems before they have readers; artists paint because they must; sculptors carve because the material demands it; novelists have to tell tales. But can actors perform to themselves? Can musicians play in empty rooms? It's hard to imagine. It's even doubtful whether the poet, the novelist, the painter would do what they do if there were no human response at the receiving end.

In recent years, I have talked at length to many internationally known artists in all disciplines. With one exception only, they insisted that even if they had no commission to work on, they would continue working because their internal drive to carve, write or paint or compose was so strong. I do not doubt their sincerity. They believe what they say. But, on reflection, I think there is an element of hyperbole in their protestations. Without the necessary other, the audience, the mutual part of the transaction, I do not believe there could be art. Private therapy, self-realisation, it might be; but art, I doubt it. It would be too private, too enclosed, too self-regarding for art. And it would certainly be a very different art, removed as it would be from the intimate engagement with the audience from which every artist learns.

So we need to take the audience seriously, very seriously indeed. There it is, out there, a recognisable collection of people, three thousand at a time in an opera house, two thousand in a concert hall, a thousand in a theatre, a few hundred in a cinema. At the end of a great performance, when the house rises as one to acclaim the performers – its acclamation expressing in the most physical terms that some thousands of people have all shared the same experience – the sense of being part of something bigger than yourself, something both collective and individual,

is extraordinary. The experience underlines the intensity of the live performance that is so central to the arts.

If only it were that simple. That audience, so apparently united in its emotional response, represents not one common reaction, but is the confused aggregation of several thousand different wishes, feelings, needs, wants and prejudices. (And that omits any philosophical consideration of how we know that when we cheer a performance, we are cheering the same thing as the person in the adjoining seat? Have we even heard the same performance? Forget it, that way madness lies!)

For I am one of the audience, as is everyone else. It is an undifferentiated concept. It includes the person who comes three times a week; the family which comes once a year, the woman who thinks the coffee was cold, the man who misread the start time, the person who thinks the tickets are too expensive, the person who objects to free programmes or the ads inside them, the couple who want to drink in the concert hall, the group who were late and complained that they had to wait for a suitable pause in the performance before sitting down.

All are part of the audience. Yet, as you examine the apparently cohesive mass of listeners in the concert hall, it splinters, fragments before your eyes into thousands of particular aggregates of desire. Any arts management team has to construct a series of systems and approaches that speak to most of the audience persuasively most of the time.

For the arts manager has to hold two images of the audience in their mind at the same time – on one hand, the audience as a cohesive group; on the other, the audience as a series of wilful atoms. The first is needed to keep your sanity, the second to keep your business.

To complicate matters still further, there are sub-groups of the audience to think about. I first learned about this from the Head

of BBC Radio 3, and later Director of the BBC Proms, Sir John Drummond. He was answering listeners' questions in a radio phone-in at least a decade ago. One caller asked about the 'Radio 3 audience', assuming that since the network was basically devoted to classical music, then the audience would have a similar cohesion to it. Drummond quickly put the questioner right. 'There isn't a single audience for classical music,' he declared. 'There are dozens of audiences and they are all different. The early music audience, the nineteenth-century audience, the lovers of the voice, the opera buffs, the chamber music groupies, lovers of unaccompanied choirs, the long-haired modernists. They are,' Drummond continued, 'united by only two things. They hate the other kinds of music; and everyone hates the lovers of organ music.'

Experience has proved him right. Nor is it necessarily a bad thing. A decade ago, it was possible to talk of a 'Barbican Audience'. It was by and large conservative in taste, that conservatism revolving around a solidly classical arts offering; the Royal Shakespeare Company in traditional productions of the classics; the London Symphony Orchestra in the orchestral mainstream repertoire. If ever there was an artistically coherent audience, it was the Barbican's for the first decade and a half of its life. It was shaped by the programming, attracted by the programming, defined by the programming in age, class and background. But if it was predictable, reassuringly so, it was also very limited and very self-defining.

In 1995, when I and my artistic and management team came to the Barbican, we would probably have said – and were certainly told by outsiders – that it would be very difficult to change the audience by design. It was just too well entrenched to be taken head on. Worse, confrontation based on sudden change in artistic policy, could have catastrophic results. Warily, we concluded

that such a frontal approach, a very abrupt change in artistic policy, could lead to a catastrophic decline in attendance. Since then, I have witnessed one audience in a particular institution where the audience simply voted with their feet and declined to attend concerts presented by an over-ambitious programming director.

At the Barbican, we adopted a more oblique approach to the problem. We did not attempt to change the audience in a head-on way. From 1995 onwards, the programming began to change because we believed that it should become more contemporary, more adventurous, more risk-taking and more international. This was an intellectual decision, shaped by professional judgement. It was not determined by prior knowledge of what the audience might want, though it was informed by a solid hunch as to what they might take.

The decision by the Royal Shakespeare Company – the Barbican's resident theatre company for fifteen years – to withdraw from the Barbican Theatre for the six summer months in the year gave us the opportunity – and the challenge – of branching out into theatre programming that delivered international, lyric, multimedia theatre. The arrival of the BBC Symphony Orchestra as an associate artistic partner, combined with our own promotional ventures into cutting-edge music events, transformed our programming in both concert hall and theatre by adding a fully fledged contemporary dimension into the unrivalled classical programming of our resident orchestra, the London Symphony.

Did the Barbican's previous, loyal former audience come with us? Were they ready to share our vision of something different? Did those who enjoyed and valued *Hamlet* and *King Lear* performed by the Royal Shakespeare Company come to see Merce Cunningham's choreography, Robert Wilson's visionary theatre

83

or Simon McBurney's physical explorations of drama? Did those who liked Beethoven or Mahler come to hear Steve Reich, Mark Anthony Turnage or Stockhausen? Sadly some did not, especially in the theatre. I thought then and I am convinced now that it was more their loss than ours.

But many did respond. From our point of view, losing an existing audience mattered to us and to our box office. It deprived us of a degree of certainty in our arts budgeting. But it should have mattered still more for those audiences who were insufficiently adventurous to contemplate the possibility that Cunningham or Wilson might offer something different, perhaps better, than what they were used to. Of course, the new and the experimental often yield disappointment and failure. But being curious, being intellectually open to innovation involves readiness to accept occasional disappointment.

What mattered far more was that the new programming attracted new and quite different audiences – note the plural. Instead of a broadly classical, conservative audience of a fairly homogeneous kind, the Barbican now acquired a spectrum of different audiences: one audience for baroque music; one for high classical performances; a distinct one for multimedia theatre; and so on. These audiences are identifiable, and tend to be younger; they are extrovert, curious and, undoubtedly, fun. The Barbican's experience is that if you want to change the nature of your audience, you must first change your programming. It is a very stimulating process that is not achieved by setting micro, sociological targets.

It yields rewards in many ways. In 2005, we discovered that as a result of transforming the programming mix, the Barbican not only presented the most 'diverse' and international programme, but that the representation of 'BME' audiences – black and minority ethnic – was some six per cent higher than at any other

comparable London venue. Had we set out to achieve that as a matter of policy, it would not have succeeded. But by extending the range of the artistic programming – to become more international, multimedia, and cross arts – by starting from an essentially artistic, values-led decision, we achieved a desired social outcome. But you do not start by treating your audience as a socially manipulable lump of humanity; they are audiences, human beings and people first, and not social categories first.

My only personal wish is that more of my own generation were ready to take risks in what they hear and see. Sometimes they do, with very positive results. In March 2006, some friends whose love is deeply anchored in the classical music canon, heard Pierre Laurent Aimard play seven of the Ligeti Etudes in the middle of an otherwise traditional programme of Strauss and Mahler songs and the Schubert string quintet at the Wigmore Hall.

While the Schubert was a deeply moving experience, the Ligeti blew their minds. As they reeled out after the Etudes, the universal reaction was: 'I've never heard Ligeti before, isn't that wonderful music.' Gratifying as the response was, my doubts remain as to the number of those first-time Ligeti listeners who will actually buy a ticket for his music in future.

In September 2006, I witnessed a similar revelation, as a three-quarters-full Wigmore Hall applauded the most austere, epigrammatic, musical miniatures of Gyorgy Kurtag. Mind opening is exhilarating.

In some senses, transforming an audience is easier than retaining it and turning it into a group of loyalists. Once the audience is known to exist, once it has been identified as a marketing target, then the real problems start. Should an audience be persuaded, cajoled, flattered or bribed? All the evidence in a huge metropolis such as London is that the audience for any art form is promiscuous. While they may have an underlying loyalty

to a venue, a loyalty bred of an awareness that its values are their values, they are primarily event- and artist-led. Should an artist be risky or unknown, then the factor that may tip the balance towards attending or staying away can be that of trust in the curator of the venue, the artistic director, the programmer.

Audiences are extremely self-regarding. They look out for their own. Whether it is the very rich, sensing in five minutes that there are too many people in the bar area that they have never seen before, and they are in the wrong place; or whether it is the hip and cool, who only need to see two suits and a little black dress to decide the venue is totally naff, audiences like to be with their own. This is where the flattery comes in. Persuade the audience, show them that their set comes, or enough of it, and half the problem is solved. It is the hardest trick to pull.

There are nights when the crowd in the Barbican is ferociously cool. They indulge in social signals of recognition which completely pass me by. When I ask my colleagues where that particular crowd come from, they are often at a loss to explain. Some set of unconscious signals involving the artist, awareness of the event and an osmotic grading of its significance, are passed in wholly subterranean ways and the appropriate crowd gathers. Equally, there are other events when I know instantly that I am among my peers.

All audiences have characteristics in common. We know from audience research that up to half the audience decides to attend because of the experience surrounding the event, an experience that includes the drinks, the food and the opportunity for social recognition and for people-watching. We have spent months working on the whole nature of the 'Barbican Experience' for our audiences and visitors. It has been hugely gratifying – and rewarding – to see that as our public spaces and foyers have been transformed, the audience arrives earlier, socialises more

and spends far more at the bars and coffee points. The actual experience of attendance in itself, even before the artistic event, has become more attractive.

Failing the ability to generate such a social, lifestyle atmosphere by design, arts venues too often fall back on downright bribery to attract audiences – discounts, bulk purchase, last-minute concessions. Audiences are far smarter than the venues. Most of us like to believe that the standby ticket at half price will attract the student, the senior citizen, the ethnic minority or the socially disadvantaged. It is – we tell ourselves – part of our education, access and outreach work and we are proud of it. Mainly, we deceive ourselves.

Sometimes, these sales tricks have the desired effect. Most of the time, those pocketing the cheap tickets are people smart enough to know the show is not fully sold, and who are ready to take the risk that it might be. They could afford a full-price ticket perfectly well; but we offer them a cheaper one and reduce our box office take unnecessarily, all because we dare not risk holding out for the real price. The result is that the wrong people are subsidised. In this respect, the audience is smarter than the arts managers. We try to bribe them, but we do so inefficiently and ineffectively. In truth, the bribe was probably not necessary in the first place.

Too many arts centres fail to manage their ticket-pricing policies strategically; too many leave it to comparatively junior members of staff. Too often, those junior members are moved by sentimental ideas about low prices being fair, more socially just or more inclusive without having the vaguest idea of what such vague instincts cost in lost box office revenue. At a recent review of Barbican ticket pricing, the discovery that there were at least five different 'lowest price' offers, each one determined by a junior member of the arts or marketing team, concentrated

the mind wonderfully. Ticket pricing is now strictly managed at an appropriately senior level. The financial returns have been measurable and significant.

There are signs that arts venues are waking up to the game. EasyJet pricing is the vogue; start cheap when booking opens, then ratchet up the price, as the plane fills up. In the US arts world, the move is away from concessions in cash and towards rewards in kind. An extreme view is that we should charge those who turn up on the night in the hope of a return ticket. Charging for a place in the returns queue would remind them how foolish they had been not to book earlier. (This is not a popular policy. I offer it as a provocation. To date it has not been adopted.)

The moral of the tale is that putting your marketing policy into full discount mode puts the audience in direct charge of your pricing and ultimately of your budgeting. A policy of bribing the audience invites one response only: 'Bribe me some more.' Besides, when audience attitudes to ticket purchasing are surveyed, price is very rarely the main determinant of whether a booking is made or not. Naturally, we all have a price bracket in which we buy; of course we will use a discount if it is available. But lower prices themselves are not the sole or the only driver. And the evidence shows that in the upper price brackets, audience resistance is remarkably elastic. A £5 increase on the top-price ticket may encounter no resistance at all but will make a nice difference to the box office take.

There is a big core mystery about audiences, which puzzles every arts institution I know from the museum and gallery world to the performing arts. As Dr Watson might have put it, it is the 'Case of the Once a Year Visitor'. This person – and there are tens of thousands like him or her – attends, visits, or buys once a year only. I have lost count of the number of marketing presentations in a variety of arts institutions which lament the once-a-year

visitor; the line, endlessly repeated is: 'If only we can turn every once-a-year visitor into a repeat visitor, then our problems would be over'. To date, I have seen no arts institution which has cracked this problem, though the Barbican is now making significant inroads into it. As a result of looking after the interests of audiences in a much more detailed, professional way – called customer relationship management – our repeat attendance figures now include almost half the monthly audience. And the Barbican is attracting new customers too.

Not that some people don't attend frequently. Quite the reverse. Some are serial attenders. That is where the frustration lies. If only the once-a-year attender could become just a bit more like the serial attender, how much easier the life of an arts institution would be.

Let's examine this more deeply. Imagine a great national museum which attracts, say, four million visitors a year. Assume, as you should, that two million of those visits fall into the 'once only' category. Ignore – as you should not – that most of those are tourists who, of their nature, are not going to visit more than once. But if, say, even half a million of the casual visitors were transformed into 'frequent flyers', are we really saying that overall attendance numbers would grow by a million or more? I doubt it. And why is it assumed that a repeat visitor is better than the unique visitor? What we are undoubtedly saying is that regular attenders are more cost-effective, more convenient for us.

There is a perverse case for saying that the one-time visitor, driven by a real curiosity when the chance of seeing a previously unknown object, is the most important visitor we can imagine. These are the ones open to the possibility of the 'Eureka' moment of discovery. Repeat visitors know it all, have seen much of it before and attend for a variety of reasons. Openness to discovery may not be one of their reasons for attendance. Which attitude

– openness to discovery, or catching up with the familiar – is the more attractive?

Further, if the balance between one-off and repeat visitors shifts in favour of the regular attender, and if overall numbers stay broadly the same or increase only a little, then the result from another point of view is disastrous. Such a shift would have the effect of drastically diminishing the overall audience base by narrowing its numbers.

On this argument, the one-time visitor is possibly a chimera, a shy and elusive beast whose exact behaviour will never fully be understood. Yet ignoring them is a mistake too. Why should they be ignored because they do not attend as often as a venue would like? How often must someone attend before they are treated seriously as a customer? From this point of view, time spent in attracting the once-only visitors and turning them into more regular attenders is time well spent. The defining way of looking at these attenders is not how often they visit – which puts the responsibility onto them – but how good an experience did we give them when they came. This puts the onus fairly and squarely onto the organisation. In other words, don't blame the customers if they don't attend; look at your organisation in the mirror first.

Does the audience know what it wants, and should the arts world try to find out? My answers, respectively, are 'no' and 'no'. To the extent that the audience does know what it wants, it wants the same thing it saw or heard last time. Left to themselves, audiences will listen to Schubert, Beethoven and Mozart for ever. (Oddly, Haydn is not on the sacred list – except possibly his String Quartets.) No audience actively asked for drama such as Samuel Beckett's – condemned at the beginning as incomprehensible – or clamoured for disconnected human exchanges as you get in Harold Pinter – initially ridiculed by the theatre critics.

Concert audiences did not demand the revelations and convention breaking of Stravinsky, Mahler or Schoenberg. Dance audiences did not cry out for works where the choreography and music were disconnected, as in Merce Cunningham. On Cunningham's first visit to Paris in 1964, the audience threw things at the company. In 2006, at the Round House in London, the venue was packed for Cunningham's *Ocean*, a ninety-minute work of riveting abstract dance with a 150-piece orchestra. In the 1960s, the London Sinfonietta, Britain's leading modern music ensemble, played the music of Ligeti to quarter-full houses. By 2006, these concerts were selling out. Audiences had not demanded either Cunningham or Ligeti.

This should not surprise anyone. No one can demand what they cannot imagine. You cannot predict what people will want to see from what they see or hear now. Moving the performance agenda on from the unbearably predictable is the most challenging and stimulating part of the arts management's relationship with the audience. It is also the most risky. But the bet that people are open to new ideas, that the once revolutionary will become the orthodox, that human perceptions of the world around them, as interpreted by art, need to change, is the most exciting and the most necessary part of the link with the audience. A colleague summed it up like this: 'Don't ask the audience what they want to see. Do ask them how they want to be informed about it.'

It is not arrogant to take this attitude. For the programmer, the curator, to know their world so well that they can sift the artists and performers who are genuinely creative from those who ape the work of others or indulge in mere posturing, that responsibility is a big one. But the example of Hollywood, where audience polls are used to shape the ending of films, has proved artistically destructive and commercially undermining. The example of political focus groups, which seem to pull

governments into increasingly conservative positions, should also give the arts world pause.

Ask audiences what they want and they will ask for more of what they know – about anything. We are bound to. If we could imagine revolutionary new art ourselves and ask for it, we would be the artist and not the audience. The evidence is that audiences are delighted when they are introduced to something of which they had no conception beforehand. How can any of us predict what new genius will create?

Underlying it all is the question of why audiences attend at all. Leave aside education, upbringing, curiosity, boredom, habit, snobbery, vanity and inertia – all reasons for buying a ticket. But what do they expect of an evening out, for going to a concert or drama is an evening out. Does the audience only want an evening when they travel, arrive, perhaps eat or have a drink, sit down, listen to music, have an interval drink, listen to more music, applaud and go home? Is that as good as it gets?

Or is it an evening when the audience comes an hour early, attends a pre-concert talk, snatches a beer and sandwich, concentrates on the concert, then joins the queue for the CD signing, exchanges words with the artist, before getting home, late but fulfilled? The choice is between the evening out as diversion, and the evening out as part of a university extension course, or an evening class in self-improvement. The gap is a big one.

By and large, arts venues incline to the latter as a model for the evening. Coming to a concert is not a substitute for the passivity of watching television as the proverbial couch potato. Arts administrators and programmers see it as closer to an intellectual gymnasium, where minds are fed, intellects stretched and emotions challenged. We are idealists, romantics and relentless self-improvers, and we want others to exist in

our own image. Often we are disappointed idealists, running headlong into the realities of life where, for many, even to get to a concert on time, leaving behind the stressful demands of home and work, is sufficient achievement. But the belief that coming to the arts involves more than turning up and sitting down is increasingly a cardinal element in the way the arts are planned and programmed.

Behind it all lies the search for loyalty; arts institutions yearn for the unique recognition afforded usually only by a wife, a lover or a parent. 'You are the theatre company we come to. You are the only orchestra we ever listen to. Yours is the best arts centre anywhere.' That is why all the concessions devised to retain constancy are called 'loyalty' cards. It is in fact a complete misnomer. Such concessions would not be needed if true, unquestioning, unconditional loyalty existed. If it has to be bought with attractions and financial inducements, what sort of loyalty is it? The answer is the 'loyalty of the marketplace', the loyalty to the brand.

One of the most fashionable trends in recent years has been brand development in the arts world. It is easy to make fun of it and protest that an arts centre is not like margarine or soap powder. Yet in the search for the perfect audience, the brand cannot be ignored. It is, in essence, the perfect arts proposition to persuade the audience to attend, a way of presenting and projecting what you do in such a way that the attender recognises a place whose values he understands, whose activities he admires and which commands his respect.

One of the reasons for attending one venue rather than another is that the idea of what it represents – usually led by an artistic vision – is so persuasive that the purchaser comes to you and not to another venue. If the institution is confused artistically about what it does, then the visitor will be confused too. That is one

reason why venues that merely present what others offer rarely possess an artistic personality or attract or retain loyalty.

At the Barbican we had to transform the brand – though we didn't call the process by that name – when we migrated from the narrow, classical, conservative artistic base eight years ago. In its own terms, the first, original Barbican brand was clear and successful – it was clear-cut, limited, predictable but formulaic. The task of migration to a brand whose internal ideals and external programming were international, leading, diverse and excellent was huge. We had to reshape the programming before openly admitting what we were doing in terms of transforming the brand. It might have sounded too ambitious, too grandiose had it been heralded as a change of policy at the outset. Once the programming had become what we wanted it to be, we retrofitted the brand image to reflect the existence of the new kind of programming. It was an essential part of persuading audiences that the Barbican had changed, and that those who were so inclined could identify with what we had become and would trust what we were offering.

Much of the relationship with audiences is mediated through the processes of marketing. I know of few arts institutions where the right type and level of marketing is not an issue. At a recent seminar of orchestra managers on the question of marketing, I asked, light-heartedly, 'Why do so many institutions hate their marketing departments?' This was greeted with such a cheer that I immediately altered it to 'Why does everyone hate their marketing department?'

The Barbican's marketing is well integrated into the arts planning process, relates closely to the various art forms, has defined functions, clear priorities and precise targets. Without such careful integration, the 'hated' type of marketing department becomes either too remote, too bossy, too prescriptive, or too

theoretical, to be truly useful. Many organisations founder on one or two extreme positions. At one extreme, the belief exists that the job of the marketeers is merely to sell the tickets. The opposing view is that the marketeers can and should tell the arts programmers what will sell and therefore what they should programme. Either attitude, taken to the extreme, will cause trouble and lead to disappointment.

At its best, the marketing department manages communication with your audience. This process is not called 'customer relationship management' for nothing. Do they talk to customers in the right tone, at the right level, in the way that they want, pitched between puff, enthusiasm and bombast. Do they communicate too often or not enough? The audience is savvy; it knows that the last-minute flyer telling you how unmissable event X and performer Y is only arrives because no one else is buying tickets for it. Managing the dialogue between venue and audience is an art as well as a commercial strategy. By and large, it is not about salesmanship in the common sense – it demands a much more adult and informed dialogue than mere salesmanship implies.

It is the easiest thing in the world to chuck bad money after good on an event which is not selling. To do so is to imagine that a sales effort by itself will get people to buy. It is too easy to seek comfort in vanity advertisements in papers which sell not a single ticket, or at least insufficient tickets to cover the cost of the ad itself. It has traditionally been said that we all know that half the marketing budget is a waste of money; but no one knows which half. But the uncertainty won't go away and time spent in getting it right is seldom wasted.

The best way to learn about audiences is to observe our own behaviour as attenders. I do have a favourite orchestra – it would be the London Symphony whether I was at the Barbican or not. I

also have a favourite hall – the Wigmore Hall. I am susceptible to brand appeal. I am also event-driven and event-attracted. I like a well-designed brochure but am not fooled by it. I am excessively affected by reviews of plays or performers. The ambience of the venue matters, as does the catering, the parking and the service. I am influenced by discounts but do not have to be driven by them. I like the intellectual add-ons and should involve myself in more of them. Essentially, I look for the challenging, the new, and for absolute quality of interpretation. If that's what I want, I regard it as a fair assumption that the rest of the audience should be offered no less.

But there remains one fundamental problem. By and large, today's audiences reflect generations whose education in the classical canon at school and university was solid and extensive. How should we approach generations whose education in, say, classical music is non-existent, whose musical awareness begins in the post-1968 era with the belief that culture started with The Beatles and where a new, very short and recent sense of history has been forged?

This is a profound problem of culture that affects society and possibly even the whole future of the arts as we presently know them. If it is not addressed, there will be no audiences for the arts, or audiences so small that public funding might not be sustainable. This remains the great unsolved issue behind the way any arts management regards, treats and understands its audiences. It must not be ignored.

The arts and the media:
whose side are we on?

few subjects agitate artists and promoters more than the critics writing in the printed media. The only subject which does cause more agitation is the connected matter of how well – or more likely, how badly – the electronic media reflect the arts world. Overwhelmingly, most of those who work in the arts feel misunderstood and usually badly treated by the media – print and electronic.

A very general response would be that the media are less well informed about the arts than they should be, that they are often indifferent if not actually hostile, that they prefer stories of failure to accounts of success, that artistes get coverage for their looks and lifestyles rather than for their art. Many artistes, frustrated by critical writing, affect total indifference to what is said about them. Yet given the importance of coverage in any medium, the ostrich posture is not one the arts can afford. How well grounded are the accusations about the media? If justified, is there a solution?

Four years ago, *The Guardian* compiled a medley of responses from journalists and broadcasters to the thesis advanced by John Lloyd of the *Financial Times* that journalism did not accurately account for the world around us; that it needed to reflect the world

of politics in particular with a degree of honesty and accuracy that journalists – he believed – do not muster at present.

My own contribution to that medley dealt with the way the arts were presented by the print media:

> From my own direct experience in the arts world over a decade, the media are closer to the mark than we would like. When they sense a wounded organisation, trailing blood in the water, they close in like a pack of sharks. Are they absolutely fair? Of course not. Do they know enough about how arts organisations operate internally? Absolutely not. But I can't go into denial. They do – collectively – sense when something is wrong and with good reason.

I saw that as amounting to a 'no, but' reply to Lloyd. The arts world is presented rather more accurately than those of us deeply involved in it would sometimes like to admit. The picture offered is highly coloured, filled in with broad brushstrokes, and rather simple outlines. It is always inconvenient when our own institutional dirty linen – or what they think is ours – is hung out to dry for all to see. But we have usually soiled it in the first place.

It would be more encouraging if success stories in the arts got the recognition that they so richly deserve. But no one writes about doctors when they save a life, only when they kill a patient. So why – it might be argued – should the arts get preferential treatment and a supposition that they deserve sympathetic understanding?

Setting aside special pleading, there are areas where the media could definitely do better. Leaving aside the accuracy of the coverage, the depth of the coverage is quite as important.

Here the issue is not so much the art itself as accounts of the organisations responsible for presenting it. Too often, critics and arts reporters stray beyond the confines of critical judgements and venture sweeping opinions about arts organisations and how they are run. Yet as they do so, they lack the financial and managerial knowledge or experience to make the judgements they flaunt – often using highly emotional terms, and sometimes declining to correct factual errors. Once arts journalists move beyond their immediate specialisation in the art form, their competence to make sweeping judgements needs to be seriously questioned.

But someone has to address such issues. It should therefore be the role of the arts reporter – not necessarily an art form specialist, a rather different beast – to be equipped to understand the working of arts organisations which are often as complex as many a commercial body. In my direct experience, the published versions of the travails of the Royal Shakespeare Company – after they left the Barbican – and English National Opera – after parting company with two general directors – were characterised by a great deal of ignorance, a quantity of emotion and a readiness to take refuge in prejudice that were truly shocking to witness. (I am not merely saying that what was written was at odds with what I knew had happened in both cases – though it was. It was the refusal to shift from a committed journalistic position driven by feeling rather than fact that was objectionable.)

Beyond that, arts reporters and some columnists are too ready to adopt uncritically the norms set out by the government as it lays ever more onerous policy prescriptions on the arts. Of course, journalists must report the terms in which the government funds and scrutinises the arts. Political allegations about 'elitism' in the arts, as if the term were self-evidently coherent as a definition, as if the arts were self-evidently 'guilty' of such a thought-crime,

these are allowed to pass as if they were statements of fact. Indeed, on occasion, the media join the charge, waving 'elitism' as their battle cry if it suits the marketing agenda of their publication.

Journalists seldom enquire whether surrounding government spending with baskets of objectives and regulations has the desired effect – that of enabling great art to be produced.

Of course, governments have both good and bad reasons for attaching objectives and performance criteria to the supply of funding. In the present context, the problem is that the media do not seem to be active partners in the debate, preferring government and the arts to slug the issue out between them, leaving the media to report on the exchanges without much comment or observation. This is surely to abdicate from the media's proper role of active intellectual involvement in controversy and scrutiny of policy-making.

So when it comes to coverage of the arts, the lack of detailed professional knowledge of the policy and administration scene means that an incomplete or downright distorted picture is painted.

Do things look any better when we look at the way the media engage with the arts as a staple of their own output? Here, the attention falls principally on the electronic media, on radio and television. Two decades ago, the arts – whether original or historic drama, broadcasts of performances from all the live arts, documentaries about the great ideas and movements in history, literature and the visual arts – were a staple of the television schedules. No one had to look hard to find them.

They have not vanished altogether today, though you may have to look diligently to find them or stay up very late to see them. But the belief that they should feature significantly in the mainstream terrestrial schedules, as distinct from the minority digital or satellite channels such as BBC Four or Artsworld, has

been seriously weakened. I think that the TV executives who believe that they should feature in this way are getting fewer and further between. Holding such a belief may even be a barrier to advancement.

Memories of television schedules are fallible, fantastical and treacherous. History records that there was a time when Jacob Bronowski, Sir Kenneth Clark and David Attenborough dominated the nightly schedules. They did so at times when viewers were awake and did so on channels where millions watched. But they did not do so every week or every night. We rightly remember the peaks of performance and conveniently ignore the troughs.

Nor is a return to that kind of serious programming, scheduled at peak times, likely, possible or perhaps desirable. Times have changed, television has changed, audiences have changed, habits have changed, we have changed. Just turning the clock back is not possible.

What can rightly concern us is an attitude of mind widespread, though not yet universal in television, that can be called 'the flight from intelligence'. It reveals itself when broadcasters do not trust their audiences with ideas; when they regard them as too ignorant or indifferent to engage with ideas; when they behave as if interest in broadcasting about ideas can be dismissed as superior and elitist; and when the resulting fall in interest and audience numbers is treated as rightly punishing those who dabble in ideas.

Underlying such attitudes is the belief that even having ideas flows from personally possessing a larger – perhaps superior – body of knowledge. In *bien pensant* circles, this is regarded as objectionable on at least two grounds. If knowledge is power, or can be used as such, then the use of that power by comparatively few flies in the face of fashionable views of equality and social

empowerment. The latter – social empowerment – is no doubt very desirable in many social contexts, but not if it undermines the very idea of the value of possessing knowledge.

The second way in which a belief in knowledge flouts conventional attitudes is that it carries ideas of hierarchy. We seem to prefer a world where all ideas have an equal value because all people have an equal value; therefore we all have an equal right to our opinions. Does this make them equally valid? In this context, the structures and disciplines associated with the acquisition of knowledge feel demanding and socially uncomfortable.

Broadcasters, with their constant involvement with mass audiences, are very susceptible to such beliefs and attitudes. It is far more natural in a mass-audience medium to favour the line of least resistance and to avoid anything that might offend or put off. One such stratagem is to 'fly from intelligence'. It has never been known to fail – as Phineas T. Barnum observed a century ago.

It shows itself in many ways, often almost unconsciously, which suggests that the rot has already penetrated deeply. At the comparatively trivial level, a Radio 4 trail for The Reith Lectures by Lord Broers in 2005 virtually obliterated the short clip of what he was saying by overlaying it with a mass of jingly music. If The Reith Lectures are about anything, they are about original ideas. But the programme trail appeared to be saying – though no doubt in a postmodernist way – 'Don't worry; as this is about the Triumph of Technology, we'll give you the sort of tinkly electronic music usually used on film soundtracks, but we won't threaten you with ideas.'

Worse still, the inclusion of a period announcer's voice – almost Monty Pythonesque in its parody – proclaiming that The Reith Lectures are for the 'stimulus of thought and the advancement of knowledge', undercuts and undermines the truth that this is

indeed what they were originally designed to be. Apparently, such a grand statement of intent can no longer be presented without deflating its assumed pomposity. It may sound a small example, but one deeply revealing of disturbing assumptions. The subliminal message of discomfort with the very thought of the serious transmission of ideas could not have been more overtly presented.

The real giveaway comes from the way television programmes are presented. All BBC presenters and news reporters have been told that they relate more to the audience – and they to them – if they wave their arms around. (My good colleague Peter Snow was the original arm waver, but that was because Peter communicated naturally, and gloriously, through his whole body. He didn't need to be told to do so by an editor.)

Such an instruction means that simply providing the audience with the best analysis possible is not good enough. The broadcasters must also signal that they are deeply into the act of communication. The appearance of communicating is now as important as the act of communication or the substance of what is being communicated. For the ideas being passed on are deemed to be too difficult, too complex or too unpalatable to be taken on their own intellectual terms. Besides, appearing like a human windmill reduces the hierarchical effect of knowledge. If somebody looks foolish on screen, what they are saying can't be that clever.

In the world of documentaries, the flight from intelligence has become a headlong rush. I call this the 'Blue Peter effect', much to the dismay of my *Blue Peter* friends who were marvellous, enthusiastic communicators with children. As this once great, natural, instinctive skill has become debased by documentaries, presenters are judged by their ability to convey enthusiasm rather than pass on knowledge. Arms don't necessarily have

to windmill, but a tone of hushed wonder at the treasures being shown is absolutely essential. Here the presenter shares his 'Gosh, this is amazing' reaction with us because telling us something might put a barrier of knowledge between him and the audience. Sharing feelings is good; passing on knowledge excludes.

Leaders in this genre include Dan Cruickshank, whose face and body are knotted into a constant rictus of astonishment when faced with another of the 80 'Wonders of the World' in *Around the World in 80 Treasures*. This is a round-the-world cruise masquerading as archaeology. As a contribution to anything else but a sales brochure for the global tourist industry, it must be valueless.

A close BBC second in the agony and ecstasy of wonder stakes comes Adam Hart Davis. A recent programme on Mesopotamia managed to omit any map of the region, but preferred to demonstrate how the Mesopotamians made beer. The 'Son of Blue Peter' tradition was continued by Hart-Davis having a nubile twenty-something sidekick – called Hermione, of course – who dashed off enthusiastically into the desert in best 'Ask Anneka' style to discover something the Mesopotamians 'had made earlier'.

The only response to the fake 'enthusiasts' is to shout impotently at the screen: 'Don't tell me how you feel, tell me what you know that I don't.' Previous culprits – surely an essential new category for the Royal Television Society Awards – included a young man called Ptolemy – of course – and a woman with a normal name who conspired in a brilliant double act on a BBC Two heritage programme, *Saved*, to say nothing at all of any value but to convey a breathless sense of wonder at the buildings they saw. Yet they were presented as experts. Presiding over it all was the genial and highly intelligent Griff Rhys-Jones, who decided

to play up the whole serious business of saving the built heritage – which the series is admirably devoted to – as if only a silly voice could make the case for doing so.

More fooling around filled the screens when that deeply knowledgeable ornithologist Bill Oddie began to present *Spring Watch* in a tone of uncontrollable hysteria. The only fact he chose to pass on was that there were visions of otters (or badgers, or foxes) playing with their young.

All these people are hired – presumably – because producers are aware that they are experts in their field. They are also persuasive, natural communicators. In the event, the same producers undercut the value of the experts they have engaged by presenting them as vacuous mannequins whose mouths can expel gusts of wonder and shrieks of pleasure, but seldom packets of information or shared knowledge.

I say nothing of the trend to use former comedians as programme presenters. This is the 'Monty Python effect'. Because *Python* brilliantly burlesqued the solemnity of historical period drama – from *The Holy Grail* to *Life of Brian* – it now seems impossible to reconstruct the past without the mediation of a Python. Here the subliminal message of reassurance is: 'Don't worry; this may look serious but don't feel threatened because the Pythonesque frame means that really it's all a bit of a laugh'.

And one last subliminal message. When the BBC uses Rolf Harris to talk about the Impressionists, and when he paints his version of great masterpieces – a fundamentally ludicrous proposition – the programme is saying: 'Look, there's nothing special about art. Anyone can do it. Don't believe those art snobs. Rolf has just done what they do before your eyes. He did it in five minutes and didn't need to go mad in the process.'

The irony is that television has exemplars of presenters who stand still, speak their minds, deploy arguments and express

thoughts and ideas in joined-up sentences. The Channel 4 historian David Starkey has embraced intelligence and seriousness and, irony of ironies, won a huge audience as a result. Tim Marlow has done it with his visual arts programmes on Five. Simon Thurley has done it on architecture on BBC Two and Five; Simon Schama on BBC One. It is possible. It's not hard to be brave.

A somewhat different kind of courage is required in the arts journalism that affects us most directly and sometimes painfully – daily reviews in the printed press. The question critics face, and the one their arts editors wrestle with, is a fundamental one about values, about good and bad. By what set of values do they write about the arts we present? Is there a shared vocabulary of critical judgement and appreciation that embraces the wide range of activities that inhabit the artistic world and range from silliness to sublimity. We can all recognise the simply silly – and enjoy it too; we can all be moved by the sublime. But placing things exactly on the long spectrum that stretches from one to the other becomes more and more difficult.

For a start, few appear to be able or inclined to use words such as 'good' or 'bad' without qualification or apology. Every judgement about the arts now needs to be qualified by a sense of gender, culture, race, inclusion and exclusion. There is even a place for class – that reassuringly grand, out-dated, sociological Marxist simplification – provided it means stirring up the newly fashionable, but in reality very old, pot of elitism versus populism.

It is possible to imagine a situation where judgement of a play or opera or piece of music theatre was so informed with these current sensibilities that everyone might agree with the conclusion that it was indeed 'good'. Conceivable as it might be, such a process would reduce criticism to judgement by performance indicators.

In the absence of a tick in every appropriate box, any sense of approval would be disarmed, virtually invalidated.

Yet judging in this way is entirely consistent with the government's approach to the arts themselves. Unless an arts body – whether museum, gallery, performance collective or street theatre – can demonstrate that they measure up to the prior criteria of being educational, providing outreach, reducing exclusion, improving access, advancing ethnic diversity among audiences and staff alike, then the question of whether the organisation in question is doing its principal job well can appear secondary. While the pendulum of social and political correctness has started to swing back to a median point, it still flickers nervously towards the politically correct indicators.

Not content with shying away from unfashionably absolute words such as 'good' and 'excellent', we have spawned our own weasel words that allow everything to be labelled but little to be judged. Performers and artists who fight for recognition and success reject the very idea and process of valuation. They take refuge in self-categorisation instead. It is as if the work of a journalist – critic is too loaded, almost obsolete a word – is restricted to saying only whether or where an artwork exists, not whether it should be judged outside its own self-selected series of definitions. Increasingly, arts journalism involves a mapping process rather than one of valuing and evaluation. To say where a piece of art exists in the broad categories of artistic activity is perhaps the only valid thing that remains to be said about it.

Needless to say, this is very convenient. Any judgement can be deflected or rejected outright by disputing the terms on which it is made. An artwork so bristles with its own sense of particularity, like defensive barbed wire, that criticism can only validly approach it on the terms that the artist has constructed. 'Don't tell me that I include too many echoes of other people's

works; I am being deliberately referential.' Or 'Don't criticise me for appearing to be stupid; can't you recognise that I am being ironic about the stupidity?' Or 'Don't tell me that some previous artist did what I am doing with greater technical superiority – I refuse to be tied down in terms of the dead (white) past.' And so on. There are a hundred reasons for refusing to be taken seriously, a hundred excuses to deflect criticism. But if anyone can define the terms on which they are to be assessed, why bother with criticism at all?

In the case of some writers, we might think the absence of agreed terms of reference is probably a considerable relief. They are free to play the role of cheerleader or publicist for the arts and artists, if so inclined. Those who choose the role of explorer in the comparatively unknown reaches of cutting-edge art, bringing back news from the unknown, perform a function. Such explorers, those who recognise, identify and report the truly original, are vital parts of the arts dialogue. But sooner or later the role of reporting, recording and discovering has to be followed by another function – that of judgement and evaluation. Do we care enough to go further and try to decide whether it is good of its kind or bad?

This is not a foolproof activity. There is no question of a posse of critics with superior knowledge and godlike objectivity descending and telling audiences what is good and bad and which works are better and which worse. The history of criticism is littered with learned pundits making fools of themselves, not least when their undoubted knowledge is pushed to one side by their own wretched human prejudices.

But arts journalists in particular should not go out of their way to avoid using their knowledge and accumulated experience to give some idea of where they stand, some indication of what matters, some idea of where their values lie. It is not enough

to accept the blandishments of the PR people, the statistical persuasions of the marketeers. We should expect journalists to be more critical of those who have a vested interest in their own success and a vested interest – perfectly understandable – in not losing money. Audience ratings and financial success are not the only criteria for judgement. Journalism should answer to its readers and audiences first. They need to draw a path of critical awareness through the assertions of the self-interested to a professional assessment of quality itself. Given the weight of commercial hype surrounding so many arts events, particularly films, how many journalists any longer have the guts to stand up to it and say that something is no good?

In the end, we should have had enough of judgements based on the evasions of relativism, of the cowardice of special pleading, of the fear of being called elitist because we take up the cudgels of robust, disinterested criticism that explains why it is trying to separate the artistic sheep from the goats. It may mean that a new seriousness is called for, one that challenges the humbug of the defence of irony. It might have no effect. It might not make any difference to what is written and performed. It might on the other hand shake some of the sheer silliness out of what we see and are supposed to enjoy and might even make it more serious.

In a recent *crise de conscience* or perhaps *crise de confiance*, *The Guardian*'s film critic, Peter Bradshaw, examined his own conscience over the film of *The Da Vinci Code*. He – like many of his colleagues – had given it a stinker. Yet the film was breaking box office records. What should he and his film critic colleagues do? Accept that they are knowing snobs, but fatally out of touch with audiences? Should he lie down in the face of the juggernaut of commercialism? To his credit, Bradshaw concluded that without honest scrutiny and honest judgement, the film business itself

could not survive. And not just the film business. The critics are there as the conscience of the art in question. A conscience is there to be inconvenient, hard to ignore and uncomfortable to avoid. Abandoning the voice of the critical conscience, surrendering to the authority of audience numbers, box office takings, weight of publicity and commercial marketing would represent a vast intellectual betrayal. Bradshaw is right. The conscientious role of the art critic is to stand as the sentry of honesty, the definer of standards, however lonely or occasionally pointless the role may seem.

Usually, quoting that deep cultural pessimist TS Eliot is a bad idea. Sometimes, it is appropriate. 'This is the way the world ends; not with a bang but a whimper.' Today, I would change that. If the world ended, it would do so to the characteristic sound of contemporary enjoyment – the giggle, a hollow one. It would, of course, be ironic. Because nothing really matters, does it? It's only a bit of a laugh.

II

Wider prospects

10

Ten commandments, four anxious moments and six certainties for the arts

anyone contemplating the state of the arts in Britain today reaches for the words of Charles Dickens in *A Tale of Two Cities*. We live in 'the best of times, the worst of times'; sometimes, we should add today, in both at the same time.

In the last ten years, Britain's National Lottery has launched a spectacular array of major new arts buildings, or extensive, creative renovations of old ones. Their steady unveiling turned heads with a brilliance and rapidity that is easy to take for granted so soon after the event. In London alone, we saw the transformation of the old Bankside power station into Tate Modern by the Swiss architects, Herzog and De Meuron; the elegant extension of Tate Britain further along the river by John Miller; the spectacular glassing over of the British Museum's Great Court by Norman Foster and Spencer de Gray; the ingenious infill extension of the National Portrait Gallery by Dixon and Jones, architects too of the spectacular Royal Opera development and the reclamation of the classical courtyard of Somerset House from the clutches of the Inland Revenue, turning it into a winter skating rink, London's answer to the Rockefeller Plaza.

But this process of renewal involved a truly national transformation. The completed schemes continued outside London: Nicholas Grimshaw's spectacular plastic set of biomorphic greenhouse domes at the Eden Project in a disused clay pit in Cornwall; Michael Wilford's multi-purpose performance arts venue, the Lowry Centre in the north west, in Salford; just across the Manchester Ship Canal, Daniel Liebeskind's Imperial War Museum of the North in Manchester; the creation of an entire arts centre on the banks of the Tyne in Newcastle in the north east at the Sage Gateshead, side by side with the Baltic art gallery. And these major projects were only a fraction of the overall capital investment in the physical stock of the arts in the United Kingdom.

Alongside the national lottery, matching funding from private individuals, corporations and foundations played its vital role too. Britain's capital stock of arts institutions has not been better for a century since the last great flowering of municipally driven arts building. The new buildings are landmarks in themselves, symbols of the importance of the arts, and indicators of the way the arts can reshape people and places.

In addition, after the first two years of funding drought in the New Labour era, levels of direct government funding for the arts rose, increasing significantly in the financial year 2003–2004 to introduce a period of stability, optimism and achievement by the middle of the decade. In such circumstances, it might seem churlish to look for grounds for anxiety about the state of the arts in Britain at the start of the new millennium.

Sadly, there are real grounds for anxiety, and they reflect trends both in public and in private life, in vocabulary, terminology, attitude, assumption and outlook. Most of them carry worrying implications for the place of the arts in society. There is a glaring contradiction between the buildings in which we house the arts

and how we pay for what goes on inside them. There is no logic in supporting the capital cost of the building and then baulking at paying for the activities taking place inside. New buildings carry their own wrapped-around prestige with them; the time-consuming task of filling them with risk-taking art is less attractive but demanding, as it involves a degree of endurance, patience and commitment that few want to sign up to.

Yet this is only the starting point for necessary anxieties. As so often, it starts, like the Gospel according to St John, with words. What you say gives the clue to what you mean and, finally, how you act. It is no accident that museums, galleries, theatres and concert halls are rolled up by government ministers and civil servants into a single economic/industrial sector – 'the creative industries'.

At a single stroke, the one word, the single idea that might have given the arts a distinctive right to exist – 'creativity' – has been taken away, democratised (or popularised), generalised to the point of meaninglessness, and awarded to anyone who can string two words or two lines together. With the same stroke, the arts have been put into a box where they are no different from any other industrial activity, and should therefore be treated in the same way. Arts activity has become just another unit of the national Gross Domestic Product, to be measured, judged and valued just like any other industrial sector. 'Never mind the quality, feel the width, or count the units.'

Such inappropriate vocabulary goes much further. The arts are increasingly judged by whether they 'deliver product', not whether they offer programming. Theatres and galleries are examined to see if their programming policy contributes to the elimination of social exclusion. Orchestras' concert schedules are scrutinised to see how much music they play that racial minorities will recognise. Funding for innovation and commissioning of new

works are rare and limited. Museums are questioned about the extent to which ethnic minorities will recognise their own cultures on the walls. Making their reserve collections accessible is given higher priority than collecting the new. All arts institutions are rated, and possibly funded, by their commitment to access, outreach and their contribution to economic regeneration and urban renewal and redevelopment. The issue is one of balance but all the evidence is that governments have lost a sense of the difference between essential, core functions of the arts and the useful but additional ones.

All arts funding is now judged by the Treasury according to whether it delivers its predicted outcomes. The arts are not immune from such accounting and accountability. From patient survival rates in hospital operations, to literacy rates in schools, to punctuality rates on the railways, to attendance at museums, to seats sold in theatres, future public funding turns on the achievement of agreed performance indicators.

Raising such issues is not, of itself, wrong. It is part of our times; it can be used and turned to advantage. It entirely depends on how it is applied. When applied rigidly and oppressively, it reflects the fact that pseudo-managerialism has become an ideology, a working creed. Like all ideologies and universalist creeds, they have most appeal for the most zealous.

More importantly, such concerns about outcomes do have a place in the formulation and management of arts policy. The arts world can legitimately be criticised for having been dilatory in addressing them. But affording them a new primacy, enforcing them with a fresh urgency, shifting them closer to the very centre of arts policy-making, may not help us carry out our core activity – the creation of great art – more effectively.

In one sense, of course, such challenges could be seen as flattering, a belated governmental recognition that the arts are

not possessed by a privileged minority but are an integral part of life, with a potential to shape and improve society in special ways. Such an attitude would ascribe to the arts a power we may not have thought that they had; it acknowledges how great their influence can be; it recognises the arts are an under-utilised social asset whose full social and economic potential has yet to be released. On this view, imposing such economic and social demands on the arts gives them the opportunity to seize a place in the democratic sun – and in the national budget – in a way they never had before.

Yet the truth is more complex and less beguiling than that. These socio-economic demands are imposed on the arts not to expand their reach – a term from marketing – or to increase their inclusiveness – a term from social science – but rather to plant surreptitious doubts about what they do, by introducing considerations that are, strictly speaking, extraneous to the activity. The arts may be regarded as – and probably are – instruments for social improvement and agents for social change, social equality or community harmony. Yet each of these demands singly, and all of them collectively, present a list of challenges which are not intrinsic to the arts, are distant from their true nature, and all of which could be antithetical to their basic functions and purposes.

In short, such instrumental ways of challenging arts policies are often elaborate dodges for slithering around the question that governments try to avoid – can the value of the arts be quantified or not; should the arts be validated principally in their own terms; and are these repeated attempts to tie them down through policies and indicators likely to squeeze the life and purpose out of them rather than to nourish them?

Faced with such confusion, it seemed reasonable to reach boldly for certainty, to draw up a list of 'Ten Commandments

for the Arts' to see if some guiding principles might help to enlighten. This is what a present-day Jehovah of the arts might inscribe in tablets of stone.

The First Commandment: Thou shalt worship the arts for what they are, what they were and what you will make them be in the future. Thou shalt not betray the arts by pretending they are what they are not.

The Second Commandment: Thou shalt not seek false profits – these can only be made by selling the arts short, in the search for quick and easy money.

The Third Commandment: Neither shall you worship false prophets, in particular the kind who command you to feel guilty about what you do, because it does not get a mass audience.

The Fourth Commandment: Thou shalt not make graven images of Performance Indicators nor bow down before them – these are false gods that almost always point you in the wrong direction.

The Fifth Commandment: Honour the masters who laboured through the centuries to make the arts what they are today; thou shalt turn thy back on those who say the past is another country and besides, today is more fun.

The Sixth Commandment: Thou shalt not covet the riches, fame and glamour of the commercial world – you're just as good as they are; even if poorer. But trying to ape them will get you nowhere.

The Seventh Commandment: Thou shalt make the arts as accessible as you can, because you want everyone to enjoy them; but if becoming accessible means dumbing down, thou shalt forget it.

The Eighth Commandment: Thou shalt not rebrand thyself without just cause – it costs a lot of money, it doesn't fool the audience, and it is no substitute for decent programming.

The Ninth Commandment: Thou shalt not covet thy neighbour's glossy new capital project – it has taken years off his life to build and he probably doesn't have the money to run it properly.

And the Tenth and last Commandment: Thou shalt not take delight in thy neighbour's downfall. The friendship of critics is a fickle thing – saith the Lord – like unto the wind in the desert, which bloweth where it listeth; and surely, what goeth around, cometh around.

Rich as these fresh carved tablets are, even they do not answer all the deeper doubts and anxieties about the state of the arts. These must be faced up to.

The first anxiety concerns the role of education in creating new generations with real knowledge and understanding of the arts. There are four well-used truisms on this subject. First, it is very important that theatres, orchestras, galleries and museums should be active in schools and universities with active educational projects. Second, even with sharply increased funding for such arts-based education, it is impossible for multitudes of projects to be a substitute for solid, systematic formal teaching about the arts within the schools. Third, such formal instruction has been badly hit in recent years. But, lastly, the creation of a generation – or two – of the young, wholly or largely ignorant of the bases of the arts, does not matter because as they grow older, they will also grow into an appreciation of the arts.

I do not believe this. There is no reason why lifestyle-obsessed thirty-somethings should miraculously transform into forty-something devotees of the arts. There is just too much to learn, too much to discover, too much ground lost to permit such a change. It is a cosy but dangerous fantasy to take refuge in the hope that time heals all, time makes everyone mature, to give up childish things.

The second anxiety is related to the first. It takes the form of what I call the 'Great Caesura of 1968'. The proposition here is that the social, political and cultural events of the Sixties created a new world, a new sensibility where the present was more important than the past, where the instant was valued more highly than the considered, where the sheer immediacy of new creation was more satisfying than any connection with the achievements of the past; and where awareness of the potential of the future was valued more than the accumulated sense of past knowledge. It was a world, too, where the sheer availability of information became separated from understanding of that information, and a historical perspective – based on authority and hierarchy – was rejected as prescriptive and authoritarian.

Such attitudes, if I have characterised them fairly, spilled over into the arts in a particularly damaging way. Knowledge of the historical canon of achievement is becoming more and more distant. Recently, a presenter on the British easy listening classic radio channel Classic FM explained its policy towards choosing performers whose CDs should be played. They would, he offered, 'Always go for a living performer such as Renee Fleming or Thomas Hampson, rather than someone dead and gone and unknown'.

I have absolutely nothing against two of America's greatest living performers; but an approach that consigns Elisabeth Schwarzkopf, Lotte Lehmann, Birgit Nillson, Tito Gobbi, and scores of others to the 'dead and gone' category of oblivion should make us pause. At the very least, such a policy reveals a cavalier abandonment of the treasures of the past that is taking a huge risk with the intellectual inheritance. To adapt: 'What do they know of the future who only the present know?'

As a result of such attitudes, the past has come to be undervalued, even rejected, as a ball and chain on creativity

rather than as a necessary part of going forward. Contemporary creativity has been democratised so that knowledge of rules, skills and traditions is rejected as elitist, restricting, authoritarian and irrelevant. In taking this path, the 'now' generation casts itself off from a strong rope of connections and references, rejects any awareness of an order of experience as having any value or relevance.

A culture of immediate expression, instant understanding, has taken precedence over the painful, learned, accumulated disciplines of the arts of pre-1968.

If this is half as true as suggested – and what else can explain the mass disaffection of the young from the historic arts – then we may have witnessed a huge cultural shift, as vast in its own way, though in a wholly different direction, as the Renaissance. If this were to be true, then we would be drawing the curtain on half a millennium of cultural and intellectual understanding and inquiry. That sounds apocalyptic, but we shouldn't assume that the apocalypse may not be about to occur.

The third anxiety springs from the contrast between the attitude of the arts philanthropists of old and that of the public funders of today. A century ago, the great patrons of the arts certainly included in their reasons for founding great museums or concert halls the belief, the certainty, that these would benefit 'the people'. What's more, the people wanted to be benefited in this way. There was a hunger for culture, for improvement, and the obvious way to improve was to adopt the culture available to the educated classes.

This was neither demeaning nor ignoble. The libraries built up in poor mining villages in the impoverished South Wales coalfields were legendary, speaking of a moving desire to reach out for something that you could get for yourself – learning; it was yours too, your right, and no one could keep you away from a

book if you wanted one. Was Shakespeare not more truly owned by the majority seventy years ago than he is today, in all but lip service?

There was, too, the work of such pioneers as Lilian Baylis, whose passionate belief in the 1930s was that the London working classes deserved, wanted and needed theatre, opera and ballet. Few thought she was right. Her idealism was triumphantly vindicated, and the fruits of her works exist today in the English National Opera, the Royal Ballet, the Sadlers Wells Theatre and the Old Vic.

By contrast, I cannot imagine a single leader involved in public arts funding – or private for that matter – setting out as their first principle that provision of the arts is for the benefit of the people because the people deserve and need them. Rather, believing that others will want to share in the arts once they are available is dismissed as superior, patronising and condescending.

The current emphasis on 'access' and 'outreach' reveals not a belief that there is a need for the arts which must be met; but rather a belief that because demand for the arts is weak, they should transform themselves into forms that audiences will find attractive and acceptable. On this view, the public does not need the arts but the arts certainly need to persuade and involve an indifferent, sceptical and fully entertained public if they are to survive. These are very different attitudes from those of a century, even half a century, ago.

There is a further anxiety that hardly dares speak its name. If – at first glance – it seems to contradict some of the preceding argument, it is, I believe, reconcilable with it.

The anxiety is not that there is too little of the arts available; very possibly there is too much. Personal experience confirms that the range, quality and frequency of arts events of all kinds are vastly bigger and better than they were when I was in my teens. Then,

the long-playing record was just being invented. FM classical radio stations did not exist. Opera videos did not exist. Classical music and cultural networks were a shadow of their present form. The arts and culture pages of broadsheet newspapers did not exist. Cycles of Beethoven symphonies were a rarity. Mahler and Bruckner still sought their advocates. Contemporary drama about the modern world – from Harold Pinter to Samuel Beckett – was just starting to emerge, and seemed incomprehensible when it did.

Today, a buyer is baffled by the numbers of recordings of the Beethoven symphonies or sonatas; record companies unearth more and more obscure composers; galleries fight for exhibitions of the great names of modern art. Theatres scour the land for the voice of new playwrights.

As we survey it, the arts scene is rich but also littered with formulae that have outlived their day and their stay. If great art is to retain its freshness, its capacity to shock, then perhaps it has to be less familiar. Some of today's indifference may stem in part from an over-familiarity that has blunted the edge of surprise of too much great art and so reduced its attractiveness. Can it rediscover its shock quality by a period of retreat into contemplation, renewal, re-dedication? The monastic strategy, you might call it.

Such a strategy, if conceivable, would involve withdrawing to the traditional, cultural ramparts of what has been created and what is known. It would not attempt to convince those beyond conviction, involve those who are indifferent or hostile, or educate those who reject education. It would live within the exiguous means that a populist-oriented set of governments would throw their way. It would endure a massive reduction of activity rather than alter the essence of the experience, understanding and revelation that the western artistic canon offers and has

accumulated. It would be like a set of believers suffering persecution or indifference. The arts would lie low, remain true, and stay poor until society at large realised what it had rejected, what was lost and the riches that awaited rediscovery.

This is not an attractive strategy but it has attractive elements. Would it not be wonderful to rediscover Beethoven as the shock of the new? To hear *The Rite of Spring* as if with the ears of its first audience? Or see *Les Demoiselles d'Avignon* with fresh eyes? We are all too familiar with what we know – a period of abstinence might scrape its ears clean, remove the scales from our eyes, chase the cobwebs of familiarity from our minds.

To argue like this would be to admit that those of us who know about the arts know too much, those who don't, know nothing, and that the only way to bridge the gap is to give the game up to the know nothings – for a time.

This is certainly the view advanced by Morris Berman in his book *The Twilight of American Culture*. Of the many fine phrases Berman deploys, the following are a sample: 'The US lives in a collective adrenaline rush, a world of endless promotional/commercial bullshit that masks a deep systemic emptiness.' Yet why should you cure that systemic emptiness by abandoning those experiences that have proved of exceptional worth over centuries?

Or: 'The highest bastions of intellectual life have become infected with post-modernism, a philosophy of despair masquerading as radical intellectual chic.' And Berman, too, reaches for the model of the monks of the medieval world, sheltered in their monasteries, apart from the rest of society, but treasuring knowledge, transmitting civilised values, thinking, learning, talking until the world was ready to listen.

While this may have an ascetic, hermitic attraction to it, it is a counsel of despair; it radiates an impatience with those who

are convinced; it takes too much of a risk with the past and is, I believe, both too extreme and unnecessary.

In that case, what is the way out of the quandary, of a huge oversupply of arts to an apparently indifferent audience? We should, for a start, be more assertive towards our funders, stakeholders, interlocutors, about what we do and how they view us. We should be more robust in answering the questions put to us, more ready to face up to a challenging catechism of belief about the arts. This is what such a catechism of our arts would include:

Q: 'Do you Believe in Accountability, to the Customers, the Funding Bodies and to Stakeholders wherever and whomever they may be?'

A: 'I do sincerely believe in Accountability, but I believe in Responsibility first – the responsibility which includes a duty to the arts as well as to the people who subsidise them.'

Q: 'Do you believe that the Arts shall be for all the people all of the time and not a few of the people some of the time?'

A: 'I do not believe in subscribing to impossible ideals. I do passionately believe – and experience and history are on my side – that even if some arts or particular creations are enjoyed by only a few and understood by fewer still, they may still change the world.'

Q: 'Do you believe that the arts must be inclusive and that funding them can only be justified if they are?'

A: 'No. Very few activities in society are entirely inclusive. If inclusiveness were the chief criterion for funding, there would be few activities that deserved it. In any case, why pick on the arts?'

Q: 'Do you believe in marketing as the answer to all your funding problems?'

A: 'No, I don't. Elevating marketing to this level of importance is a snare and a delusion; it confuses form and image with substance and reality. In any case, I've seen too many organisations brought low by staffing their marketing departments to unrealistic levels and failing to meet their promised income targets.'

Q: 'Do you condemn elitism, elitists and all their works and attitudes?'

A: 'Only up to a point. If by elitism you mean a deliberate attitude of wrapping up the arts in arcane rules and terminology, so that people are put off by them, then I do. But if you mean the sustained pursuit of the excellent, the best, whether it is easy or difficult to understand, then you're on your own.'

Q: 'Do you believe in focus groups as a guide to arts programming? You should do, because the best politicians from Bush to Blair do.'

A: 'You mean, do I believe that where five or six are gathered together we should grant their request? No. We can't ask for what we do not know. On this basis, the

arts would never have advanced from the known or the familiar.'

Q: 'Do you believe in art for art's sake?'

A: 'Yes, I do. But my Culture Ministry only seems to believe in art as an instrument of social or economic policy.'

Will this get us out of the quandary in which the arts seem perpetually to exist? Of course not, but a robust attitude always helps.

Recently, I heard the legendary leader of the Juilliard Quartet, Robert Mann, give his personal summary of the importance of music and the arts. Music and the arts were necessary because they provided, in this order, 'Entertainment, Catharsis, and Good Citizenship'. I can sign up to that. But we need to go further.

Far from withdrawing from the challenge of the busy, modern world, think of the millions who have yet to enjoy the revelation of their first sound of Beethoven, their first sight of Picasso, their first look at Michelangelo, and who will be bowled over by the experience. Anyone committed to the arts should be invited to sign up to 'The Six Certainties':

We know that the most radical artists of today, including composers such as Alfred Schnittke and John Adams, find essential inspiration from the past for their creation of the new.

We know that the categories that make up the arts are becoming more blurred, but we also know that the vitality from these blurrings produces innovation, discovery and vitality.

We know that the new buildings now going up for the arts will be landmarks of inspiration equivalent to the medieval cathedrals of Europe.

We know that the collective experiences conjured in these places contribute to the way society feels; the ideas generated there shape the way we understand; the images created there colour the way we see.

We know that any society which cuts itself off from such a body of inspiration, does risk cutting itself off from the future.

And we know that at their best, the arts are a creative test bed where the best of the past is combined with the openness of the present to produce the transformation of the new.

Not everyone will be convinced. Not everyone needs to be convinced. If enough can be convinced, then we stand a good chance of finding ourselves living in the best of times after all.

East is east and west is west – and a good thing too!

Most debate about international relations, foreign policy or world affairs fears that without significant growth in understanding between the Islamic and the western/Christian world, without imaginative and sympathetic reaching out, the world community will end in disaster. It could be political; its symptoms could be sociological; its results could be military. The only way of avoiding such a confrontation is some new cultural rapprochement, of a kind not as yet defined or understood, but earnestly hoped for.

A similar debate takes place between international cultures. Should they keep their distance or should they – like the most modish kinds of international cuisine – reach for the sacred goal of fusion cooking, where once totally distinct tastes – Thai and French, say – consciously blur their differences and claim to find a new richness and diversity?

Fusion cooking has its exponents and advocates. So does fusion culture, the idea that a globalised world, and the new imperatives of multiculturalism demand that cultures and their arts blend and combine their individual and once separate characters. In

the process, claim the advocates of fusion culture and arts, they will discover new riches and new sources of innovation and creation. The tide of cultural fusion is so strong that it needs challenging. To pin Kipling's banner of cultural separation to the flagpole appears deliberately provocative. To challenge fusion, to celebrate difference, to suggest that a certain distance between cultures is both desirable and necessary risks appearing indifferent, callous or wilfully obtuse.

Yet the Kiplingesque proposition deserves to be looked at afresh; namely that, in the world of the arts at least, true creativity has an important local component to it; that regional and continental traditions deserve respect; that assumptions about the desirability or inevitability of creative cross-fertilisation should be examined with care and suspicion; and that a necessary distance between cultures could be both desirable and attractive, especially as an antidote to the commercially driven, globalised pap that is so often proffered in the name of multiculturalism.

To say this is not to advocate isolation, exclusion or ignorance of the artistic and creative world beyond our particular national or regional borders. But how is commercialised globalism to be effectively countered and resisted except on the basis of the maintenance and development of a strong local identity?

To argue in this way is not to pose as some sort of antique, cultural isolationist. After all, the last decade of programming at the Barbican demonstrates the internationalism and global reach of our credentials as a major international presenter.

This is possible because the Barbican houses all the performing art forms in one concert hall, two theatres, three art galleries and three cinemas in a single, unified complex. All the arts are under one roof; more importantly still, all the art forms are under a single, unified arts direction. While each art form – music, theatre, visual arts – has its own needs, its own priorities, they

do not plan and perform in isolation from their colleagues and peers, still less without sympathy for them. Being aware of the latest ideas and currents in other arts is a crucial way of keeping programmers alert, up to date, open minded, and aware. Being international is part of the shared awareness of the arts planners; being international is one of our brand characteristics.

And our location plays its part in this instinctive looking out. The complex stands in the middle of the City of London's financial district – the so-called Square Mile – and not in the West End, along the South Bank of the Thames or in London's Theatreland. International banks, dealers, investors, companies, surround us on every side. The City eats, breathes and sleeps the spirit of internationalism. That sets the Barbican apart still further, funded as it is by the City of London Corporation, and not by the government through the Arts Council of England.

So, from the way it is funded to where it stands and from the architecture it inhabits to its approach to the arts, the Barbican is different. Difference, distinctiveness, is poured into the fibre of the concrete that supports the building. Internationalism is part of that fibre.

The last few years of programming at the Barbican demonstrate internationalism at its richest. In the theatre, companies from every continent have displayed their magnificent variety. Deborah Colker's Dance Company from Brazil; African Dance companies from the South; the Maly Theatre from St Petersburg; the Schaubuhne from Berlin; Third World Bunfight from Africa; marionettes from Georgia; puppets from Canada; opera from China; dance theatre from Taiwan; Strindberg's Dream Plays directed by Robert Wilson; Merce Cunningham from New York; multimedia about the impact of call centres on the Indian subcontinent; and French classic eighteenth-century opera directed by a great French choreographer, Jose Montalvo.

Audiences have revelled in an all-male *Twelfth Night* in Russian and a free adaptation from Iceland of Buchner's *Woyzeck*, complete with swimming tanks and flying trapeze.

The Barbican has also mixed its art forms, presenting drama with video; drama with dance; drama where musicians become actors, where dancers dance with their electronic shadows; where ex-miners dance in gumboots; where a string quartet moves as it plays. There has been mime, satire, cabaret, tragedy and every imaginable combination of the performing art forms. We have learned a lot and so have our audiences.

The music programming is comparably outgoing and international. The Barbican has presented whole weekends of music from Mexico, Colombia, Ireland, Cuba, South Africa, and the Mediterranean rim; there have been festivals of Argentine Tango, music from the Gypsy World, sounds from the Urban Beats environment of Dakar, New York, Caracas and London; and jazz music in almost all its forms. It has celebrated the American Originals – such as Harry Partsch – witnessed the return and revival of the classic Irish folk band, Planxty, and revelled in the heady mix of revolution, rebellion and music that made up the Tropicalia movement in Brazil in the 1960s.

In the classical music arena, the Barbican has pushed the limits of the performance envelope with daring stretches across performance conventions. Contemporary dance set to Beethoven; a solo singer dancing and singing through Schubert's greatest song cycle; the director Peter Sellars dramatising Bach cantatas; orchestras playing with light shows, with film, with video.

From this record, my cultural base is at an international, outward-looking, curious, open-minded organisation. So in arguing for the value of keeping separate and distinct the forms of eastern and western creative expression, I cannot be charged with isolationism, indifference, superiority, or any kind

of cultural apartheid or separate development. It is possible to retain a sense of distinctness in one's own artistic identity while keeping the most open of minds to the way others do things. Separation need not close eyes, ears or minds; it may in fact help to keep them open.

Barbican audiences too seem to be equally open-minded about the work of other cultures. They do not want to exist only in a world where all that is available is the great Western European musical canon. From medieval Church plainchant – those haunting unaccompanied monks' choirs exploring their devotion to God in Gothic buildings – through the peaks of classicism under Mozart, Haydn and Beethoven; to the great nineteenth-century Romantics such as Brahms and Tchaikovsky, to the twentieth-century masters such as Stravinsky, the European classical music tradition is an extraordinary achievement which will remain at the heart of western, American and increasingly Japanese music-making. That place as a defining cultural experience is not under threat.

But recognition of the central nature of that experience for many Europeans does not mean that it is an exclusive one. It does not preclude curiosity about, or openness to, the arts and music of other cultures. Rather, I believe that cherishing the European tradition is often the natural starting point for understanding other traditions and cultures, not a reclusive cul-de-sac where they are excluded and ignored. If such is the experience of those of us from the European tradition, does it not follow that cherishing and developing Asian traditions is the necessary starting point for a journey of discovery and openness to other cultures in Asia itself?

This is what it comes down to. First, recognising and owning your own cultural and artistic traditions is an essential aspect of cultural identity. Secondly, equally and essentially, openness to

other cultures is a necessary part of modernity, a vital ingredient of innovation. But thirdly, setting out to fuse those cultures, being ashamed of and undervaluing their unique characteristics and elevating the task of fusion of cultures as some kind of priority goal run the risk of producing an unconvincing, and undigested mess of modish, cultural gestures. Even if achieved, they contribute little in themselves, apart from making some people feel morally good and culturally inclusive. Worse still, commercial globalisation of culture – as if economic globalisation were of itself a model to ape – which often follows hotfoot on the processes of fusion, can be a code word for domination and all too often suppresses or destroys local cultures.

Take the experience and very different approach of two contemporary composers – the Chinese American Tan Dun and the German Heiner Goebbels. Add to these the experience of the sculptor Anish Kapoor and the theatre director Simon McBurney. They provide revealing case studies of the different ways that an artist can react to and relate to different cultures.

The Chinese American composer, Tan Dun, is perhaps the most public case of a composer who seeks to blend his native Chinese tradition with the western school of classical composition – he is a prominent example of the 'cultural fusionist'. In a series of works – such as *Water Concerto* for percussion, *Marco Polo*, *Tea*, *A Mirror of the Soul* – and in the *Silk Road Project* with the cellist Yo Yo Ma, Tan Dun draws on, explores, fuses, blends and takes forward these two contrasting, perhaps contradictory, musical traditions.

The impulse is clear, the intention admirable, the execution highly accomplished. And yet, does it get us anywhere creatively? Does it solve problems of artistic expression, of artistic innovation? Does it set a new path or offer a new resolution to the long-lasting western dilemma of how to reconcile the harmonic/

melodic tradition of the eighteenth and nineteenth centuries with the innovations of the cerebral/intellectual approach of the twentieth? If harmony/melody in the post-Romantic world have run their course – and in the twenty-first century that is by no means clear – the evident failure of the intellectual, rationalist, serial school of music to gain public acceptance and support is glaringly obvious. Could West/East fusion provide a globally inspired answer to what has looked increasingly like a western creative dead end?

While it has its attractions and many admirers, my fear is that the stylistic homogenisation typified by Tan Dun merges forms and colours and omits any real blending of substance. Like fusion cooking, the odd exotic flavour from one cuisine dropped into another becomes just a bit of palate tickling. Worse still, such a melange is too like the interbreeding of a horse and a donkey – producing the stubborn sterility of a mule.

So my reluctant conclusion is that elegant stylistic crossing such as Tan Dun's is a sterile process leading nowhere but doing so in a highly professional and accomplished way. East and West merge but perhaps all it shows is that their distinctness and their differences are too great for the blend to create something greater than the sum of its parts. Each withholds a fundamental part of its essence in the process.

Some musical observers believe they can detect in Tan Dun's continuing work evidence of a growing inclination to mix the ingredients of fusion music. But whether it reflects a growing profundity in Tan's composition, or rather a growing dexterity at pleasing his listeners is regarded by many as a very open question. One of the great miraculous metamorphoses of cooking is when the egg yolk is stirred in with olive oil to create something totally new – mayonnaise. Sadly, such a transformation into a new form does not – to my ears – yet occur in Tan Dun's works.

A very different conclusion can be drawn from the strikingly different approach of the German composer, director and theatre creator Heiner Goebbels. Typically, he creates theatrical pieces for concert halls, concert pieces for theatres and operas which are not quite operas. They result in new musical-theatrical forms that break conventional ideas of what those historic art forms have been and ought to be.

Like Tan Dun, Heiner Goebbels draws deeply on all forms of sound and music-making from around the world. In one theatre piece in particular, the mixture is apparently challengingly complex. Called *Hashirigaki*, a Japanese word meaning 'running, writing fluently, outlining', the performers are a Canadian musician, a very tall Swedish dancer, an actress and a Japanese classical musician. The text is by the American surrealist Gertrude Stein, and the music ranges from the Beach Boys' greatest hits to Japanese classical music.

While the strength and originality of the piece is the extraordinary range of its references, Goebbels is not slipping a touch of Japonaiserie into the Beach Boys, or a dash of the surf into the Japanese classical. He is deeply opposed to the homogenisation of cultural difference, to any striving for an imposed, artificial and – as he would see it – ultimately false synthesis.

When Goebbels introduces artistic elements from many cultures into his pieces he says: 'I want to keep the elements transparent. I want to keep the different quotes or cultures or languages which come into a performance, I want to keep them transparent.' And then he defines his approach more subtly still: 'I don't want to paternalise or fraternise or cover them up; and I would rather keep them pretty much clear. And I might rather put something in opposition to them, but not in the way of making a melting pot.'

That explicit rejection of the comfortable idea of the 'melting pot' is crucial to such an approach. It involves using many cultures but respecting the integrity of all. Extraordinarily, *Hashirigaki* has a remarkably unified quality to it, a consistency of tone, a unity of purpose, despite the distinct cultural voices it contains and even, perhaps, because their distinctiveness is maintained.

Curiously, Goebbels himself cannot entirely explain why such apposition – placing side by side – has the mesmerising effect that it does:

> I think there must be a possible link at the moment where these two cultures, or where these two musics, touch each other. There must happen something – not necessarily in the music maybe, in the lighting or in the costumes in the staging – there must happen something which makes it usable.

If that is an impressionistic explanation of an artistic process, we should not be surprised.

The ingredients of Heiner Goebbels' approach are essential. Each cultural element keeps its own integrity and identity. None is merely blended into the other so that they surrender their identity. The originality of the work depends on the separateness of the elements, but that very separateness contributes to the distinct character of the whole. 'Usability' is the key. But distinctness is the result; and a genuine new creativity is discovered in the process.

The difference from the Tan Dun approach could not be greater. In Goebbels' work, East and West, and North and South, do meet but on the basis of strict equality – and functionality. They contribute to the result because they keep their nature.

Such a meeting allows for the possibility of learning about cultures, but relies on the prior awareness of the existence of

other cultures. Without such awareness, such readiness to recognise the qualities and properties of other cultures, works such as Goebbels' could not be created. Can they be replicated? No. Do they set an example? Only of a very limited kind. Does this matter? No, because they demonstrate that a readiness to respect other cultures can vitalise work in other cultures. If this sounds a modest lesson, it is a precious one nevertheless. Great lessons do not have to be bombastic ones. New ways forward often point the way quietly and diffidently.

Another artist contributes to the argument, one with a perfect viewpoint from which to observe these matters of inter-cultural influences. He is the British sculptor, Anish Kapoor, though since he is Indian by birth and from part Iraqi, part Jewish origins, the Britishness is cultural. Kapoor has struggled with the identity that others have placed upon him for years. In his early years, his works contained a lot of the intense pigments that you would readily see in any Hindu temple enclosure. In the process, he was labelled with the tag 'exotic', one he considers synonymous with being touristic, carrying with it the overtone of someone peripheral to a culture, incidental to it and probably ignorant of it too.

Of course, Anish Kapoor draws on his Indian, Iraqi and Jewish background. The question is how he does it. Kapoor rejects any idea of being some sort of cross-cultural bridge. But when I raised this issue with him, he defined his terms with great care. 'If what we're saying is that we're building a kind of bridge between one bank of cultural reality and another bank of a different cultural reality, then maybe there's some moment of crossing, there's some "Mister In Between" over there, which is powerful and new, different'. In fact Kapoor regards his very personal, distinctive but uncategorisable work as making him a 'Mister In Between' figure, a position that offers exciting possibilities.

Having defined his position in relation to his rich cultural background with some care, Kapoor is scathing about any approach that tries to blend cultures. 'If there's a culture over there that is rather *Madame Butterfly*-like – it comes back to the conversation about exotics – from which one can extract those bits that are attractive and have them reside in a resident culture, then it's cheap and trivial.' On this view, extracting the pretty bits of a culture is analogous to exploitative mining – it takes away but leaves nothing behind. The warning is well put.

A similar set of conclusions come from a very different starting point and from another British artist who relies on a very eclectic range of artistic references. Simon McBurney is one of Britain's most innovative theatrical practitioners. His most recent work, *The Elephant Vanishes* in 2005, was based on three short stories by the Japanese novelist, Murakami. Though McBurney spoke no Japanese, he worked with a Japanese company in Tokyo to create the production which then played with huge success in London. Its success derived from mixing the most advanced technical production techniques with an authentic Japanese sensibility.

McBurney insists that he learned from working with Japanese actors, who showed him different ways of seeing the world. In the West, he says, 'we come from a dualistic society, we divide everything into good and evil, and right and wrong, the mysterious and the prosaic. It's very binary.' By contrast, McBurney learned:

In Japanese society, everything is seen as part of the same whole. Therefore there is an understanding that meaning and emptiness can be part of the same thing. I found an incredible release in the idea that meaning and nothing, meaning and no meaning were all part of the same thing.

That lesson puts the case for respecting the integrity, the sheer difference of particular cultures, very convincingly. McBurney did not produce a bogus piece of Japonaiserie. Its richness flowed from the interplay of the very contemporary with the distinctive Japanese view of life.

This topic was well aired at the conference of the International Society of Performing Arts held in Singapore in June 2003, where the issue of Asian and western cultural identities featured large in the papers and discussions. How separate should they remain? How intertwined could they become?

Without addressing those themes directly, the Danish Ambassador to Singapore, Jorgen Moeller, offered a glancing reference which proves to be central to my argument. 'Global culture is enjoyable,' he declared, 'but local culture is far deeper.' If that is accurate, then we must think a good deal harder about how to preserve local culture and to judge its true value in the global context.

In defining the characteristics and processes of internationalism in the arts, Moeller noted five distinct aspects to the way internationalism works and how it is experienced. First, it carries with it a threat to diversity. The case for maintaining artistic diversity is identical to, and just as powerful as, the case for preserving bio-diversity. Fundamentally, no one knows what is lost as diversity of form and expression is reduced.

Next, culture and technology. Culture is shaped, developed, transformed, perhaps debased in many ways by innovations in technology. There is a tendency to regard the impact of technological innovation with a kind of deterministic fatalism: it happens, it occurs without thought for its effects on culture; but because it exists, and because of its appeal and power, we are invited to accept technological change without critical scrutiny of its possible consequences for the arts.

There should be, said Jorgen Moeller, a 'propitious connection between culture and technology'. And he invited those who search for creativity to recall Schumpeter's famous theory of 'Creative Destruction': innovation cannot be achieved without some destruction of old ways of thinking or doing. (I do not believe, in passing, that Schumpeter would have regarded the destructive domination by an outside culture as offering the opportunity for the kind of creative renewal he anticipated.)

There was very wide agreement that, in two key areas at least, western and Asian sensibilities are quite markedly distinct – all participants used the collective geographical descriptions with very large inverted commas around them. Most notably, the idea that western notions of time and space in the arts are very different from Asian notions and artistic practice was put forward by Professor Stanley Lai of the Taipei National University of the Arts. In a detailed analysis of his eight-hour theatre epic *A Dream Like a Dream*, Professor Lai noted that such a piece had its origins in Buddhist notions of the mandala, a graphic description of the spiritual path faced by a practitioner. In a mandala, all directions and pathways lead to the centre or, putting it another way, all things revolve around the centre.

Such a work, too, depends for its existence on a performance space like a Buddhist stupa; this is as profoundly different from a western proscenium arch theatre as you could get. The proscenium, argued Professor Lai, is a confrontational space, ideal for the confrontational forms of western theatre. The stupa is a philosophical and conceptual space, demanding a very different kind of drama. Visual perspective is shunned, because realism – so dominant in western theatre – is placed second to symbolism.

According to Professor Lai, the consequence is that western narrative has a very specific notion of time, one that is linear,

strictly defined and, as it were, precisely measured and placed into quantifiable units of existence. In the Buddhist tradition, insisted Professor Lai, 'time is much vaster in the Buddhist scheme of cause, condition and effect. To see how cause and effect really works, one must use a unit longer than a single lifetime.' Ritual, too, plays a defining role in such art. Ritual requires extended time – hours, certainly, days possibly – to reach its goal of transformation. Inevitably, drama that resides in a sense of such ritual will have a very particular sense of the space in which it is performed, the narrative process along which it moves, and the time within which it is understood and experienced.

If such awareness springs from a Buddhist aesthetic, an important element in that rough portmanteau term, the Asian aesthetic, Stanley Lai insisted that it springs from the inner awareness of any artist with claims to an Asian aesthetic. It is not about forms or decorations. But it is about a distinct, cultural position that is valuable because it is its own, founded on a unique grounding in religion, philosophy, architecture and practice. In making these assertions, Professor Lai strongly supported the proposition that such distinctive and distinct cultural characteristics are too important, too valuable to be swept in a tide of shallow well-meaning homogeneity. The Taipei experience supports the view that 'East is East, and a Good Thing too!'

Of course, there are objections to my thesis. In Britain, many would shout with a single cry, 'What about Peter Brook's version of the *Mahabharata*?' This was one of the seminal theatrical productions of the 1990s in Western Europe, an eight-hour version of the intricate, polydeistic Hindu epic, which had western audiences rapt in a wholly different kind of theatrical experience. Drawing on an international cast, and after years of theatrical research across several continents, Peter Brook created

a version of the epic that did not blur its distinctive ethos and character but realised it as fully as a western mind could. Stanley Lai reckons his own work and Peter Brook's share what he calls 'Asian concepts of space, time and storytelling'.

If that is the case, and it is a description that most critics would recognise, then the example of Brook's *Mahabharata* supports the argument that a partnership of mutual respect and acknowledgement of separate strengths is the most creative way to develop. For Brook could not have revealed to western theatre audiences the richness and differences of one part of the Asian experience had it not existed in its own right beforehand as a separate tradition.

The interplay between global and national music was powerfully addressed by the American composer, Steve Reich, during the Barbican celebrations for his seventieth birthday. Giving the 2006 Royal Philharmonic Society Lecture on that occasion, Reich compared the predictions he had made for music in 1970 with what had actually transpired. Then he forecast that western music would learn from African, Indonesian and Indian music. How wrong he was. When Reich listened to so-called 'world music', what he heard was African pop and rock, Indonesian pop and rock, or South African versions of the same. Their traditional music had been swamped by western pop and rock and in the case of Ghanaian music, had vanished entirely as an independent voice.

When I asked him how much these musical cultures had lost from this merger with the West, Reich said simply 'Everything!'

And at this stage, a related and essential question emerges. If East and West are to retain their separate identities in order to work as equal partners, how strong are they in their own terms? It is clear that Buddhist traditions deeply inform the work of Stanley Lai and others; Peter Brook's *Mahabharata* tapped into and fed at

the still intensely powerful streams of Hindu consciousness and mythology.

Some of the most powerful interpretations of Shakespeare – on stage and screen – have come from Japanese directors. Kurosawa's version of *King Lear* – his film *Ran* – or his version of *Macbeth* – *Throne of Blood* – have put these most English of artistic expressions through the transformative prism of Japanese psychology, aesthetic and stage traditions. They stood revealed as new, not because Kurosawa tried to conceal the intensity of the Japanese imprint on these English works, but because he did so without any attempt at concealment. To have made his films less Japanese would have rendered them artistically compromised and worthless.

On the British and American stages, Yukio Ninagawa has brought transformatory readings of Shakespeare to us – *Hamlet*, revealed in a passionate, romantic frenzy as few national directors would attempt; *A Midsummer's Night's Dream*, where the Athenian ducal family are portrayed as samurai warlords, and the rude mechanicals as contemporary noodle sellers from back-street contemporary Tokyo; and *Macbeth*, where the fit between medieval Scotland and warlord Japan is almost too easy but visually overwhelming. Ninagawa puts the Japanese imprint on these plays with absolute mastery and total success. These productions do not compromise the artistic traditions of the plays or the production styles in which they are realised. By accepting the authentic strengths of both cultures, the result is greater than the sum of their parts.

Yet, on two occasions that Ninagawa has directed Shakespeare in English – *King Lear* for the Royal Shakespeare Company and *Hamlet* for the Barbican – the magic of 'bi-culturalism' could not work. On both occasions, it was as if Ninagawa was seeking a blend of the English and Japanese traditions, but ended by

delivering only a weak compromise. His creative instincts emerged blurred and compromised, revealing nothing about either tradition, suggesting that both were warring in his mind, yet allowing neither tradition to make a decisive contribution.

But if cultures are to take the risk of standing side by side with others, how confident are they in their own worth and strength? In the case of the national music traditions referred to by Steve Reich, their innate strengths consist of their very difference. It is not music for a concert hall, but music for the great ceremonials of private and public life – weddings, birthdays, deaths and mourning. It is driven by feeling, limited only by time measured in days not hours. Its continued existence depends on a continued commitment to these rituals and the practices surrounding them. But a facile blending with the outside leads only to extinction or emasculation.

Unexpectedly, China emerges as a potential problem case as far as cultural strength is concerned. Speaking in Shanghai in October 2004, my colleague Graham Sheffield, the Artistic Director of the Barbican, worried at the weakness revealed by China in presenting its cultural traditions and artistic awareness abroad. What do we know of Chinese performing arts, he challenged his audience? Acrobats and Circus! Is that all there is within China itself?

To the extent that we do know anything else of the Chinese way, it is almost entirely filtered through the minds, eyes and ears of Chinese-American exiles such as Tan Dun, the filmmaker Zhang Yimou and the instrumentalist Yo Yo Ma. While there is interest in any work by such considerable artists, the absence of the authentic Chinese mainstream is glaring. If these were the only available gateways into the Chinese artistic mind, said Sheffield, then we should be grateful for what we had but we could hardly hope that it was the real thing.

In Sheffield's experience, the authenticity and appeal of the Japanese and Taiwanese companies that visit London successfully was what he called 'a clarity and singularity of artistic vision ... which respect their roots, hold to their originality and integrity, while finding a language in which to speak to an international audience'. Underlying his view is the insistence that what determines the validity of the output is the quality of the imagination of the artist concerned, as much as the culture from which it originates and in which it exists. But he is not describing, or arguing for, fusion or anything like it.

While I believe that Sheffield's analysis of the profound weakness of the current Chinese indigenous artistic tradition is acute and accurate, reaching out to an international audience as if it were a substitute for indigenous strength can turn to fool's gold if it weakens the authenticity of the original culture still further. A national culture is what it is in its own environment; once it adapts to the outsider's view of what that culture should be, it has been commodified and homogenised into bland acceptability. This is no basis for a robust engagement with other cultures.

This question asks itself of cultures beyond China. It is clear that the questions being raised about Islam in its political and social manifestations extend to arts and culture as well. How deep are the traditional roots in which any trend to modernism can develop? How strong is Islam's own sense of artistic culture which allows it to define a contemporary art that is Islamic rather than western dominated? Is Islamic culture sufficiently resilient to resist the tide of shallowly rooted, commercially driven, globalised so-called culture?

Ultimately, I do not see a nation, a culture, a continent retaining a worthwhile identity without keeping its own artistic traditions, definitions, aesthetics and sensibilities. Being modern should

not involve surrendering local cultural knowledge and experience to the most commercially dominant forms of entertainment. To innovate within national artistic traditions does not demand a forced merger with others, still less surrender. Awareness of other cultures? Of course. Engagement with them? Naturally. Surrender to them? Where is the benefit?

The crucial question is that of equality; the equal strength of cultures to stay as they wish, to redefine as they wish, to evolve as they wish, to engage as they wish, but all the time keeping their ability to choose the appropriate path by themselves. The world needs to keep the bio-diversity of thought, expression, forms, and culture as rich as possible. Culture, ideas, aesthetics, sensibility need to be kept alive in all their variety because the world can't flourish on a restricted range of thoughts, propositions, ideas and expressions. We never know which lessons from which culture may be the lesson we need to assist – if we cannot guarantee – human survival.

And besides, homogenised cultures driven by commercial imperatives are so deadly boring, so insufferably polite, so scared of difference, so terrified of offence that they cannot sustain the vigour, the creativity, the energy of the activities we associate with and expect from culture.

Making the arts possible

almost every conversation about the arts reverts to – or worse still – starts with talk of money. The habit of moaning about the lack of funding – however true – is so ingrained that it has long outlived any use as an analytical tool. If generous funding does make the arts possible – and everyone can point to cases where it does not – does lack of funding make the arts impossible? In reality, the money question may be only one – and perhaps not the most important – factor in the list of conditions that make the arts difficult and occasionally impossible.

On this basis, there are many factors other than lack of money, whose absence would fatally compromise the possibility of a lively arts scene. Lack of Vision; Lack of Will; Lack of Artists; Lack of Audiences; Lack of Intelligence; Lack of Courage; Lack of Education; Lack of Curiosity; Lack of Risk; Lack of Understanding – to which I add the important reminder qualification to myself, lack of understanding that the arts are different. By comparison, 'Lack of Money' suddenly looks less critical as the element whose absence makes the absolute difference between a world with art and a world without art. Looked at more broadly, if the qualities above are absent, the arts will be impossible because they probably won't exist. They would certainly be less searching,

imaginative, exploratory and creative – in a word, less good. Let's explore those qualities whose absence would damage or undermine the existence of the arts.

As I wrote 'Lack of Artists', the name of the doyen of American composers, Elliott Carter, suddenly flashed into my mind. When I first met him seven years ago, he recalled that he and others had founded an association of American composers in the 1930s because there were so few of them that they felt a threatened species. Today, he said, there are well over 20,000 active composers in the USA alone. The question is obvious. Is American music more healthy today because of the number of active composers? Must a critical mass of activity exist in order to produce the single genius? Do you need more than a critical mass, given that no one can say how many composers make up a critical mass?

After all, Carter himself was of the generation of Aaron Copland and Charles Ives. Ives, the ultimate loner, needed no one else to aid and abet him in the process of writing some of the most startling creations in twentieth-century music. Nor did Carter. Both are solo creators, standing apart, and courting little recognition, in order to develop what was finally seen as genius.

On the other hand, John Adams fled the music school at Harvard because of the stifling conservatism of the teaching. He could find refuge and reassurance on the West Coast, where a more open approach to composing existed and where he could find his freedom in a congenial atmosphere. That decision required an equivalent act of courage to the one demonstrated by Carter and Ives.

So while sheer numbers in themselves may not matter, and their existence is not a sufficient condition for creativity, a certain volume of activity in the arts may be necessary in order to allow varied and innovatory ways of creation to emerge and flourish.

On that basis, 'Lack of Artists' should be taken seriously as a living ingredient in making the arts possible.

But back to the starting point. There is nothing inevitable about the existence of the arts; society does not have to have them. There is no divinely ordained decree assigning the arts an assured place in the human order. That place, whether it is large or small, has to be willed, earned, won, deserved and constantly redefined. That is as it should be. For since neither the nature nor the quantum of arts activity can be taken for granted, nor should it be protected and reserved.

It could be argued that the natural state and level of artistic activity in a society is close to zero. I have no idea of the regard given to prehistoric humanity's cave artists by their social peers and family groups. Were they slackers, too weedy to hunt? Did they draw in caves to protect their work from young Neanderthal vandals? Were they the necessary visionaries, the licensed mystics? Or were they the admen of their day, creating the tribal brand images for the most desirable meats?

If we assume – and it is an assumption – that the cave drawings and their creators were to their fellow hunter-gatherers as artists are to the rest of society today, then the essential quality they possessed was vision, a different way of looking at the world. Perhaps, even the activity of looking, capturing and interpreting what was familiar was a startling breakthrough. In that respect, nothing has changed. Without a vision, there will be no art, and no arts either. And more than one kind of vision is needed; the vision of the artist for a start, and the very different vision of the enablers in society who can create, neglect or destroy the environment in which the arts are possible.

In the seven years to 2005, I conducted ten interviews a year with major international artists in almost all the creative disciplines. People such as Elliott Carter – whom I have already

mentioned – the architect IM Pei, the sculptor Anthony Caro, the composer Harrison Birtwistle, the photographer Eve Arnold, the painter Frank Auerbach, the sculptor Richard Serra, the film director Bernardo Bertolucci and so on. They had a lot in common. Almost all, for example, were over sixty; some were over seventy; a few were in their eighties and going strong.

They also carried a good deal of historical and political baggage with them. This was no accident. I was often teased that my ideal interlocutor was one born under fascism, who survived under communism, fled to America and then defied McCarthyism, and in that agonising process of surviving three forms of tyranny and oppression achieved a resolved wisdom in maturity. It is a statement about the past century that a remarkable number of great artists followed just such a career path and life trajectory and lived to tell the tale, expressed through and in the creative arts.

It is not a sentimental observation that those who had to fight for their art often produced great art as a result. This could be another version of 'impoverished artist in the garret' syndrome, the implication that only lack of recognition and poverty – often leading to a picturesque and terminal encounter with death – leads to great art. Just because this is occasionally true does not mean that it is always true or that it needs to be true. It is certainly not recommended as a path to follow. But the unintended consequences of having to do so may have been to find a truthfulness in art that was hard won through adversity.

Similarly, while artists suffer under dictatorships, great art emerges even under conditions of repression, and as a reaction to it. Think only of Alexander Solzhenitsyn in the Soviet Union, the Czech novelists of the communist period – such as Milan Kundera or Ivan Klima – or of film-makers such as the thoroughly comically subversive Czech Milos Forman; art does survive despite the worst efforts of the politicians.

Solzhenitsyn wrote because he was morally determined to resist the immorality of godless, and un-Russian, Marxism. In Czechoslovakia, Milos Forman, Milan Kundera and their peers used satirical codes to undermine rulers; they saw no reason why they should pretend that they were not ruled by idiots. When they used satire to make political criticism of the regime, the joke was doubly rich – the regime couldn't jail them for making jokes, though it did ban Forman from making films; but the regime also knew that the joke was on and against them. But although art does flourish under dictatorship and tyranny, the price paid by individual artists is a huge one. As a way of making the arts possible, this is not a model to be recommended.

What every one of the artists I spoke to possessed was a personal belief that they had to be an artist – composer, painter or sculptor. They had that belief in themselves especially when no one else shared it. They also had an intense instinct, a vision, of how they needed to express themselves. Take the example of Harrison Birtwistle, who studied at the Royal Northern College of Music in Manchester. His fellow students included Alexander Goehr and Peter Maxwell Davies, destined to become leading European composers.

Harry Birtwistle, by contrast, appeared to be just a clarinet player who kept quiet about his composition because it wasn't like the prevailing compositional orthodoxy. This was twelve-tone serialism, which his friends Sandy and Max were clearly so good at. It was only when Birtwistle heard the music of Olivier Messiaen, an original of originals – an Ivesian in approach though not a recluse in any way – that he got the courage to write as he knew he must, not as others wanted.

At this stage, something else is needed to make art possible. Another vision comes into play, that of the founders of music conservatoires, art colleges or drama schools. Artistic creators

do not spring out of the ground without training and discipline; both have to be passed on, explained or communicated. Their existence is taken for granted, except when their running costs seem excessive, and the very idea of the mega-institution comes under question as it frequently does. But does anyone believe that American music and performance levels would be what they are without the great music schools at the Juilliard, the Curtis or Bloomington, Indiana? Russian music without the Moscow Conservatoire and so on? English music without the Royal Academy, the Guidhall School or the Royal Northern Colleges?

Another caveat is needed here. Many painters and sculptors reacted strongly against the conventions of what they were taught. The art colleges sometimes acted as the grit which so annoyed the young oyster that they produced the pearl of huge beauty and value. Recently, the former Director of the Royal Shakespeare Company and the National Theatre, Sir Peter Hall, was teaching at a major American south-western drama faculty. He was asked how Oxford and Cambridge Universities had created such a wealth of acting and directing talent from himself to Derek Jacobi to Trevor Nunn to Ian McKellen, and so on. Who ran the drama faculties at those universities, he was asked? Peter Hall replied gleefully that no one ran them because those great British universities had no drama faculties at all. They had English departments and many theatrical performance spaces. You could argue that the very absence of a Faculty of Drama allowed talent to emerge.

While Hall's answer was partly tongue in cheek, and certainly sat happily with the self-mocking English delight in amateurism, it is less true than it sounds. Don't abandon support for drama faculties; for every Ian McKellen from Cambridge, there is a Ewan MacGregor from the Guildhall School in London and no doubt many more besides.

Any visitor to Singapore or Kuala Lumpur becomes very aware of the importance of the visionary in the field of the arts. Both cities have recently built concert halls. In Kuala Lumpur, the state petroleum company, Petronas, built the tallest tower blocks in the world. At a late stage in construction of the towers, the Petronas Chairman decided that while this was a grand concept, it was an essentially materialistic one. What was lacking was an idea, a vision. As an addition, he ordered the construction of an 850-seat concert hall at ground-floor level between the towers. For good measure, he decided that the Hall would have a resident symphony orchestra of international standard. Petronas would fund the whole lot. Without the idea of an enriching necessary vision, that contribution to the arts would not exist, they would certainly be more difficult and probably less possible.

In Singapore, the government built a magnificent arts complex – the Esplanade concert hall, theatre, studio theatre – which opened in October 2002. It is a great architectural landmark on the Singapore bay waterfront, with the most modern facilities. With the skyscrapers of banking commercialism filling the Singapore skyline, this architectural icon expressed a very different set of values, as it was intended to. It was a reminder that any society must take time to look beyond materialism, should engage with an artistic vision, and should 'lift up their eyes unto the hills' as the writer of the Psalms put it.

There is, of course, something quixotic – wrong-headed some have said – about building temples to classical western-style performance in countries where that tradition barely exists. The words 'white' and 'elephant' spring to mind. Yet, they do not express a stupid vision. To do this combines both visionary quality and sheer hard-headed calculation. The existence of these apparently anomalous institutions will not only change the culture of the countries where they exist, but will stimulate a wide

range of arts activity, not only of a western or western-inclined type. The very supply of the arts delivered by the existence of the Esplanade in Singapore stimulates a demand for them. The vision that underpinned their creation will reveal itself over the next generation. In this case supply creates demand; provision stimulates use. They make the arts possible.

Yet the creation of such institutions is a somewhat less dirigiste activity than it may sound. The notion of spending millions of pounds on them would not have been countenanced had a certain demand from the public, fed by supply from the artists, not been growing steadily over the years. For the professional, technocratic classes who staff and underpin the knowledge, information and commercial economies of Asia themselves demand a richer quality of life. Work on a trading floor, or days spent hot-desking at anonymous work stations with scores of other ships who pass in the night is no sort of life – there has to be something better.

At an Asian arts conference, I watched *Global Visions*, a fascinating theatre piece by a Singaporean choreographer. In it, five performers – three singers, two dancers – explored in words, movement and music the sense of journey through life that is at the core of Buddhist thinking. It was slow, meditative, reflective, often very beautiful and, undoubtedly, very Asian.

The theatre was well filled with young, thirty-something Singaporeans, who sat and watched with stillness and concentration. I do not know where that audience came from – it is a work I would hesitate to mount in London – but it suggested the existence of a bedrock of desire for the arts that needs satisfying even or indeed especially in areas where it has not immediately revealed itself.

To anticipate that need is not wrong, it is smart. Otherwise, the arts behave as if they lived only in a marketplace where their

activities were driven and their existence was justified by the opportunities of the marketplace.

It is smart to meet anticipated demand, because of the so called Bilbao effect, or the Sydney Opera House effect. They are slightly different. The grimy, somewhat derelict northern Spanish port of Bilbao has had its fortunes transformed by the building of the Guggenheim Museum by the architect, Frank Gehry. Hundreds of thousands of visitors visit Bilbao because of the art, and because it is housed in a building of startling originality. Whether it is a great piece of architecture or a remarkable sculpture is a side issue. It is also true that the Bilbao Guggenheim was only the concluding element in a huge programme of public investment in infrastructure of which the Gehry museum was the iconic climax.

The same might be said of Jorn Utzen's Sydney Opera House, a project over which the architect departed two decades ago in a cloud of controversy about vast cost overruns. They were real enough. But during the succeeding quarter of a century, the billowing sails of the Opera House on the banks of Sydney Harbour created an unforgettable global image which ultimately drew the Olympics to that country. The very idea of Sydney was captured in an arts building, and then went on to capture the global imagination.

Both Sydney and Bilbao demonstrate the economic power of investing in art. It brings a return on the investment, in ways that are often unexpected and hard to quantify. I have no idea whether the sums earned in tourism over a generation balance the original investment in the Sydney Opera House. But, as with many other supposedly commercial investments, at a certain moment you abandon the sunk costs and accept the current benefits. (Concorde, the Channel Tunnel, or the Jubilee Line underground extension, which has revitalised parts of South East London, spring to mind as British examples.)

The smart professionals who represent the lifeblood of enterprise and creativity need environments of this kind. The price of attracting and retaining their skills and innovation is an environment with artistic riches in it. Why do they want to work in London rather in Frankfurt? Because Frankfurt is artistically boring. Why do they prefer to work in the City of London rather than in Docklands and Canary Wharf? Because the City has the Barbican Centre on its doorstep. The arts fit into a commercially innovative environment because the two activities are far closer than might be supposed – open-minded, experimental, questing. They also represent our new audiences. These investments make art possible.

And these audiences, new or old, have a role and responsibility too in this process. The responsibility is to be more curious than they are. In some respects this has changed little in my lifetime. Adventurous promoters who put Beethoven, say, in the first half of the concert and Boulez, say, in the second, would find a good chunk of the audience had left for an early supper at the interval. Promoters then tried the 'sandwich' approach – Beethoven and Brahms on either side, Boulez in the middle. Hard to escape this, but it was never loved, just scorned for what it so obviously was.

At a recent Barbican concert, we experienced some revealing responses to a piece of adventurous programming. The second half of the concert was the Pergolesi *Stabat Mater* with Andreas Scholl, a star whose name alone would fill the hall. What to put in the first part? The performers, members of the Berliner Philharmoniker's chamber ensemble, suggested a work that was in their repertoire and was for the right combination of players. But it was by the great Russian mystic Sofia Gubaidulina, well known but not an obvious crowd puller; nor was it easy sounding, a setting of seven poems by TS Eliot. But it was a deeply serious, agonising and rewarding work.

At the interval, I canvassed various friends and acquaintances who had bought tickets to hear Andreas Scholl. All, without exception, recognised the Gubaidulina work as a fine piece of music which they had valued hearing. But sadly, none of them would have bought a ticket for Gubaidulina's music in its own right. Audiences have their role to play in making the arts possible.

This may be a problem peculiar to modern music. The visual arts are not so encumbered by the past. When Tate Modern filled the massive entrance hall – the former Turbine Hall – with a hundred-foot twisted tube, its mouth not unlike an old gramophone horn, the whole thing made out of steel and PVC, the latest work of the sculptor Anish Kapoor, more than two million people saw it in three months. When the British art collector, Charles Saatchi, opened his new gallery in the former home of the government of London, it was filled with works such as Damien Hirst's sliced and pickled shark, and Tracey Emin's heavily fornicated in, unmade bed. These once 'shock-horror' artworks were visited as if they were landmarks as famous as Turner's *Fighting Temeraire* or Constable's *Salisbury Cathedral*. In a sense they are. The visual art audience, at least, has embraced modernism and much the better we are for it. It has literally made adventurous modern visual art possible. A similar openness is needed in other creative disciplines, including architecture, to make them alive and innovative.

A better balance is needed, too, between tradition and innovation. Every serious composer or painter I know cheerfully and proudly acknowledges the existence of one foot in the past of tradition, an awareness of the previous greatness of predecessors, an understanding of earlier steps forward. Some audiences though behave as though the works of the last thirty years are all that matter and are the only works of value, and

that what happened before has nothing to say to the present, no lesson to pass on. There are many ways of treating the past, but knowledge and respect are good starting points. Indifference and ignorance are not.

Recently, a British poll of 'Best Films Ever' turned out to be in effect a judgement of 'Best Films Recently or Regularly Shown on TV'. Predictably, there were no films chosen from before 1960, with the possible exception of Orson Welles' *Citizen Kane*, because it is obligatory to include it. Otherwise the list was heavily concentrated on box office hits. Do such responses matter? I believe they do. Those who never see what was deemed excellent in the past can never truly judge what is excellent today. How can you reject the understandings, the insights of the past as if they are familiar, when they have never been witnessed? Nations are frequently warned about the dangers of walking away from a knowledge of their past and of their history in politics. But similar dangers lie when a cultural tradition is wilfully abandoned as if it is without value or relevance to the present.

There is a tension and a possible contradiction here. In some areas of arts activity, the present is the only time that matters; in others, the present is a time to be feared. The past must be knitted into the continuum of understanding which real creativity needs.

But for the arts to be possible, they must be understood for what they truly are. The arts are different. Different from what? Different from the mass, commercialised arts. Why should they be different? The answer is surely simple: if the arts are to be more than the playthings and diversions of the rich, then they must justify themselves by their difference. The creation of things that no one else creates is a prime justification for the existence of the arts. They produce acts of special or unique imagination. Universal subsidy, however niggardly, cannot be justified otherwise.

But how different and in what ways? The arts must, at their best, provide ways of seeing – like Picasso – ways of hearing – like Stravinsky – ways of reading – like James Joyce – ways of watching drama – like Samuel Beckett – ways of building buildings – like Mies van de Rohe, that transform the way we do those things. No one could have conceived the proposition made by these revolutionaries through the normal processes of commercial design, or formulaic evolution of images for the purposes of style or fashion.

The obvious cases I have listed – and many more can be listed – have made the world a different place and a better place. Better, because our view of the world would have otherwise stagnated in an introverted pool of old thoughts, repetitive tricks and stale formulae. Lively societies depend on a large gene pool of ideas. Artistic innovation is like bio-diversity; who can predict when a crazy little organism in the heart of a rainforest will turn out to be the source of a miracle cure. Who knows in advance when a crazy young artist is going to reshape the way we think, look or talk?

The negative case for the importance of making the arts possible is that the risks associated with damping down the flow of good ideas are too great to take. The tap of human imagining shouldn't be casually or flippantly turned off. It belongs to everyone. It may end up being the only clean water around.

At this point, another risk emerges in the process of making art possible; that we lack the courage to defend the arts against charges of elitism, and therefore of exclusiveness and irrelevance. It is the easiest accusation to level, and it feels the hardest to defend but it shouldn't be. It feels hard because, certainly in British society, elitism carries with it explicit overtones of social and class superiority. Class is, sorry to say, still alive and usable as a weapon of polemic both in its overt and in its inverted forms.

Many attacks on the arts use the accusation of social exclusion

through social superiority as an explanation – a justification even – for those who do not attend a concert or see a play. It has even been said that you cannot expect people to buy tickets to see Shakespeare or listen to Beethoven when the very act of buying tickets is deemed to be a middle-class activity for which some special social courage and skill is needed. The very same people do not find buying a (generally more expensive) ticket for Premier League football constitutes a barrier of exclusion.

The charge of deliberately fostering social exclusion is, of course, tendentious nonsense but those working in the arts too often allow the charge to be made because we secretly feel there might be a case to answer. In fact, there is no more a case to answer over this than there is over the way people dress at arts events. With the exception of summer country opera in England, I know of no arts events where a dressed-up code is either asked for, expected, imposed or delivered. Yet the class-based charges are not rebutted strongly or often enough. If the arts are to be made possible they must be defended.

But we need to keep a clear eye on why the arts are different if we are to enable their existence. The arts are different because they are not about mass audiences – though there is nothing wrong with them; they are not primarily about entertainment – though they are often enjoyable; and they should not be confused with mass entertainment or judged by the criteria of mass entertainment.

To say this is not to evade the responsibility of the arts world to be efficient with money, whether public or private. It is to say that the risks associated with the arts, especially the truly innovative, are so great that if they had to pay their way, they would never be mounted.

If the arts are to be made possible, then the need to judge the arts by their right to fail, by the near inevitability of early failure,

by their need to be measured by relevant criteria is absolute. To say that the arts are unpopular is a debating trick that we have to face up to. Having only a few people in the audience may be a sign of failure in the commercial world; in the arts world it can be a sign of originality and hope for the future. We need to have a different vocabulary for the arithmetic of numbers, without kidding ourselves that poor attendances are always a badge of high art.

After all, the existence of the arts represents no threat to the world of commercial entertainment. The one often feeds on the other. The relationship is less competitive than symbiotic. The commercial arts world uses the actors and singers nurtured by the arts world. Where would commercial art be without The Scream by Edvard Munch or the Mona Lisa? Where would TV ads be without Beethoven's Fifth, or Verdi's La Donna e Mobile, or Strauss's Also sprach Zarathustra? The commercial adoption of great moments from artistic creation points to a live and let live policy between them. And they don't pay royalties back to the arts!

If the arts are to be made possible, they must be defended for what they are – often difficult, often rude, often uncomfortable, sometimes silly, occasionally shallow, frequently exhibitionistic, but almost always pointing us somewhere we had not thought to go. It's worth speaking up for that.

There is a final plea to make; that everyone should be less self-conscious about the arts. So much time is spent theorising about them, scrutinising them, revamping them for artistic effectiveness and financial accountability, judging them against objectives and performance indicators, benchmarking them, marketing them, observing best practice. In the meantime, they offer outreach to those who cannot afford them, access to those who cannot reach them, education to those who have no background in them and accountability to those who know nothing about them

and care less. The very processes of accountability themselves demand critical scrutiny as rigorous as that applied to the arts themselves.

For more and more is demanded of the arts, even as they get funded less and less. The government wants the arts to make a divided society whole; the Treasury wants the arts to make society richer; the Department of the Environment wants the arts to revive collapsed neighbourhoods; the Department for Education want the arts to fill the gaps in their own students' knowledge; social workers want the arts to set audiences a good example. Such demands are in truth paying an extraordinary – if back-handed – compliment to the arts. They recognise that the arts do not exist in a vacuum; rather they have the potential to have an impact on and to enrich most areas of life. The underlying fallacy is the belief that the arts can be social and economic instruments without first being true to their own values.

No one is willing to let the arts get on with doing what they try to be best at – to revive our stock of the so far unimagined. That's worth paying for; that's worth supporting; that's worth defending. That's why we should make the arts possible.

The arts are good for your health, but they won't make you a better person

Some things are easy to assert. Smoking kills. Well, not immediately, and not everyone, but often enough and nastily enough for the statement to carry weight. Drinking kills too, though probably more slowly and slightly more selectively. The real objection to excessive drinking (unlike smoking) is that it is disgusting to watch and sometimes very difficult to avoid. Exercise is good for your health, though those who indulge in it obsessively are often stupendously boring about it. But boring others is the worst to be said about the compulsively health conscious.

By contrast, there is no equivalent charge to be made about the arts and those who indulge in them. Does the pastime of watching, listening to and thinking about the arts make those who do so better as people? Given that the arts per se are held to represent the best that has been thought or imagined, surely exposure to such spiritual expression ought to rub off morally. Would it were that simple. Yet if the moral benefits of tuning in to the arts are highly speculative, the evidence that the arts are therapeutic seems to grow in strength.

Recently, I visited my former local hospital, the Royal Free in North London. Clinically, you understand, I have no criticism of it whatsoever. But one of the most depressing experiences on entering it – apart from the hideous ugliness of the building itself – is the annual, or as it sometimes seems, continuous exhibition, of paintings by patients and medical staff. It is awful. No worse than most other exhibitions of amateur art around the country, no doubt. But as a prelude to a great hospital, as an expression of its spirit, as an expression of aspiration, as an offer of consolation, as a contribution to heart lifting, it could not be more mediocre or depressing.

It might well be that the very act of painting, the attempt at self-expression, however inadequate judged by the highest standards, is good for whoever did it – patient or doctor or nurse. No doubt it is. It should certainly not be undervalued as an act of personal therapy just because the end result doesn't merit a second look from an outsider.

In 1996, following a letter in the *British Medical Journal*, more than 300 people – lay and medical – responded with their views of the beneficial effects on health of poetry. Three-quarters of the patients said that reading poetry reduced stress; two-thirds said that writing poetry reduced their stress levels as well as relieving strong feelings.

While it is hard to imagine a stressed GP saying to a differently stressed patient, 'Now, go away and try to write a poem a day and you'll soon feel better,' it could be the right prescription for the right patient. At all events, the responses to the survey are tantalising and suggest a good opportunity for further exploration.

But self-expression through art is one thing; it may indeed be relevant for private cure. There is a far larger question about what kind of art is relevant in healthcare at large. Is there a place for

art to make the big public statements that can improve medical results in hospitals and other health institutions? One instant reaction could be that any such public expression of art should reflect the community, the staff and the patients and that, as a result, it should be largely or wholly chosen by them.

This is a fallacy or just plain wrong. For a start, most people are extraordinarily conservative about the visual arts. Holiday posters are often regarded as a terrific way of brightening up a waiting area in a clinic. Most official institutions are no better. The best that British Embassy visa offices can muster for their walls are, yes, those very same tourist posters of London policemen or double-decker buses passing Big Ben. Anything remotely advanced – i.e. twentieth-century – is dismissed as daubs. When asked why staff at 10 Downing Street were so conservative about the artwork on their office walls, the official reply was that this was an entirely reasonable attitude 'since they had to work there'.

In other areas of officialdom, the first response of the politician, the administrator or just the medical group is to take refuge in the entirely safe concept of getting art from the community. When the British Government Art Collection's experts were planning an ambitious programme of integrating high-quality and innovative art by contemporary artists into the new Terry Farrell Home Office building, the response of the then Permanent Secretary was that he didn't see why so much money had to be spent on art; why couldn't local schoolchildren be used to fill the spaces on the walls? These attitudes were prevalent even before the entire Home Office was condemned by its latest Home Secretary, John Reid, as being 'not fit for purpose'.

What lie behind such attitudes in officialdom are multiple layers of fears: fear of living art as such; fear of accusations of exclusiveness and elitism; fear of the unknown, leading to the bureaucrat's nightmare – fear of losing control. Yet the evidence

from Chelsea and Westminster Hospital and others around the world is that, for the use of art to be effective in a therapeutic environment, it must be in the hands of experts. In this respect, art in the health environment is just like any other medication. The doctor does not ask the patient what drug they might like. The patient expects the doctor to know which drug is most likely to make them better.

So too with the use of art in hospitals – it works best when left to the expert. And the expert is quite astute enough not to put up art which is aggressive, rebarbative or just plain frightening. (You don't have to be a very bright curator not to put up a lurid painting of skeletons. Though, in the Middle Ages, art in hospitals was as much a question of preparing yourself for the Last Judgement as anything else.) What is reassuring is that, when left in the hands of experts, those who understand that the interconnection between art and its impact on health is a subtle one, the resulting art becomes accepted and valued precisely by those who might have rejected it had they been responsible for choosing it.

Beyond this, there is much anecdotal evidence that exposure to music lowers blood pressure, slows down the heartbeat and calms respiration. The precise effect depends on the music – my favourite piece of research shows that babies in the womb respond to the music played to their mothers. Bach is experienced by mother and foetus as very soothing. But the foetus gets a real kick – or the mother does – from hearing *Carmen*.

Four years ago, a research programme began into quantifying the impact of the arts on health. Its starting point was the report that eighty per cent of hospital patients found visual and performing art – usually some kind of theatre – diminished stress, improved moods and distracted from worries. Would not eighty per cent of any concert audience report similar feelings?

Another piece of hospital research studied whether performed

music improved the recovery of patients after hip surgery. One group received the customary, purely medical treatment. The other had paintings on the walls of their wards and enjoyed – if that is the word – a regular half hour of accordion music. Leaving aside the fact that even the lame might throw away their crutches to avoid thirty minutes of accordion music, the challenge is fascinating. While I haven't seen the results of the accordion study, other research shows that a third of cancer patients undergoing chemotherapy reported being less depressed when exposed to visual and performing arts; thirty-two per cent reported reduced anxiety levels under the influence of music; and eighteen per cent reported feeling calmer in response to visual arts. Even if these are only placebo effects, they suggest some transaction is under way even if it is only auto-suggestion. And bringing comfort surely has its own value.

Some years ago, the British Medical Journal carried a challenging editorial headed 'Spend (Slightly) Less on Health and More on the Arts'. In it, the editor argued that the biggest savings in health spending could come from thinking differently about how care is provided. He suggested that medicalising long-term chronic conditions was not necessarily the best way of relieving them. If coming to terms with these conditions involves understanding them then, said the editor, quoting George Bernard Shaw, 'the only possible teacher except torture is fine art.' If art can help us to learn about healthy being, if it can help us to understand the experience of suffering the incurable, then perhaps it does have a serious call on the health budget after all.

For years, when I was Managing Director of the BBC World Service, listeners in Britain told me how much they valued its availability on domestic medium-wave frequencies overnight. Not only did they enjoy the programmes, but the process of listening also put them to sleep if they were suffering from insomnia. I

often told government ministers that part of the funding for the BBC World Service should come from the National Health Service budget, since it must reduce the drugs bill by saving on sleeping pills.

The social benefits of the arts are increasingly well documented. Unmanned railway stations which relay classical music to their platforms record less vandalism as a result. There is no explanation for why vandals are congenitally averse to classical music sounds.

Studies of church congregations – or faith groups – find that the wellbeing generated by the regular sense of belonging to a group, no doubt combined with involvement in hearty singing, produces significantly higher levels of happiness among their group members.

A recent study announced at the British Association of Science's annual gathering revealed that orchestral musicians retain more grey matter than non-players. While non-musicians over the age of fifty tended to lose their grey matter, orchestral musicians kept theirs. And the benefits accrued well before retirement. As for younger colleagues – those below the age of fifty – playing music actually increased their stock of these brain cells. In retirement, they had more of them to keep.

Of course, this may simply be a 'use it or lose it' observation. We don't know if, for example, poker or bridge players keep more of their brain cells through life because their brains stay active. It may be that research into wellbeing has concentrated on the role of the arts. But the beneficial impact of the arts does not have to be unique to be real. And circumstantial and anecdotal evidence suggests that it is real. At all events it is hardly likely to cause harm.

I have always wondered why Indonesian gamelan orchestras are regarded as essential ingredients in the educational

programme of any serious arts institution. One explanation appeared from research into the growing use of these orchestras in penal institutions. Involving, as they do, close rhythmic and harmonic interplay between twenty to thirty players, the overwhelming conclusion was that they were highly beneficial as therapy, instilling a sense of belonging, partnership and cooperation into people who often found such behaviour difficult or impossible. One inmate volunteered the observation that if every jail had a gamelan orchestra, they could close their psychiatric units – a shade ambitious, but a reminder of the beneficial effect of doing something where self-esteem is enhanced rather than challenged.

The importance of self-esteem, of an appreciation of proper self-worth, is an ingredient in wellbeing and ultimately in health. When the great American jazz trumpeter Wynton Marsalis had a residency at the Barbican, one of his commitments was to workshops with children from the thirteen neighbouring 'Adopt the Barbican' schools. A group of children with no special musical aptitude but an interest in music worked on a free jazz composition under various local teachers. Marsalis then took over and polished the piece for a public performance in the Barbican foyers.

As the young people – mainly in their mid teens – took the applause of audience and parents, a teacher said to me, 'You have no idea how important this is. Most of these children have never been applauded or recognised for anything they have done. The boost to their self-confidence is incredible.' It was also incredibly moving. The benefit to a sense of wellbeing was both strongly felt and undoubtedly real.

In other areas of health, the distinction between what is felt and what represents a real effect on the body is harder to pin down. This immediately raises the question of whether a felt

effect – by definition a subjective observation – is less real than a supposedly observed and measured effect. Just because it cannot be measured, does that make it less real?

Many years ago, I took part in a blind test at the Royal Free Hospital on the effect of painkillers after an operation. Not knowing whether I was on the tested medication or not, I was then asked whether I felt more or less pain than I might have felt. Then, and now, I thought this was an odd test. How could I know what pain I might have been feeling if I were not on the – presumably enhanced – anti-pain medication? The contradiction between actual pain, pain relief and a blind guess as to what the kind of pain might have been was complex and elusive. But it did highlight the gap between the experienced and the assumed.

Twenty years ago, research reported that patients with a good view from their hospital rooms recovered faster and using fewer painkillers than patients whose ward looked out over a brick wall. There is something very Old Testament in spirit about this research, since – so far as I can recall – its pages are littered with cases of 'X turned his face to the wall and was gathered into the bosom of Abraham!' But this image of the face turning to the wall is an abiding one.

For architecture is a key area where quality and health go together. We all know about Sick Building Syndrome, though the sick buildings that have always interested me are those where the facilities are adequate but the layout and configuration militate against decent behaviour.

One such case was the old BBC Lime Grove Studios in Shepherds Bush, home of ground-breaking programmes in the 1960s and 1970s such as *Tonight*, *Panorama* and, from the 1980s, *Newsnight*. It was an intensely creative but highly competitive and disputatious place. The word was that feelings ran so high, that people were 'stabbing each other in the chest'. My own view was

that since the building consisted of a warren of joined-up terraced houses, the endless staircases offered a series of evasive rat runs which led to one inevitable result – the inhabitants behaved like rats. Bad architecture led to bad behaviour, but also – here's the problem – did not obstruct the impulse to creativity.

Everything said so far about the benefit of art on health has been a way of evading the far harder question – 'does art make you a better person?' It can make you feel better, or at least not feel worse. But are we better people, morally, spiritually, ethically, as a result?

Gut instinct impels a belief that looking at great pictures, immersion in great music and concentration on the great thoughts of searching literature must have a beneficial moral effect. What is the point of engaging with 'the best that has been thought and imagined' if it has no effect, if it does not make us better, if it does not contribute to a greater, more generous understanding?

Absence of such an effect would argue that we do not learn from the experience and understanding of others; that we do not examine our own thoughts, actions and motives self-critically in the light of the best that has been thought and written. Does seeing *Hamlet* or *King Lear* not cause you to think more closely about aspects of personal behaviour? Does hearing *Fidelio* not force you to think about loyalty and devotion, and *The Marriage of Figaro* about betrayal and forgiveness? The list is endless.

Are such works morally neutral or, worse, morally indifferent? Does their subject matter, their treatment, their moral sense, not matter to their creators or their audiences?

There are two possible answers. The first is that if we use these works only as part of a self-conscious campaign of moral self-improvement, then going to see them is merely a substitute for going to church. Why should entertainment be put in thrall to

morality? Is it worse as entertainment if it politely stands aside and avoids walking through the door opened by the moral police? The second answer is that these works are not created for the purposes of moral improvement. They are created because – for the most part – their creators are driven to make them. Art is a very personal business or activity. Audiences may take from them such moral messages as they will, but a work will not be judged by whether its moral message – if one exists in the mind of its creator – is learned or not.

In talking to leading creative artists in recent years, many of whose works would be judged by audiences to have a significant moral or ethical content, I was struck by the total absence of preaching or high-minded pontification in their approach. They were serious, of course; they were engaged with issues and questions of character and behaviour. But even when they explored that behaviour, they did so in ways that detached their own views absent from the actual materials of artistic expression.

Yet shouldn't the art created from motives and impulses of high seriousness impress itself on those who use it regardless of the intentions of its creators? Making people better may be an unintended secondary consequence of the act of creation but it could be a consequence nevertheless. At the trivial level, those who attend concerts are not mugging someone in the street; though they could do so after the last encore. But if the effects of art were merely as a displacement activity – they restrict the time available for crime – then it would rank low on the morality scale. On this analysis, concert-goers were not indulging in crime merely because they lacked the time to do so, not because they had been morally improved by concert-going. It would be nice to think that they did not indulge in crime because awareness of art reinforced their feelings that crime is wrong. But that can only be a hopeful presumption.

How might you test such a challenging proposition that art makes us better morally? Take the audience at the Wigmore Hall. Nowhere is more high-minded in its programming, no audience more serious in its approach to the arts of song and chamber music. Few groups of people could be more systematically exposed to the refining thoughts of the world's greatest poetry, the most rarefied music.

The next stage in the test is very tricky. Ask yourself this question. Among that group of 550 people listening in the Hall, are there significantly fewer adulterers or wife-beaters, than in another cohort from non-arts-going members of society? Put it another way – does the audience that constitutes the Wigmore cohort love its neighbours better, visit the sick more, comfort the oppressed more devotedly and so on? (You could, of course, ask exactly the same question about the audience at any major arts institution throughout the world! I am a fully paid-up member of the Wigmore audience too.)

The answer can only be guessed at; and only a brave person would dare to undertake the research. If the answer proved to be that there were, indeed, fewer adulterers and wife-beaters, more people generous of their time and affection, then would it prove that they were indeed better morally because of their exposure to art? It's far more likely that the groups of people who are not criminally inclined are also those who are inclined to the arts. There is no cause and effect.

At this stage, the evidence of recent history must be faced, and it threatens to undermine the whole proposition about the moral impact of the arts. This is the evidence of the Nazis. Hitler loved Wagner. Martin Bormann loved Schubert. The Auschwitz camp commandant spared the young Jewish pianist because she could play Schubert and Beethoven at his dinner parties. Far from making them moral, better people, it had no effect whatsoever.

They could see no contradiction between opening themselves to great music and committing the foulest atrocities. Worse still, did their encounters with great art give them a sense of validity, a belief that if they had the sensitivity to be moved by Schubert, then everything else they did had a moral justification to it? How could someone who loved Schubert be a bad person? On this basis, you might consider banning art because it is used as a justification by the morally degraded. In fact, the Nazis and the Communists had a particularly strong sense of what constituted morally degraded art and had no hesitation about destroying it.

If the Nazis thought they could categorise art into the moral or the degenerate, then that approach should be avoided. We need a different escape route from it pretty fast, and from those who move from denying art's moral impact to asserting that without it, art has no special value whatsoever.

The escape route is to assert that art is not created in order to be useful. We know that it does make people feel better, increases concentration and develops self-esteem. We know that it revives run-down areas, that it is an effective instrument of economic regeneration. We know that it creates employment and attracts tourism. But even if it did none of these things, it would not only be desirable, it would still be essential; essential for curiosity, for discovery, for understanding, for reaching out, for surprise, for taking us out of ourselves. These are useful attributes; they carry no moral overlay. They may, though, be attributes, essential to and for the arts.

If we do feel better as a result, if we do become occasionally better as people, and if we choose to ascribe that improvement to the effect of art – so be it. But it is our choice to make that connection, a connection that may well be motivated by pure vanity. It is not a connection made in the intrinsic nature of art. But is art diminished by proving that it has no moral impact?

All it shows is that the wrong question has yielded an irrelevant answer.

Should the past have a future?

Should the past have a future?

One of the many opportunities afforded by running a multi-arts form centre like the Barbican is that it obliges you to spend time with many art forms and many different artists. In the process of watching and listening, the interaction between past and present is a constant theme and subject for discussion and speculation. Because the question of how past and present connect and relate to one another; how far excessive reverence for the past becomes a ball and chain on creativity; how far it is possible or desirable to break with a past regarded as a burden rather than a foundation; or whether the very notion of a break in the continuity of creativity and understanding is an illusion – these are relevant to all the arts and not merely the performance arts.

It is important to be honest at this stage. I am an amateur in the arts, a keen one, someone described by The Times as having an 'insatiable appetite for culture'. I would not dream of programming the concert hall, the theatre or the art gallery. Being a generalist gives certain freedoms. I can say things that arts professionals cannot say, or might choose not to say.

There is a famous article about Shakespeare's Macbeth titled 'How Many Children had Lady Macbeth?' A very serious question based on remarks she makes in the play, but it is not answered

directly in the text. The reference to giving suck to a child might suggest that the answer to the question is 'one'. Scholars argue about this, not as a matter of pedantry but as a way of trying to probe a profound part of Lady Macbeth's psychology. Yet such questions may turn into pedantry at worst or innocent game-playing at best.

Similarly innocent questions in the world of music might include: 'How mean was Beethoven?' 'Was Salieri a far worse composer than the play *Amadeus* makes out?' (Answer, on the basis of Cecilia Bartoli's last CD of his music, a resounding 'yes'.) 'How simple minded was Anton Bruckner?' 'Did Hindemith know he was bad or could he just not help it?'

And the clinching Great Unanswered Question About Music could be: 'Who taught Hildegarde of Bingen about marketing?' After all, she chose to be a woman composer in a man's world. That was shrewd. She worked in the huge growth area of liturgical music. That was opportunistic. And she devised the best marketing catchphrase of all time: 'A little feather on the breath of God'. Could Hildegarde possibly have scored so brilliantly in such very modern career choices without some professional guidance?

These are riddles of one kind. Number riddles are another. What music is associated with the following numbers? The only clue is that they are not a sequence:

5½; 8; 9; 12; 24; 41; 48; 64; 104; 237; 273; and 863.

The answers are: Don Gillis's Symphony number 5½; 8, the number of notes in the scale; 9, the number of symphonies you are allowed to write after Beethoven without risking premature death; 12, the tones of serialism; 24, 'hours to Tulsa'; 41, Mozart's symphonies; 48, Bach's preludes and fugues; 64, Haydn's String

Quartets; 104, Haydn's symphonies; 237, Honnegger's musical Pacific railway engine; 273, the number of seconds in Cage's '4'33' and also the temperature of absolute zero; 863, the number of Schubert songs.

These are intentionally silly – if harmless – questions. The real question remains – how seriously should we take the past? What risks – if any – can artists afford to take with their connections with the past?

For many today, especially the generations now at university and who make up the audiences in the Barbican, the past can seem treacherous territory. 'Here be dragons,' it says on the map, the dragons of knowledge, of authority, of hierarchy, of right and wrong. Why are they so alarming? In part because the Internet is too often based on a very different commodity: information. We prize information; we pursue it in quantity; we want it in shed loads. We value it because, unlike knowledge, it is often raw, preferably unfiltered, and often valued precisely because it is unfiltered. Beyond information, the stocks in trade of some parts of the web – allegation, innuendo, disinformation, mendacity – have their own appeal. Statements and opinions are disseminated on the web that would be rejected in the processed, mediated media. The information carried on the web is immediate, free and has an appealing if spuriously democratic tone to it. Since anyone's web posting is as good – or bad – as anyone else's, all have equal status in matters of access to it. 'Banish the gatekeepers of expression' is the cry. 'To the gallows with the agenda setters.'

For the past, and its historic expression through acquired knowledge, critical questioning, peer review and hard-won discovery come lumbered with unpalatable words. First of these is 'authority', which invites deep scepticism and immediate challenge in a society where everyone's opinion is as valid as

everyone else's. The second word that encumbers the idea of knowledge is 'hierarchy'; everyone is certainly against that! The very search for immediacy of experience, the intensity of the present, the attraction of the instant, its offer of gratification, all run counter to the possibility that the past, as revealed through the acquisition of knowledge and understanding, is a universal possession that deserves protecting, a resource that yields understanding, an asset that repays study.

Any idea of the past as having a compelling value for the present is a dubious proposition for many in the post-1968 generation. For a start, is there anything before 1968? Was that not a break year, politically, socially and creatively, as radical as the Renaissance?

This is not just another lament for the drastic foreshortening of memory in the last generation, real as that may be, regrettable as it undoubtedly is. But it is more than a lament; it is an observation and a warning. Heedless turning of the back on the past should carry a health warning for it also carries a price. What could that price be? How should awareness of the past influence the way that arts institutions conduct and present themselves. Even as we face the most pressing problems of the present, the past is lurking there somewhere. How do we use it creatively, even as we try to step away from it?

Take the case of the artist, Bill Viola. For some – for many – the very phrase 'video art' is a contradiction in terms, a forewarning of laziness, mediocrity, art college modishness, short cuts to expression. The numbers of quality practitioners in this field is dauntingly small. Bill Viola is certainly one of them – Bruce Naumann, Nam June Paik and Michal Rovner are others. Viola's trademark work is of super slo-mo videos of human figures doing very familiar, timeless, eternal things: crying, running, appearing to eject out of water like a projectile, facing one of the apocalyptic

cataclysms such as fire or flood. Viola could not do what he does, could not express what he wants, without the latest technology; the highest-definition video screens, digital editing, cameras which slow down action to the point that the movements as they unfold are almost indistinguishable, so that they appear to have become a series of held, animated tableaux, at once monumental and moving. He addresses the journey through life; or birth through the primeval water. If the techniques are radical, the subject is universal.

At art college, Bill Viola reacted against the conventional teaching of the curriculum. He was the classic rebel until he discovered the fifteenth-century Sienese masters – such as the Master of the 'Osservanza'. It was a very personal discovery. Thereafter, he decided that his subject matter as an artist would be the reinterpretation of Christian iconography. This was as uncool as you could get among his Californian colleagues and classmates.

That decision, once taken, the integration of the modernity of Viola's techniques with the openly historical nature of his sources could not be more overt and complete. The fifteenth-century painting of the Annunciation by Pontormo, The Visitation, inspired the work called The Greeting. A sequence of studies of a woman alone in a room at different seasons, with the light changing as the seasons outside change is a meditation on spiritual devotion itself, based on echoes of Vermeer.

On other occasions, Viola explores the scene surrounding the Tomb of Christ, when the sleeping soldiers completely miss the epic event of the Resurrection; or the journey through life, including saying farewell to a dead parent, or humanity's common links in facing flood. In the Nantes Tryptych, the most intensely personal of Viola's works, the ancient forms of the religious triple image allow him to deal with the agony of his

mother's dying which he videoed – with his father's agreement – as a way of coming to terms with the awfulness of the event.

Yet these are not pious pastiches, holy archaisms, devotional pictures, just a modern tweak on ancient beliefs. Bill Viola is the most contemporary of artists, whose Christian awareness is subtly informed by Buddhist sensibilities. He is not, I think, proselytising. But his serious re-examination of these great scenes of Christian mythology does throw a different, and wholly serious, light on them. He employs the most modern techniques to express his meanings; but using them as an instrument to explore the great themes of two millennia gives the work a strength, a resonance and an originality which mere technical tricks would not achieve. In this respect, Viola is a leading witness supporting the argument that connection with the past is a source of strength to the modern artist, part of the lifeblood of creation. It is not a slavish act of homage, mere dutiful obeisance to the past.

Consider the very different case of the choreographer, Merce Cunningham. As a young man who loved to dance, a charismatic figure on the stage, Cunningham, tall, strikingly good looking, with a feral yet lyrical athleticism, was trained in the Georges Balanchine/Martha Graham tradition. At a very early stage, Cunningham decided that he wanted to part company with what he felt was a too heavily narrative-based style of choreography. His instincts drove him towards a more abstract dance, one where the exploration of movement through the expression of the body was the principal driver.

In 1944, he met the composer John Cage, with whom he had a relationship for almost fifty years. Together they explored the idea that the ingredients of dance performance – music, movement – did not need to be tied together as they had been in the past. Each had its own autonomy; each had its own integrity;

each would gain from the context of the other. But music did not follow the movement or vice versa. They were equal and separate. In Cage's view, for the dance to follow the music represented a kind of slavery.

This was a startling concept. As John Cage wryly explained it: 'Merce does his thing and I do mine, and for your convenience, we put them together.' We should not be fooled by the characteristically flippant tone of Cage's remark. It conceals the reality that in creating each work together, there were – as Merce Cunningham recalled in a conversation with me – a number of time milestones, providing a necessary structure. Cage was strong on structure, leaving maximum room for freedom in between the milestones.

When artists such as Robert Rauschenberg became involved in the process of creating stage works, the design of set and costumes was treated in a similarly independent manner. The radical nature of Cunningham's work was there for all to see. Too radical for many, who just hated or could not come to terms with what they saw or heard. On the famous European tour of 1964, the work was greeted with boos, hisses and catcalls in Paris. In London, where I first saw Cunningham's work, there was a breakthrough of recognition, though not always an easy one. For Cunningham represented an apparently total break with the past, from the way ballet had been created. Cunningham's challenge was the overturning of a tradition.

But there was a further stage of innovation to go. It came when Cage introduced Cunningham to the Chinese *Book of Changes*, the I Ching, the practice of turning to random choice as a way of determining future actions, of choosing future directions. On the face of it, nothing could be further removed from the western tradition of the artist driven by a sense of purpose, an idea of direction, exercising detailed control over the order, structure

and development of his work. The very notion of allowing chance to determine anything creative, let alone be the deciding factor, could hardly be more alien to the western creative approach.

In a fairly late work, *Split Sides*, in 2004, Cunningham has two sets of choreography, two stage and costume designs, two lighting plots and two sequences of music. Before each performance, the die was cast on the stage to decide the order the works would be performed, to which piece of music; with which lighting plot and with which set and costumes? There were thirty-two possible permutations of all the artistic elements for each nightly performance.

This should have been a formula for chaos or incoherence. It should not have worked. In fact, far from being either chaotic or incoherent, the performance regularly drew the audience response that the elements, though separately created and randomly assembled, perhaps in a unique combination, emerge with an extraordinary sense of discipline, connection, controlled form and inner order.

On this evidence, Merce Cunningham is an instance of the artist who has broken from his roots, ignores tradition, and has succeeded in creating something truly original, unfettered by the traditions of a discipline traditionally bound up with restrictive ancient practices.

Perhaps it is more complex. For a start, Cunningham never wholly rejected Balanchine and Martha Graham. He set out to go beyond them, to find out more on the journey of discovery that they started. That is subtly different from pure rejection. While rejection has its place in the armoury of gestures, it seldom works as a creative driving force by itself. Continued evolution is a very different matter. Few can watch Cunningham's work without recognising in it an utterly familiar classical discipline but with a dramatically enhanced language of movements and connections.

Then, too, Cunningham's use of chance should not be taken at face value. The automatic reaction to the very idea of the random is that it destroys order, especially when aleatory techniques are applied to ordered forms. Cunningham uses it in an entirely different way – to increase choice and to indicate new directions of discovery. In this respect, he appears as a very radical but also very traditional kind of artist. Like Bill Viola, he uses the contemporary tools to help him explore, renew and extend traditional forms. Within the spirit of the I Ching, says Cunningham, there is a very strong sense of 'going forward'. It is not fanciful to argue that for Cunningham the forward path also stretches back to deep roots.

The comparison with his partner and mentor, John Cage, is very instructive. Cage's instincts were those of the joker, the innovator, the prankster, and very valuable too. His open assault on the past was explicit. Cage had a simple explanation. It was all Beethoven's fault! Specifically, it was Beethoven's sense of structure, logic, purpose and intense rhythmic drive that Cage couldn't abide. In one of his most controversial statements, Cage declared: 'Was Beethoven right or were Webern and Satie right? I answer immediately and unequivocally, Beethoven was in error and his influence which has been as extensive as it is lamentable, has been deadening to the art of music.'

Cage's declaration of independence from the past continued with his observation that anything worth knowing about harmony could be learned in half an hour. Not surprisingly, Schoenberg – from whom Cage took lessons – commented that he had 'no feeling for harmony'. That explains a lot.

Apart from his obvious shortcomings in composition and technique, Cage was fundamentally limited by his inability to understand the past. Cocking a snook at Beethoven denies you a position from which to advance and develop. (Like Dali painting

a moustache on the *Mona Lisa*, it is a one-stop joke.) Cage – like Dali – is left marooned and rudderless with nowhere to go.

How much of this can be said to apply to the American Minimalists, that now jaded and outmoded portmanteau term for the early works of composers such as John Adams, Philip Glass and Steve Reich? If any school of composition set itself apart from the past, it was the self-conscious repetitions of the minimalist school. Yet that very rupture created its own difficulties. As Louis Andriessen, the great Dutch contemporary observed, even Steve Reich calls it 'repetitive music'. For other composers, such as Harrison Birtwistle, listening to it is like waiting for the bus to arrive; you see it coming from a long distance; there's absolutely no surprise left by the time it gets there. For others, such as Elliot Carter, the abandonment of formal, traditional disciplines and their replacement by surrender to orientalism carry overtones of the totalitarian in them.

Carter's reaction is indeed extreme. Repetition in minimalism is akin to using the techniques of advertising or political propaganda to woo audiences. 'This is a way,' Elliot Carter told me, 'of destroying intelligence.'

Perhaps the reliance on a single formula, of insistent repetition, and harmonic repetition at that, is just too limited expressively to take you very far creatively. Of course, repetition is an important gesture in music, from Rossini to Ravel at least. But to take a single gesture and to attempt to build it into an all-inclusive system seems to sideline the other available lessons of the past. Rather like a simplistic act of rejection, mere repetition is not rich or complex enough by itself as a code for composition.

Yet even rejection, as a way of setting a new artistic course, has its part to play in the search for originality. Take the case of the Hungarian, Gyorgy Ligeti, who died in 2006. In 1956, the young Ligeti emerged from the ruins of Budapest and the democratic

revolution suppressed by the tanks of the Red Army. Such was the political and cultural control exercised by the Communist Party that Ligeti's access to contemporary music was almost entirely through hearing broadcasts from western radio stations. Despite that, and despite being Hungarian, Ligeti arrived in West Germany – as it then was – never having been able to hear the third and fourth of Bartok's String Quartets.

His fledgling reputation led him to Darmstadt, where he found himself the centre of attention. Very flattering, no doubt; Pierre Boulez wanted him in his school; Karl Heinz Stockhausen wanted him in his. Each wanted the talented Ligeti as their follower.

After an entire lifetime living under fascism during the war and communism after it, Ligeti told me that he was not prepared to allow further control of how he thought, how he wrote. Serialism was not what he heard in his own head. It might be the prevailing theory, but it was not for him. Besides he hated its totalitarian overtones. He quoted with contempt Schoenberg's claims for the influence of the twelve-tone row: 'I made sure the domination of German music for the next hundred years.' Ligeti dismissed those who expressed no interest in the past and accorded no value to it as egocentric and self-important in thinking only about the future.

But in rejecting serialism, Ligeti had somewhere else to turn. There was his own Hungarian past, with the folklore tradition captured, codified and enhanced by Bartok and Kodaly. Those roots went much further, back to Renaissance polyphony, to Gesualdo, Monteverdi and to any good music. His rejection of serialism, of everything that was presented as the most contemporary and advanced, the new way of writing music, could only work because he had foundations in the past as well as a unique personal sensibility of how he needed to compose. Turning to the past involved an understanding of the past. Turning

to the past as an anchor doesn't involve resorting to pastiche, mere nostalgia, pallid revivalism. Strong roots deliver true originality. 'I am deeply linked to tradition,' Ligeti emphatically told me. 'I don't think we discover new styles from a zero point. We are always continuing, whether we want to or not.'

A further case in support of the argument concerns the British composer, Harrison Birtwistle. In the pecking order of the day, Alexander Goehr and Peter Maxwell Davies were the clever ones, the composers, the Young Turks, the confounders of the English pastoralist or cow-pat school of music. For Sandy and Max were serialists. Harry Birtwistle was just a clarinet player. In fact, Birtwistle was composing, but serialism meant nothing to him. He recognised it as one of the most important movements of the twentieth century. But it simply did not square with what he heard in his head. He couldn't make it work.

Putting composition to one side, Birtwistle had his revelation when performing Messiaen's *Quartet for the End of Time*. If Messiaen could write with such personal freedom and originality, so could he. It gave Birtwistle the courage to write as he heard. As he spoke to Messiaen, Birtwistle got the sense that his music, deeply original as it was, stood in the great tradition of music from the beginning of time.

In acting as they did, Birtwistle and Ligeti were taking a stand on the great issue of twentieth-century music: whether to sign up to the Second Viennese School or not. In passing up the opportunity, each of them had major resources of intellectual understanding to turn to. In Birtwistle's case, the rich veins of classical mythology – everything from the Masque of Orpheus to his latest work, the *Io Passion* – and the earthier traditions of English music hall and folklore.

How do such debates affect performers? Of all contemporary pianists, Pierre Laurent Aimard stands out for his commitment to

and understanding of the contemporary. In particular, his fearless interpretations of works such as Ligeti's *Etudes* or Messiaen's *Vingt Regards sur L'Enfant Jesus* stand out as definitive realisations. True, Aimard is bored with what he calls 'music that wants to please the masses. I'm watching for talents, like Birtwistle, that will challenge me again and again.' He recalls that as far back as Robert Schumann, mere entertainment was seen as the enemy. 'Easy success and demagogy have always existed.' But Aimard's own commitment is clear and unqualified. 'As a human being, I need both the future and the past. There are children and there are parents. We cannot sacrifice one generation for another. Our first role is to interpret the music of today. But we must also renew the old.' That seems a classic statement of the integral awareness of past and present. Yet as a modernist, Aimard rightly puts the interpretation of today's music first.

That may be a satisfactory solution for Pierre Laurent Aimard personally, but the debate about how new and old fit in together will not go away, nor should it. A recent discussion in the arts world turned on the question of whether it was right for the Royal Ballet – custodian, in part, of the nineteenth-century classical tradition – to dance to a work whose music consists of three songs by Jimi Hendrix. Why not? Merce Cunningham's *Split Sides* was set to music by Radiohead and Sigur Ros. Ballets exist to music by the Rolling Stones. It is essential, argue the supporters, that classical dancers should not be prevented from engaging with the music of the world all around them. They cannot be kept in the historic cocoon of the Russian Imperial Court of the nineteenth century.

Opponents of such innovation maintain that innovation for its own sake – and ballet set to Jimi Hendrix falls into that category – certainly attracts attention, creates ripples, but achieves little else, beyond sensation and a degree of notoriety. It is seldom

going to be judged according to criteria of excellence rather of sensation.

I think such objections miss the point. While, as I have argued, the past is there to enrich the present, our experience of the past can be revived, re-stimulated through contact with the new, even if it appears at first glance to be anachronistic. It is a two-way process, not an antithesis.

You can observe this in close detail in the new Disney Concert Hall in Los Angeles, designed by Frank Gehry. To the casual viewer, no buildings constructed today could have more of the contemporary, less of the past in them, than those by Frank Gehry. From his Guggenheim Museum in Bilbao, Gehry has created dazzling sculpturally shaped buildings that seem to exist in the now, to be utterly dependent on modern materials, the latest design techniques and concepts. They contain no obvious connection with the past.

Yet Gehry has always acknowledged two huge influences from his first visit to Europe as a young architectural student. These were the French Romanesque Churches and the Baroque extravaganzas of southern Germany. In the first, he saw great internal volumes enclosed in stone; in the second, he revelled in the pierced vaults, the dazzling illumination of the internal spaces. Look again at his buildings and the sense of volume and complex patterns of illumination are there to see. These are not today's ideas but those of a millennium ago. The modernist Gehry would not be the architect that he is without these deep roots to the past.

The debate goes beyond artists alone. Every arts institution should question itself searchingly. What are your values and goals? How have they altered? Have they evolved in step together? Has the past and its traditions been acknowledged as strengths without letting them contradict what has to be done in the present?

For the past cannot be neglected and should not be overlooked. Its uses are capable of infinite variety and modification. Correctly, imaginatively used, they can create a fusion of calm and energy, stability and radicalism that make up a real foundation for the future. Innovation is vital. Yet, paradoxically, it may be most effective when it is recognised as being fundamentally a conservative business.

The carrot and the stick: a new compact for the arts

Most of the money that funds the arts in Britain comes from the public in one way or another. The state's acceptance of responsibility for the arts is one of the glories of the British system. We can argue about the sums spent, whether they are adequate and where responsibility for funding the missing millions should lie. But there is no doubt that the nation wants public subsidy for the arts from the government to continue. It is a part of the 'welfare state' which has not yet been privatised.

Yet many important questions are then raised. What are the right respective roles for government and the arts bodies in determining how public subsidy should be spent? How overt should government policy-making for the arts be? How intense should be the demands for social – as distinct from artistic – outcomes, to use the language of arts bureaucrats. This debate has been a running one between ministers and arts heads for most of New Labour's time in office. Towards the end of the first term, in 2001, the atmosphere of hectic, policy-making hyperventilation had subsided. We could look back through 'Cool Britannia', past 'Creative Britain', past the promise of a wholly 'Rebranded Britain' abroad; less happily, we could look past the unmet promise of a Britain where every building developed with

public funds had to be good architecture. Whatever the merits of those early enthusiasms, they soon took on a period look, that of a tattered poster tugged by the bleak winds of political oblivion.

Then there was the Millennium Dome, the intended exemplar of everything New Labour stood for, a visionary building housing wretchedly patched together contents – in its contradictory dualism, it may have mirrored New Labour's own contradictions too well.

Yet just because policies have failed, been abandoned or been replaced does not mean that 'policy' has vanished altogether. That would be unreasonable and unwise. If the arts world could sense where the policy wind was blowing, it could offer its own thoughts as to how evolving government policies might square with the needs and obligations of the arts and of audiences. In the absence of any firm policy direction, I sought a reliable source who could share with me the Department of Culture, Media and Sport (DCMS) team's ideas. (In the interests of anonymity, and in the best traditions of keeping sources secret, I called my source 'Shallow Throat', to protect both their identity and their gender.)

Why, I asked, couldn't I see any new policies coming from the DCMS?

'Because you're not looking in the right places. Didn't you read about what happened at the World Athletics Championships at Edmonton?' Throat replied.

'What has Edmonton got to do with it?' I protested.

'Well, for a start DCMS includes sport in its brief, as you have typically, narrow-mindedly forgotten, and didn't you notice what David Moorcroft, Chief Executive of UK Sport said once the Games were over?'

'Yes, I did,' I countered. 'He was worried that lottery funding for UK Athletics would go down since the Team missed the

agreed performance targets to win a certain number of medals. But what has that got to do with arts policy?'

'You're a bit slow,' Throat chided. 'If anyone who receives funding in our departmental remit misses their agreed performance targets – whether audience numbers, tickets sold, masterpieces created, whatever – then according to the Treasury, they have to be brought into line. Less funding until they do better.'

'How can they do better if they have less money?' I explored hesitantly. I paused as I tried to relate to the profound psychology behind Treasury thinking. This wasn't carrot and stick, even; it was more and more stick and less and less carrot.

Shallow Throat didn't attempt to explain, still less to justify this contradiction and instead tried a different tack. 'Don't think it's all negative. Let me tell you – in total confidence – about our new strategy for medium- and long-term performance indicators for the key cultural sectors.'

'Will I like what you're going to tell me?' I protested.

'You should, because they are blue-sky, big-picture stuff and you're always going on about too much petty bureaucracy.'

'Go on,' I encouraged.

'Well, DCMS will set the national drama schools and the national theatre companies a new sectoral LTPI – Long Term Performance Indicator – to find a new William Shakespeare by 2030.'

'Fair enough,' I said. 'That sounds quite doable. We've got a whole generation to find one.'

'Britain's publishers, booksellers and libraries will have an MTPI – Medium Term Performance Indicator – to find a new Charles Dickens by 2015. But we are saying he can be found in instalments.'

'Very subtle,' I agreed.

'The Building and Architecture Trades will have an LTPI of 2020 to find the new Christopher Wren. The Opera houses have a short-term indicator of a new Benjamin Britten by 2015, but a stretch LTPI of a British Verdi by 2025. Shall I go on?'

'I get the message. It's better than "blue skies". More like a new Golden Age,' I replied. 'I can't wait. And what if they don't?'

'Well, we've got to get the gold medals in the arts as well as in sport. If we don't, what are we paying the arts for,' observed Shallow Throat as the line went dead.

Radical and logical – even admirable – as these proposals must be, there could be more modest solutions, ones that could help to create a *modus vivendi* between arts and government bureaucrats, a new compact for the arts which goes beyond the mountains of bureaucracy on one side and somewhat impotent ridicule and sniping from the other.

Such a compact would involve the arts, government and audiences, with all sides accepting obligations and responsibilities as well as receiving concessions. As things stand, the relationship between government and the arts is non-collaborative, prescriptive and antagonistic, especially when funding gets cut. What would this new compact for the arts consist of?

On the government's side, it would accept that detailed over-specification of targets, objectives and performance indicators had become counterproductive, ineffective and a waste of everyone's time and resources. It would think harder about the relevant, high-level objectives that arts institutions should be set. It would have to be more subtle in admitting the limitations of bureaucracy and more creative in understanding the very distinctive nature of much arts activity. It would recognise that the opportunity cost of over-prescription of targets and over-regulation by objectives is high.

The government would accept that results from investment in the arts will not necessarily come in the lifetime of a parliament and that the pursuit of short-term results distorts activity and virtually guarantees failure. It would seek other ways of maintaining accountability and necessary scrutiny.

Finally, government would define an arts policy that was not the product of focus groups and the anticipated hostility of the tabloids, but sprang from the government's beliefs and society's and the arts world's values. Under existing circumstances, these might be seen as significant concessions, but they would in fact prove to be a more effective way of getting the best results from the arts.

For their part in the new compact, arts institutions would acknowledge, as a matter of course, their obligation to serve the government's social agenda – through improving access, outreach, education and exclusion. They would shape their policies in a way that took the government's key objectives as pillars of their activity. They would build public accountability into their normal ways of working without having to be harried by the arts councils or civil servants. But they would do so in a way that did not distort the fundamental obligations and disciplines of their core activities – performing, showing, or creating the best possible art for the widest audience.

The new compact for the arts should be a triangular arrangement, involving and engaging with audiences that are increasingly fractured, disaggregated and self-aware. Their demands and needs are bewilderingly varied, the cost of meeting them worryingly high. The arts have a responsibility to acknowledge this diversity and to respond to its increasingly vocal demands.

There is a responsibility on the other side too. Each section of the audience has a general obligation to take more risks with their

time, their money and their imagination. The younger audience should not run away from anything where the language appears too difficult or the rhythms too subtle, or where the meaning of an artwork depends in whole or in part on some engagement with the past. The past is not another country; it belongs to the young too, and is far too precious to be discarded in a spasm of irritation or a gesture of inattention.

The greying audience has a set of parallel obligations; not to behave as if music written after 1930 is too difficult; not to react to every contemporary theatre production as if it were a violation of good taste; not to behave as if nice landscapes were the essence of true art, and the prevalence of videos and installations merely proved that young artists today can't draw. For the greying, the artistic present and future must not be treated as a hostile country beyond a creative Iron Curtain; they should recognise that it is their country too, so long as they have the courage to cross the border. It may be unmapped and confusing for everyone, but it is not a wilderness peopled by barbarians.

As part of the dialogue which should characterise the new compact, perhaps everyone in the arts and the media that report them should address a series of fundamental questions about the terms in which any dialogue can take place. For example: are we more ready to value, report and celebrate hype rather than achievement? Are we more interested in recording the Warholian fifteen minutes of fame rather than the lifetimes of achievement?

Do we set more value by lifestyle rather than ways of living? Do we collude with the heavily promoted, commercialised and globalised cultures, rather than cultivating and celebrating local individual ones? Those often need protecting. Does that make them worse than globalised cultures or just apparently impotent in a one-sided struggle where the rules of engagement favour the big artistic battalions?

Do we confuse the power and persuasiveness of the commercialised arts with their sheer facility and usability? Have we lost our ability to view them critically?

Do we avoid value judgements and opt for relativism because we are lazy or frightened, or because we really believe that any activity is as good as any other, provided that somebody, somewhere, enjoys it? Who gains what by running away from attempted definitions?

To achieve such a new compact for the arts would require humane debate about the arts through openly taken positions rather than predetermined political posturing. It will never be achieved through the increasingly bureaucratic prescriptions of the past decade. It would involve a radical departure from past approaches; but it could hardly be less effective than they have been in finding a creative resolution to deeply ingrained tensions.

Standing back

16

On being a musical nationalist

16

On being a musical nationalist

There may be a deeper explanation for the way that I feel about Czech music, but I don't intend searching too hard for it. The fact is that the harmonics, the cadences, the rhythmic lilts, the sheer sounds and textures of Czech music resonate for me and in me, in a way that no other music quite does. They touch some deep reservoir of memory and psychic formation whose existence I can't account for. They fit some basic primal imprint of whose creation I was unaware. Part of it affects my mind; the deeper effect of the Czech-ness of Czech music goes straight to somewhere above the solar plexus, the pit of the stomach. For me, this, far more than the heart, is the centre of the deepest feelings. This is where emotion starts; this is where sounds trigger feelings and flood the entire body. You will gather from all this that Czech music matters to me.

Now this is not to argue that Czech music is the greatest body of music ever written. If I have to play the 'national schools of music competition' game, I have no hesitation in placing the German school – in all its historic varieties – at the top of this order of merit, closely followed by the Italians. Nor is it the case that I respond more intensely to the sound of Czech-ness than I do to the sound of Elgar, who engages and triggers my British

side. But I do respond with a different kind of intensity to the Czech sound which I have to acknowledge and would not dream of rejecting.

There are vivid experiences, however, that may account for the intensity of my responses. My mother did not sing Czech lullabies to me as a child. But my father and his friends regularly sang their old Sokol songs every Boxing Day. The Sokol movement was strong in pre-war Czechoslovakia, a hearty mixture of nationalism, pride in the new state, gymnastics – including a great deal of swinging on the parallel bars – physical fitness, open-air camaraderie and, finally, the singing.

For some fifteen years, the Czech community that worked for and lived around the Bata Shoe Company factory on the Tilbury marshes came to our house on Boxing Day at lunchtime. After an hour of polite conversation, the men would shift on their feet and say, 'Isn't it time for the singing?' Typed word sheets were produced, they withdrew to the next-door room, and then for the next three-quarters of an hour these middle-aged men sang the old songs as if it was 'Czecho' in the happy days of their youth. I believe it was the happiest hour of their year. To my young ears, the sound of their voices was that of friendship, shared experience and a certain eternal harmony. For their instinctive harmonising brought into our oak-framed, medieval Essex house a sound from the centre of Europe.

Later in life, I discovered that the sheer homespun quality of Dvorak's music worked on me far more than I expected. The guileless rusticity of the serenade, the innocence of the bagatelles for strings and harmonium, these offered a musical experience that I would have expected myself to reject. Knowing as I did that the fierce intellectualism, the persistent disputatious engagement, of the late Beethoven Quartets was the summit of musical achievement, how could I take seriously the gentle

musings of the unintellectual Dvorak? Besides, even I had to admit that he sounded like Brahms on a bad day.

It was when I found that I did not mind that I preferred Dvorak on an average day to Brahms on any but his best that I realised how deep my addiction was. Ask me to choose between any of Dvorak's symphonies and Brahms and I have no hesitation in choosing the former. They have a limpidity, a purity of sound, an instinctive joyfulness and clarity of structure that leave me satisfied in a way that Brahms' relentless thrashings and heaving muddiness cannot.

This revelation came largely from hearing live performances by the great Czech conductor Rafael Kubelik, and from the lyrical outpourings of the complete set of the symphonies conducted by a Hungarian, Istvan Kertesz, with the London Symphony Orchestra. And make no mistake – Dvorak is not as innocent as he chooses to sound; the cunning calculation of the composer who wants you to discount the skill of his work has a kind of Schweikian quality to it.

Czech music is more than Dvorak, of course, and it was a visit to southern Bohemia a decade ago that sealed my feelings. As we drove south towards the historic town of Cesky Krumlov, the landscape unfolded itself: green, wooded, lushly grassed, and interspersed with glassy ponds and running streams. So this was the landscape Smetana immortalised, and how romantic but also mysterious it looked. South of Cesky Krumlov, I had the final revelation. The immortal river Vltava swings through the town in a series of majestic bends. And it does more than flow. It dances its way through Bohemia, it dazzles, it shows itself off with self-conscious brilliance as the force that shapes the landscape all round. Smetana's music understands all of that. It encapsulates that spirit and distils it for those who have to take the river's character on trust.

But there is a connection with the Czech language too. I speak a very little, half-remembered gobbets of nursery talk, childhood slang and skeletons of grammar that collapse under conversational stress. But I know its sound intimately, its funny and sad cadences, the sounds of convivial Czech around the family table, the warm wrap around of Czech terms of endearment, the playful use of diminutives of affection, the shared laughter of friends, the silly jokes. I first heard these moments of innocent happiness as expressed by Czechs in the Czech tongue. Later, those remembered sounds spoke to me through the musical language of the great Czech composers.

Perhaps these experiences account for something of what I feel about Czech music. Those feelings do not exclude other musical loves and sounds. I can get as soppy as anyone else at the association of Elgar and the Malvern Hills. But as someone totally and gratefully brought up in a very English boarding-school educational system, my response to the sounds of Czechness invokes an acknowledgement of the basic, non-English, me. It is not something I long for, not a sentimental throwback to a past I never knew.

Rather, it is a precious tie to an earlier, otherwise uncomprehended part of my earliest perceptions. It remains a treasured part of my own personality.

Looking for Janacek – finding myself

As we drove north up the autobahn from Vienna to the Moravian capital of Brno, I wondered what exactly I was looking for. With my BBC Radio 3 colleagues, I had set out to find Leos Janacek, in his 150th birthday anniversary year. He remains the twentieth century's musical puzzle, the composer who came from nowhere, who acknowledged no one, who left no school, yet who bestrides the international opera scene to this day.

The country north of Brno, central and north Moravia, is utterly Janacek country. He was born in Huckvaldy in the north; he loved and recorded the music of the Lassko villages and people nearby; he frequented the spa town of Luhacovice. He made his name and career in Brno.

These lands are also mine. On the drive from Brno to Janacek's Huckvaldy, you pass Zlin, the Bata shoe town where I was born. The road skirts Bystrice pod Hostynem, where my mother was born. I left Czechoslovakia – as it then was – in 1939. My feelings of being Czech after a lifetime being British are bound to be vestigial. But they do exist. The very sounds of the town and village names, the cadences of the language – to which Janacek was almost unreasonably attuned – are my imprinted sounds and melodies, too. He could not listen to speech without writing

it down in musical note form. In looking for Janacek, would I also find a part of myself?

On the first evening, the Janacek Opera of the Brno National Theatre were performing *Katya Kabanova*. Part of a fortnight's anniversary festival including all of Janacek's stage works, it was a turbulent evening. Janacek sung in Czech by Czechs has a special impact; this is not surprising, given Janacek's obsession with the way the spoken language sounds and the way in which it influences composed music.

But it was the theatrical brutality of the piece that took me aback. The speed with which Janacek disposes of the action, culminating in Katya's suicide, is breathtaking, yet achieved without skimping. The emotional impact is huge, because the economy and concentration of the music are so intense. That is the paradox. That is his genius.

The capacity audience took it respectfully, if not with wild enthusiasm. But as I looked at the almost entirely local crowd, I had a moment of recognition. These were my people – Moravians. I look like them, stocky, square-faced. Had my family not left Czechoslovakia in 1939 to work in England, one of those people in the audience could well have been me. I was closer to this audience than I could ever be to any other.

Two evenings later, we were in Janacek's home village of Huckvaldy, surrounded by the wooded hills he loved so much, the 500-year-old lime trees, the old castle on the hilltop about which he lyricised, the clean air and bright sunshine that seemed to give him creative energy. We were in the pub Janacek used, Pod Hradem, 'below the castle'. Then, as now, musicians played folk music, violin and dulcimer, perhaps even the dulcimer the composer listened to. They sang while they played. In Janacek's time, the musicians were local farmers and peasants, the music preserved and transmitted through the oral tradition. That

evening the two performers were computer programmers by day but had learned folk music at the hands of local musicians.

Lasskian and Walasskian rhythms stirred Janacek deeply. I couldn't establish whether what I heard had that exact origin. But I am sure that the music, enthusiastically accompanied by Pod Hradem's regular Friday-nighters, does not sound like homogenised 'mittel Europaischer' ethnicism. Such checked, off-the-beat rhythms are subtler, unexpectedly displaced. They do not thump obviously, but hold themselves back with an inner instinct. No wonder Janacek, so sensitive to the sounds of nature and speech and music, was captivated.

Standing outside the pub in the cool, spring night, the evening star had risen. The young moon lit up the ruins of Janacek's favourite brewery and owls hooted on the hill. I desperately wanted to hear a fox's bark, distant descendant perhaps of Janacek's beloved vixen of his opera. But no amount of imaginative straining could conjure it up.

The next day, I got closer to the vixen and to Janacek. Lower down the village is the house where Janacek used to spend many summer holidays. Karel Zak, who lives there today, is the grandson of the forester who entertained the composer. He showed me the rustic seat where Janacek sat to look at the hills, the beehives that he watched, and pressed on us some honey mead from the hives, as the great man would have drunk it.

It was Grandfather Zak who arranged the expedition to show the composer a family of foxes near the castle on the hill. Janacek appeared at nightfall dressed in an immaculate white suit; the Forester sent him packing to dress in something practical. Even when the vixen and her cubs duly emerged, the childlike composer was so thrilled that his yelps of glee finally sent the foxes back to their lair. That sense of pure animal joy permeates the whole opera.

Later, Karel was joined by his friend Joszka, a schoolteacher, to play Janacek's little piece for violin and piano about the castle on the hill. Karel played on a Hammond organ, tucked in a corner of his over-stuffed room, Joszka rather tentatively on the fiddle, earning frequent reprimands from Karel about his intonation. But given the place, the family connection and the music, surely the old man's spirit must have been hovering?

Karel also repairs instruments, the most famous of them being the harmonium that stands in the living room of Janacek's own house higher up the hill. In the last weeks of his life, Janacek persuaded his so-called 'muse', Kamila Stosslova, to visit, accompanied by her young son, Otto. When the custodian, Karel Dohnal, plays the harmonium it conjures up memories that are both farcical and sad. Farcical because Janacek made life intolerable for his love and her son by playing the harmonium at night, often hammering at the same chord repeatedly. Tragic because he caught a cold days later during a walk in the hills and was dead within days.

On our way to Huckvaldy, my eye had been caught by a road sign pointing to a village off the main road – Blahutovice. 'That's where uncle Joszka lived,' I said to my wife, Ann. 'That's where we went on holiday with him in 1947. I had no idea it was around here.'

Driving back to Brno, Ann suggested we turn off to see if I could recognise the farmhouse. Nothing could be more different from the image of the traditional English village. Here are large, free-standing buildings, farmyards and barns, with massive double wooden doors to let in the carts. I could remember all that. I could remember Uncle Joszka's magnificent stallion, his tame deer, his almost pet pigs. Did we find the actual farm? I doubt it. The spirit of the place was familiar, the exact look of the building could not be conjured up. I just know that it was

good to be there and that in 1948 none of my family ever spoke of Janacek.

To the north east of Brno, we came to Janacek's favourite spa town of Luhacovice. Its fake rustic, half-timbered spa buildings survive to this day. The broad promenade, flanked by hills, has not changed. Here he fell in love with the actress Kamila Urvalkova, about whom he wrote his opera *Osud* ('Fate'). Here he met Stosslova, whose relationship shaped his creative life and whose correspondence is enshrined in Janacek's Second Quartet, *Intimate Letters*. I stood in front of the house where Janacek once stayed, waiting for Stosslova to appear from the house opposite and then happening to fall in with her in the street.

Here, too, my family came to relax, take the waters, nurse sickly children, enjoy the early years of their marriage. I may well have stumbled on the sandy paths on which Janacek trod with Kamila.

To look for Janacek is to tussle with contradictions: he was impulsive yet considerate; intuitive yet calculating; a fantasist and a realist; a superb psychologist of women on the stage, yet a disastrous one with the women in his life.

I can't argue with a composer whose understanding is so deep that he makes you feel compassion for the Kostelnicka, even though she has drowned Jenufa's baby; who sees the pathos in the Forester, though he has shot the Vixen. There are no easy gestures in his operas, no slick resolutions, only a compelling universality that emerges from the deepest particulars of his Moravian landscapes and sounds.

And myself? Sitting in the spa at Luhacovice, I remembered – once again – that my parents gave a Boxing Day party for many years in England, where the local Czech community gathered for one reason above all. The men needed to sing the old songs of their youth, when they were part of the nationalist, gymnastic

movement, Sokol. As they swung instinctively into the old unaccompanied harmonies, I realised that they were singing of their lives and homes. The rhythms of the way they spoke and the way they sang were in total accord. How Janacek would have understood; how he would have approved.

18

The new ABC of the arts

Five years ago, I spelled out an 'ABC of the Arts' in order to show outsiders – and some insiders – how much of our time is spent on anything but the arts. While it had a light-hearted side to it, the arts alphabet set out starkly – and almost to my surprise – how managerial obsessions and discipline had transformed the work of everyone running an arts institution. It was no longer sufficient – or even necessary – for an arts leader to know anything about the arts he or she was supposedly managing. A passing acquaintance with, and huge public support for, management theory was obligatory for preferment. Oh, brave new world that had such concepts in it.

Reading the alphabet again, the definitions have an absorbed look, old-fashioned almost, as if they have passed into the language and the currency of management. A few have vanished, some are irrelevant, some distinctly of their time, but most have endured.

Five years ago, A was for Access; B for Benchmarking; C for Culture and Creative; D for Deficit. E stood enduringly for Education; F for Found Spaces; G for Grazing and H for Holistic and Heritage. I commended both Inclusiveness – that ever so fresh New Labour mantra – and Indicators, which, like the poor, are always with us; J was for Joined-Up Government, an

elusive chimera; K slipped out altogether, while L was for Life Episodes, a tiresome piece of Whitehall pseudo sociology. M offered the then newish art of Mentoring; N was for NESTA, the National Endowment for Science, Technology and the Arts; O stood for Outreach; P for Policy and Products; and Q for Quest, a now-defunct monitoring outfit; R was for Regeneration and S for Stabilisation; T for Targets; W was for Worth; X stood for Excellence, a banal commitment, to which all had to aspire; Y was for Youth; and Z rounded it all up with Zero Based Budgeting.

So far, so familiar, you might say. You might also think that little or nothing had changed, that the landscape of imposed, pseudo-managerial and bureaucratic jargon had not altered, did not need to alter and probably could not do so if instructed. If so you would be wrong.

For, little noticed, an entire new alphabet has wormed its way out of the corners of Whitehall bureaucracy to try to stop the arts world from doing what it really needs to do – provide wonderful art. What this new alphabet shows, this New ABC of the Arts, is how far the arts world, the way we look at it, the way we run it, has been transformed yet again within five short years. It has not been transformed in its own terms; rather in the concepts by which it is judged, managed and evaluated. The creative fertility of bureaucrats has an unstoppable energy of its own.

So how do the letters of the arts alphabet trip off the tongue today?

A is for Assessment. All organisations are examined, scrutinised, quizzed, questioned and bothered, all in the name of efficiency and effectiveness. None of the assessment involves judgement of the art produced.

B is for Brand. It is an essential part of marketing. What does a brand do? It means that audiences – or anyone who buys a ticket – recognise the values of an institution immediately when

they see the public face of the brand which is the logo. The great mistake is to create the logo without first defining what the brand values are or what you stand for. The worse error is to define the organisation's brand values without consulting those who work for it to see if they do represent the organisation they work for.

C is for Culture. Once it was closely related to the very idea of 'being cultivated', an entirely passé notion connected with membership of a certain view of European, Græco-Roman civilisation. Now it has been bureaucratised – and perhaps democratised – since it became the title of the government department that funds the arts. If the previous use of the word was tiresomely pretentious, its present breadth of meaning shows that while the government does indeed care for the arts – and funds them – it prefers not to say so too openly.

D is for Delivery and Diversity. In many areas of government – such as health and education – New Labour has wriggled on the hook of pouring money in but never getting as much out in return as it hoped. The 'key deliverables' weren't being, well, delivered. Delivery simply means doing what you said you would do with the money. Most arts organisations are used to delivering rather more than they are paid for. They neither get – nor expect – thanks when they do so.

Diversity has made us all think about audiences and the sheer variety of national groups that make up our audiences. It is a slightly evasive word for racial mix. The secret is that achieving diversity targets is not best met by chasing audience quotas. Change the nature of your programming and the diversity of the audiences looks after itself.

Most fashionably, D is for Direction of Travel. This is high cant. Ask somebody if their organisation is going 'in the right direction' and the question will be disregarded as woolly and imprecise. Ask if the organisation's 'Direction of Travel' is

correct and you will be praised for the depth and sophistication of your thinking.

E is for Excellence. You must not be elitist or exclusive; but you should be excellent. Truly, it should not need saying, should not need to be set as a goal. Those who prate about their excellence do protest far too much and probably aren't excellent in the first place. Those politicians who clamour for excellence are usually disinclined to fund it.

F is for Fundraising, which used to be called sponsorship and has now migrated to development. This wobbling with words and meaning reveals a continuing unease about raising funds from the private and individual sector. But if it is faced head on, confidently and honestly, the relationship between the giver – whether private or a company – and the asker can be strong, positive, supportive and thoroughly enjoyable. And both partners end up learning from the other. But while the English can't stop talking about sex, and have given up talking about politics, they are reluctant to ask for money.

G is for Governance. This one came from the blind side. Thirty years ago, when the Labour Prime Minister Harold Wilson wrote a book called The Governance of Britain, we all thought he was mad. We didn't know what he meant. Today every board of every arts organisation spends hours pondering its governance. Who are they? Why are they? What right do they have? How do they act? The end result of all this effort should be that the organisation concerned is better run than it was. This can happen, but too much time spent in contemplating the governance navel can lead to blindness. Civil servants insist on it because it is another way of getting more control over supposedly independent boards of trustees.

H is for Headhunters. In other sectors, they have existed for a generation or two. They are now seriously fashionable in the

arts world. The results have been mixed. Headhunters feel that they need to justify their massive fees by recommending a really stupendous candidate. Very often the candidate is Australian. At other times, they parade a vastly overqualified European who is bemused by British culture, the complexities of the funding, the intricacies of the politics, the philistinism of the government and the brutality of the press. They leave. Headhunters are less good at recommending the safe, local candidate who then goes on to do a terrific job.

I is for Instrumentalism. At last, we have a word for it. For years, we argued about how much the arts contributed to the economy, the environment, education, health and prosperity. Only – it was said – if the arts were 'instrumental' in 'delivering' improvements in all these fields could funding be justified. Finally, two years ago, the Culture Secretary, Tessa Jowell, declared that 'Instrumentalism was Dead'; we could all go back to believing in 'art for art's sake'. Unfortunately, her pamphlet was a private statement not government policy. The Treasury still insists on instrumentalism as the guiding principle behind arts funding. So it isn't dead after all.

J is for Jobsworth, as in 'It's more than my job's worth to let you do that!' The bane of any living organisation's life, they are all too typically found in the health and safety business or in anything to do with external regulations. The classic 'jobsworth' would rather close a building down than run a tiny risk of harm to life or limb.

L is for Leadership. In the arts world, this has become an industry. Having diagnosed the arts sector as lacking in leadership skills, three major programmes dedicated to putting this right have sprung up. The oldest is the Clore Fellowship, a high-quality one- to two-year course with intensive academic and in-house training. It works with an impressive number of its

Fellows immediately springing into new and higher jobs. There's no excuse for amateurism any more, no room for those who shy at the thought that the arts might, indeed, be a business.

M is for Mission. We all need one and we all need to put it into words. Doing so should clarify what an organisation is about. But if we tie ourselves in knots over whether we are an arm of social policy rather than a home for creativity, defining the Mission can end up causing confusion and distortion.

N is for Nolan. Originally, Lord Nolan was asked to chair a Committee to improve standards in public life. It was about stopping – or reducing – corruption. Once that was done and dusted, he turned his attention to how public institutions appointed themselves, ran themselves and behaved themselves (see Governance above). The result was that the 'great and good' of the best arts boards found themselves pitched off the board after two terms, allegedly on 'Nolan grounds'. In fact, this is a total misrepresentation of Lord Nolan's recommendations, almost certainly used by civil servants to keep boards less experienced than they should be.

O is for Objectives. Once you have your Mission, it is realised in practice by having objectives. There is nothing wrong with having them. What is wrong – and totally counterproductive – is having outsiders – usually civil servants and bureaucrats – set them for you. Internally devised objectives are energising; externally imposed ones are enervating and designed only to exert control, when the policy is supposed to be 'arm's length'.

P is for Partnership. There are myriads of arts organisations. All believe they are unique. This is a fantasy – many share identical problems. Believing in their uniqueness allows them to remain separate in every detail from making the coffee to crunching the numbers. Feeling unique allows organisations to stand aloof from others like them, because the way each does marketing,

press or programming is judged to be uniquely effective. This too is fantasy. Arts organisations are now considering partnering one another. But too many would rather stay unique and risk failure than be part of a partnership and dare to achieve success.

Q is for Quantification. You might call it measurement. Some of it is easy and second nature. How many seats do you sell? What do you charge? What do you earn from commercial activities? But arts organisations are challenged to justify themselves on more rigorous grounds. Can you measure how good your art is? Why can't you measure the difference it makes to people's lives? It's a nonsense question but that doesn't stop the mini-men from asking it.

R is for Risk. Programming art is totally, innately, constantly, gloriously unpredictable. In other words, risky. Programming art can be, financially, totally unpredictable. In other words, very risky. 'Risk Registers' are usually statements, laboriously compiled, of the blindingly obvious. They consist of observations such as 'Failing to sell enough tickets represents a High Risk for the organisation.' The reality of risk-taking in the arts is that it is a constant process, regularly monitored, consciously undertaken, carefully balanced, because without risk-taking there is no worthwhile art.

S is for Selection. Who chooses the programmes in any arts centre? The specialists in the arts. Who gives them the right to do so? Those whose responsibility it is to choose the most expert in the art form concerned. Why isn't it more democratic? Because the exercise of skill, special knowledge and considered judgement is only crudely and imperfectly met by the usual democratic processes. Look at politicians if you have any doubts on the matter. Why can't audiences choose more? Because audiences know what they already know. The experts' job is to make available the best, the newest, the most innovative that

exists on the arts market. The expert, in this sense, is not a remote 'high priest' of high culture. The arts expert is far more like a retailer. Because ultimately who chooses? The audience when they buy – or don't buy – tickets.

T is for Transparency. Everything a public sector organisation does must be so fully reported and accounted for that the processes, costs, decisions and judgements are fully transparent, and judged to be transparent by outsiders.

V is Variances. These are worrying – if they are adverse – or encouraging – if they are favourable. They tell you if you are meeting or missing what you said you would do in your budget. Monitoring the budget involves scrutinising the variances. Overreacting to variances can lead to premature decisions which you regret later.

W is for World Class. Any arts institution that really is world class doesn't need to brag about it. The really great arts institutions – in the performing or visual arts – are recognised and acknowledged to be in an arts super league. 'World Class' is most often used by politicians when talking up some item of public investment. It often indicates that it isn't well enough funded to be truly world class.

X is for Exclusion. The notion that people are excluded from the experience of the arts is usually pedalled by those who know nothing about whether feelings of exclusion really exist. The customary accusations revolve around the notion that either the building in which the arts exist, the other people who go there, the (often non-existent) dress codes, the intellectual assumptions, the knowledge required, individually or collectively keep people away. Arts buildings which have steps at their front door are widely deemed to be involved in an act of exclusion. The notion of exclusion also often carries with it the accusatory notion that the arts want to exclude and connive at creating difficulties in the

way of attendance. In fact, the greatest obstacle to 'inclusion' is the weakness of the education system, which places a low priority on introducing children to the world of the arts.

Y is for Year End. This involves mounting anxiety and tension. Will the year-end finances show a deficit or a surplus? There is no way round it. The tension is part of life. The only gratification is the momentary relief when the numbers turn out right.

Maybe it's just me but the shift in the alphabet towards a much fuller, more rigorous, more comprehensive, more demanding set of administrative and managerial criteria is real enough. Some are nonsense. Some are needlessly onerous. Some can actively distort the core purposes of the arts. But they won't go away. The skill of arts management is to turn the awkward, obfuscating and bureaucratic alphabet into a language that truly serves the arts and their audiences.